The Namban Art
of Japan

THE HEIBONSHA SURVEY OF JAPANESE ART

For a list of the entire series see end of book

CONSULTING EDITORS

Katsuichiro Kamei, *art critic*
Seiichiro Takahashi, *Chairman, Japan Art Academy*
Ichimatsu Tanaka, *Chairman, Cultural Properties Protection Commission*

The Namban Art of Japan

by YOSHITOMO OKAMOTO

translated by Ronald K. Jones

New York · WEATHERHILL/HEIBONSHA · Tokyo

This book was originally published in Japanese by Heibonsha
under the title *Namban Bijutsu* in the Nihon no Bijutsu Series.

First English Edition, 1972

*Jointly published by John Weatherhill, Inc., 149 Madison Avenue, New York, New
York 10016, with editorial offices at 7-6-13 Roppongi, Minato-ku, Tokyo 106, and
Heibonsha, Tokyo. Copyright © 1965, 1972, by Heibonsha; all rights reserved.
Printed in Japan.*

LCC Card No. 72-78597 *ISBN 0-8348-1008-5*

Contents

The Namban Art
of Japan

The Background of Namban Culture

SILVER TRADE AND THE NAMBAN

In Japanese art history, the term *namban* refers to works of art produced as a result of intercourse between the Japanese and the southern Europeans—mainly Portuguese and Spaniards—who arrived in Japan in the sixteenth century. The word, then, does not signify a particular style or system; rather it is a convenient general term for works in two heterogeneous styles of completely different origin—a Japanese style and a Western style.

Since both Japanese and Western systems arose separately as a result of historical exigencies, it will be more significant to conduct our initial inquiries in terms of the cultural history of this period of Japanese-European relations, before going on to a further historical investigation of the styles and relationships of the artworks produced. No study of individual works that come under the general heading of *namban* art, no examination of the biographies of individual painters can do more than show us the branches and the foliage, and leave the roots beyond our grasp. For this reason, I propose to deal first with the early period of intercourse between Japan and the West and then to summarize the conditions under which *namban* art appeared.

The paucity of historical materials, particularly in the arts, has necessitated frequent reliance on conjecture, but I have tried to stay on firm ground, and to keep such instances to the absolute minimum.

Originally, the term *namban* [literally, "southern barbarian"], although read differently, was one of the four terms used by the Chinese to describe the alien peoples who surrounded them, and it referred to all the peoples of Southeast Asia. In Japan, the term was first applied to the Portuguese who sailed to Kyushu in the sixteenth century by way of Southeast Asia and was then extended to include the Spaniards who arrived from the Philippine Islands. *Namban* art, therefore, is simply that art which owed its rise to these two peoples of the Iberian peninsula. Thus it is necessary for us to take a quick look at the expansion of the citizens of Spain and Portugal—the *namban*—in the eastern and western hemispheres, and their relations with Japan after their arrival there.

In 1510, the Portuguese established the viceroyalty of India at Goa, on the western coast of India. The following year they took Malacca, on the west coast of the Malay peninsula, already a flourishing center of the entrepôt trade between the countries of the Far and the Near East, and made it the headquarters for their operations in the Far East. At the end of 1511, they had already sent vessels to the Spice Islands, or Moluccas, and two

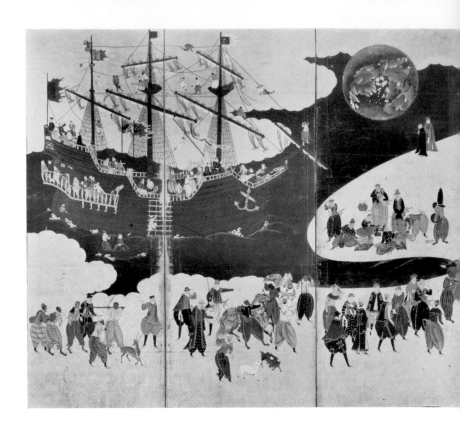

years later were appearing in the waters off Kwantung Province in south China. The arrival of the first Portuguese ships in the southern part of Kyushu, Japan, occurred in the 1540s. (For map of Japan see foldout facing page 129.)

Earlier, in the 1530s, when vast quantities of silver were unexpectedly produced from the Omori mine in Iwami Province on the southern Japan Sea coast of Honshu, the main island, and from the Ikuno mine in Tajima Province, near present Kobe, Chinese junks came frequently to the ports of southern Kyushu to serve in its export.

Since the ninth century, Moslem merchants controlled the trade in silver from the Near East to South China, supplying the West with spices, dyestuffs, and cotton from tropical Asia and silk thread and fabrics from China, and bringing to the countries of the Far East spices, precious metals, and

gemstones. Of the precious metals, silver was in the greatest demand as a medium of exchange in the East and particularly in China, most of it coming from the mines of south Germany and passing through the Mediterranean into the possession of Moslem traders. It is estimated that from the fifteenth to the mid-sixteenth century, over one half of the world's total silver production came from German mines.

In the New World too, the range of Spanish exploration increased with the conquest of Mexico, which was completed in 1521, and that of Peru in 1532. And with continued exploration in other parts of Central and South America, viceroyalties were established at Mexico City in 1535, and at Lima in 1542.

The expansion of the Spaniards into the East sprang originally from a desire to gain possession of

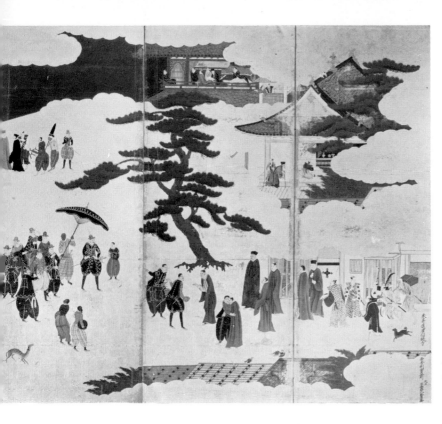

1. Arrival of a Portuguese ship: detail from a sixfold namban *screen by a follower of Kano Naizen. (See also Figs. 95, 113.) Colors on paper, 156 × 330 cm. Toshodai-ji, Nara.*

the Spice Islands of Indonesia. From the odyssey of Magellan, who first rounded the southern tip of South America and crossed to the Philippine Islands in 1521, to the many other trans-Pacific voyages subsequently undertaken over a period of almost forty years, all voyages had the Moluccas as their objective. However, the Portuguese had already explored and occupied them and were able to prevent the Spaniards from achieving their aim. The Philippines, on the other hand, came under effective Spanish rule beginning with the dispatch of Legaspi's fleet in 1565, and a regular annual service was instituted by the Spanish government between Manila and the Mexican port of Acapulco. The Spaniards had already perceived, even from the very year Legaspi first arrived in the Philippines, that in the voyage to Mexico they would have to follow a great-circle route that would carry them

northeast to the vicinity of 40° north latitude. Thus these ships sailed a northeasterly course though the seas east of the Japanese islands, but under the *padroado* agreement between the Spanish and Portuguese governments not to interfere in each other's spheres of political domination, trade, or missionary activity, they never once visited Japan.

Another important way in which the Spanish conquest of the New World influenced the East was the opening of new silver mines in Mexico and Peru. At first, output lagged behind that of the south German mines, but with the opening of the Potosí mines, located in present-day Bolivia, New World production rose rapidly until in the 1560s and after it amounted to seven or eight times the total for the entire Old World. The silver was, moreover, very cheap. It was only natural that with this enormous torrent of silver flooding into Spain and then

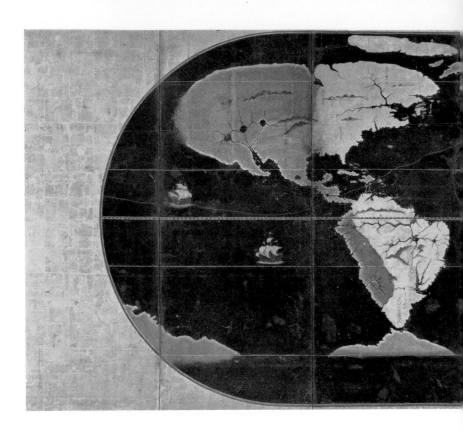

finding its way to the other nations of Western Europe, an unprecedented inflation—indeed a price revolution—should result. And with Spanish administration of the Philippine Islands, the silver of the New World flowed via Manila into China, giving rise to inflation in the East as well.

In the 1530s, when the sudden increase in Japanese silver production occurred, the New World mines of the Spaniards had scarcely been opened, and production was not even one tenth of what it would be at its height forty years later. Thus it is hardly surprising that virtually no one in Europe, let alone the East, was able to forecast what was to happen, and we may imagine the attraction that Japan's silver deposits, the only ones in the East, had for China and other neighboring countries. Innumerable junks came to Japan from south China—mainly Fukien and Chekiang pro-

vinces—laden with the silks that were in such demand by the Japanese. The Chinese traded these for silver and sailed away. And since this silver, which was so desired by the Chinese, was sold to them at far less than the standard exchange rate in China, it takes no great effort to imagine the enormous profits these merchants must have made. There has been no equal before or since to the fleet of Chinese ships, numbering not below two hundred, that put into the isolated rural harbors of the provinces of Satsuma and Osumi (present Kagoshima Prefecture) every May during the 1540s. These ports were used as a result of the continuing domestic turmoil in Japan, which meant that, because of the frequent depredations of pirates and local warlords in coastal waters, ships were unable to use the developed ports of the Inland Sea and the north and west coasts of Kyushu.

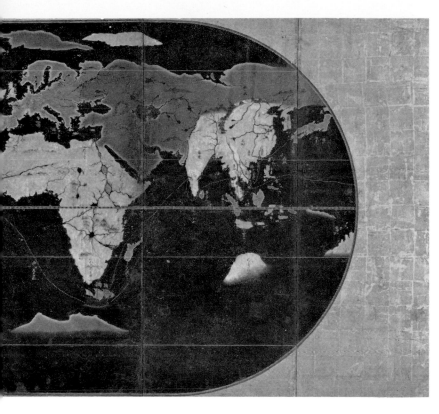

2. *Map of the world. Sixfold screen paired with the Japan-map screen in Fig. 73. Colors on paper; each screen, 153 × 360 cm. Sixteenth century. Collection of Ataru Kobayashi, Tokyo.*

THE PORTUGUESE DISCOVER JAPAN

Portuguese ships first came to Japan in 1543 from their main port in south China in the wake of Chinese junks. Once in Japanese ports, they realized that they could obtain all the silver they wanted and could operate more profitably there than in any other Oriental country they visited. And so for a number of years afterward, their ships called at the ports of southern Kyushu on every voyage.

Their trade was in the same products as that of the junks. Heretofore the Portuguese had loaded pepper from northern Sumatra and Java at Malacca, traveled to China to exchange it for silks and other Chinese products, and returned to India. This route, along with the one to the Moluccas and the one to Hormuz on the Persian Gulf, had formed the "great three" profitable trade routes

that the Portuguese had developed in the East. Now it was proposed to extend the network to Japan.

The trade involved bartering pepper for silks in China, selling these at great profit in Japan, converting all proceeds to silver to be transported to Chinese ports, again buying silks with the silver, and returning to India. This realization of gigantic profits four times over meant gains of many times more than could be obtained before the extension to Japan. Indeed the whole India-Japan voyage, sometimes yielding returns of ten times or more on the value of the original cargos loaded in India or Malacca, was the most profitable of all such routes.

Up until the mid-1550s—that is, about the time when Macao was opened up—the Japan trade was left to private Portuguese merchantmen, but in 1556, a captain-major was appointed for the route

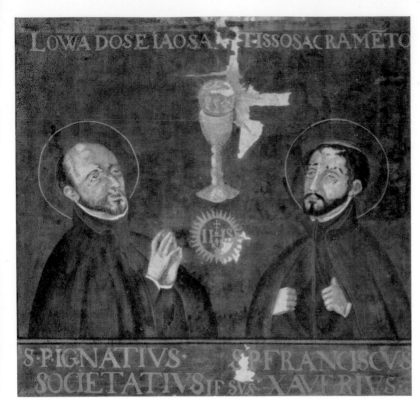

LOWA DOS E IAOSA...TISSO SACRAMETO

S·P·IGNATIVS·
SOCIETATIVS IE SVS

S·P·FRANCISCVS
IE SVS XAVERIVS

3. *Xavier and Loyola: detail of* The Fifteen Mysteries of the Rosary. *(See also Fig. 129.) Colors on paper, 81.6 × 64.8 cm. Collection of Fujitsugu Azuma, Osaka.*

4. *Street scene in Goa from Jan Huygen* ▷ *van Linschoten's* Voyages, *a collection of logs of sixteenth-century Portuguese ships. 1595.*

between Japan and China, bringing it under government control. Each year, he deployed a single enormous carrack, or *nao* in Portuguese. The *nao* were probably the largest merchant vessels in the world, and with a capacity of eight hundred tons or more, each ship could carry as much cargo as several Chinese junks. The very fact that the Portuguese commonly referred to these *nao* as "silver-carrying ships" only goes to reaffirm how much they prized Japanese silver. The Portuguese government chose as their captain-major each year a gentleman or merchant with experience in the East, and as in the case of the captain-major of each of the other major routes, invested him not only with the right to regulate trade but also with administrative control over all Portuguese subjects within the area served by the voyage as well as the right to represent Portugal in diplomatic intercourse.

The Portuguese and Chinese ships that had

visited the ports of Satsuma in southern Kyushu during the 1540s had, by 1550, concentrated at Hirado, Hizen Province, in the fief of the Matsuura clan, and at Funai, now Oita, the castle town of the daimyo Otomo Yoshishige, in Bungo Province, in the northwestern and northeastern corners, respectively, of Kyushu. In the early years of the 1560s, Portuguese ships called at Hirado, and soon afterward at the port of Yokoseura, also in Hizen, but under the rule of Omura Sumitada. Subsequently, trade was carried on at Fukuda, which lies outside the present harbor of Nagasaki. This frequent change in port of call was, as I shall later clarify, due to the inseparable connection that these voyages had with the propagation of the Christian religion. And it was extremely advantageous for the mutually hostile feudal lords that foreign ships should visit their ports and attract to them the wealthy merchants of Kyoto, Sakai, and Hakata.

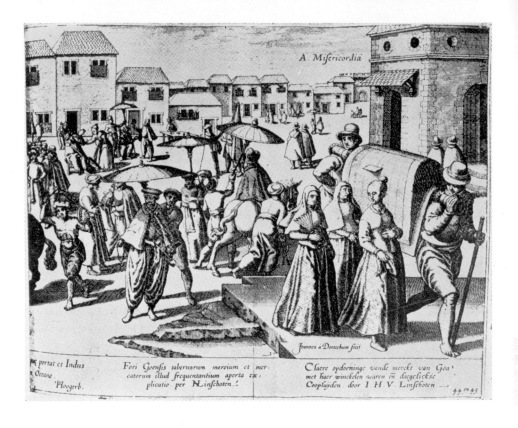

As the 1560s dawned, the accustomed fleets of junks suddenly disappeared from the coasts of Japan. The Portuguese were thus able to monopolize Japan's foreign trade, which was essentially a brokerage trade with China, so that Portuguese mercantile activity rose toward its zenith. The reason for this cessation of calls by Chinese ships was that in the 1550s the three south China provinces of Chekiang, Fukien, and Kwantung were increasingly ravaged by *wako*, or Japanese pirates, and the Chinese authorities, in an effort to defend the region, increased the severity of control over traffic with Japan.

CHRISTIANITY BEGINS IN JAPAN

Inextricably tied to the Portuguese trade and entering Japan at the same time was the Christian religion. The Spaniards and the Portuguese, who took the lead in the voyages of discovery, had then, as they still have today, an inflexible faith in Roman Catholicism. From the end of the fifteenth century, the governments of both countries sent out to all those countries of the eastern and western hemispheres that they had explored or conquered, or with which they had developed commercial relations, Catholic missionaries to propagate the faith among the native peoples. In Western Europe, the first half of the sixteenth century saw the sudden eruption of the Reformation and a mighty increase in Protestant influence. The violent contention between the adherents of the two faiths in central Europe and the frequency with which they visited on each other the most bloody devastation are notorious. And it is also well known how, spurred by this, a new monastic order, the Society of Jesus, arose with the objective of purging the Church of the sinful practices that had arisen during the Middle Ages, and how it

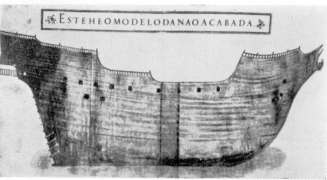

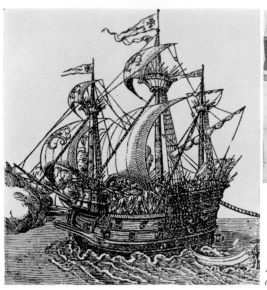

6 (above). Model of a great Portuguese nao *launched in 1616.*

5 (left). A nao. *Early sixteenth century. From* Caravelas Naus e Galés de Portugal.

devoted its energies to the counter-reformation of the Church.

Shortly after the founding of the Society of Jesus, the Portuguese government entrusted the fledgling order with responsibility for religious propagation in those areas of the East within its sphere of influence. And St. Francis Xavier, one of the founders of the Society, heeded this call and set out for India. After traveling through India, Malacca, and the Moluccas, he set his course toward Japan, landing at Kagoshima in southern Kyushu in 1549, several years after the first calls by the Portuguese. Here, then, were the beginnings of Christianity in Japan. Xavier was, however, unable to gain the support of Shimazu, daimyo of Satsuma, and so in less than a year he departed for Hirado, in Hizen, where the Portuguese ships had by then begun to call. Subsequently he passed through Yamaguchi, Sakai, and Kyoto, and then, moving to Bungo (present Oita Prefecture), he returned to India after a sojourn in Japan of somewhat more than two years.

Following in Xavier's footsteps came many Jesuit missionaries who zealously taught the faith in Japan. Their headquarters was at Hirado, and it was then moved to Funai, to Yokoseura in Hizen, to Omura, to Arima and Kuchinotsu in the Minami-Takaki district of present Nagasaki Prefecture, and to Fukuda. And except for Hirado, all the ports at which the Portuguese ships called were in the territory of Christian clans. Hirado, the conspicuous exception, had been, for about ten years preceding 1561, a trading port for the Portuguese, and there were not a few converts in the surrounding areas. But because the daimyo of the region, Matsuura Takanobu, was not favorably disposed toward Christianity, the missionaries were forced to leave and Portuguese vessels were forbidden entry into the port. Omura Sumitada and Arima Yoshisada, lords of the areas around Nagasaki, were strong believers, and in their domains proselytizing progressed smoothly and the number of converts increased. And the ships too were thus

7. *Gunpower flask decorated with namban figures wearing the baggy* bombacha *trousers of the Portuguese colonies. Gold and black* ▷ *lacquer on wood, 28 × 36 cm. Tokyo National Museum.*

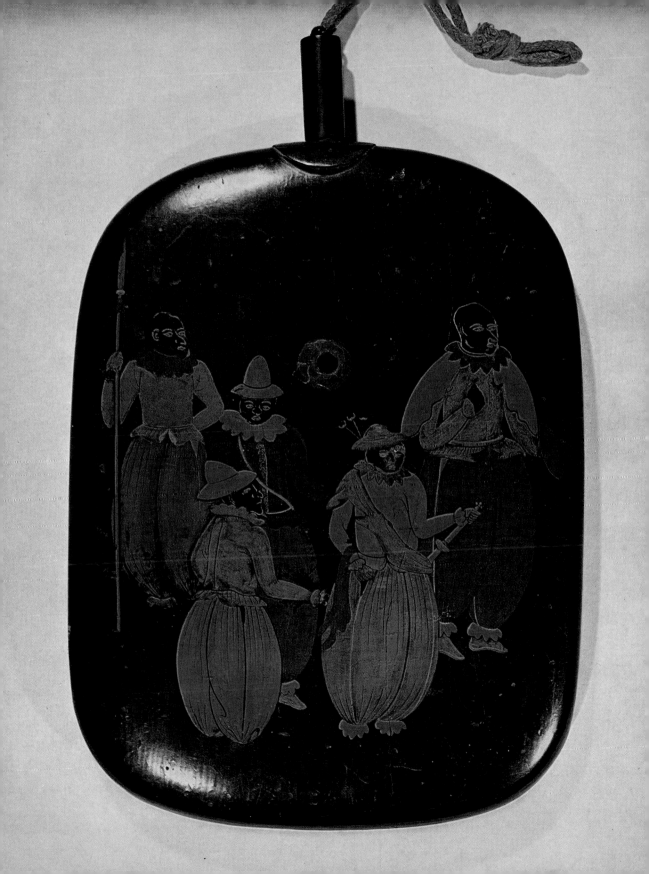

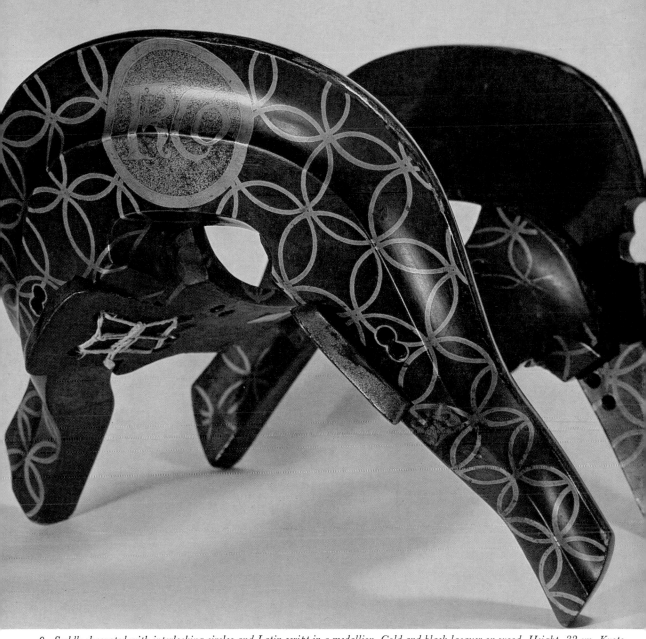

9. *Saddle decorated with interlocking circles and Latin script in a medallion. Gold and black lacquer on wood. Height, 32 cm. Kyoto University, Department of Japanese History.*

◁ 8. *Detail of folding chair with* namban *figures. Raised gold lacquer on wood. Full height, 104 cm. Tanko-ji, Kyoto.*

10 *(overleaf). Detail from a pair of sixfold* namban ▷ *screens. Colors on paper; dimensions of each screen, 156 x 365 cm. National Museum of Antique Art, Lisbon.*

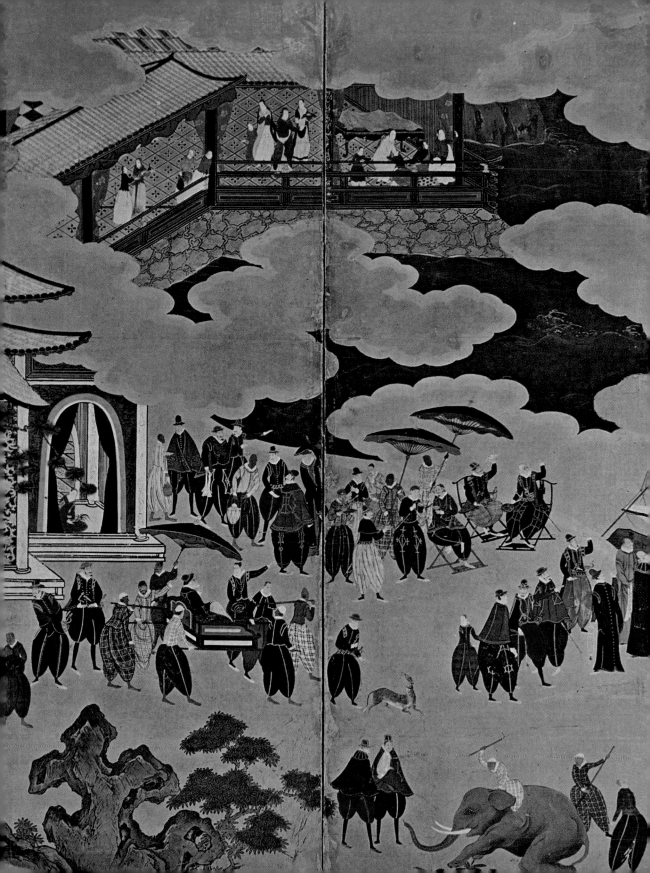

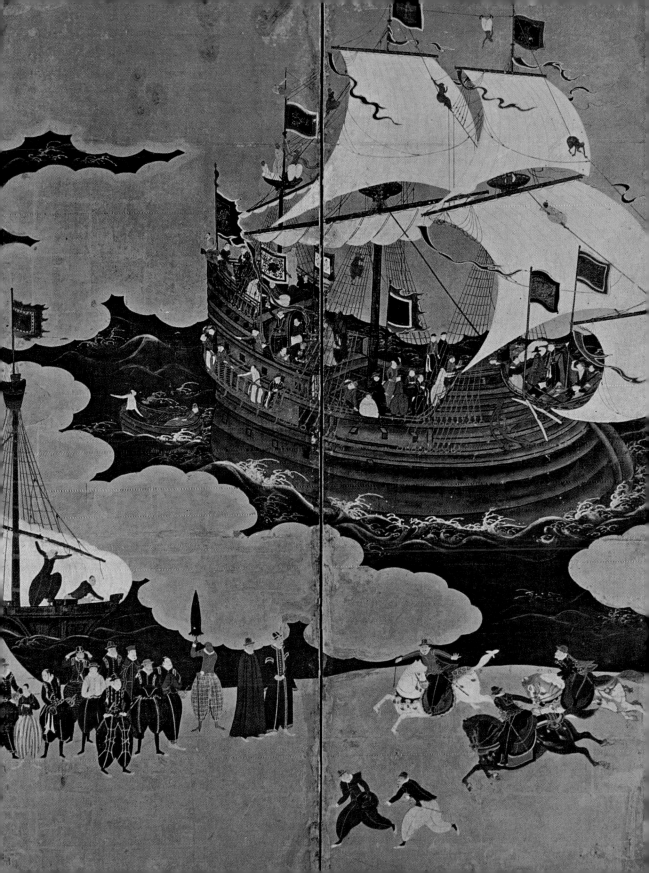

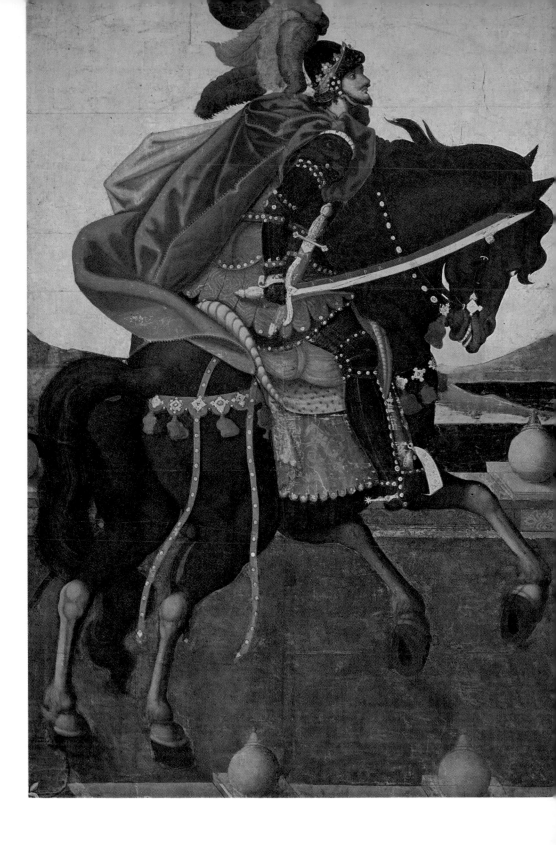

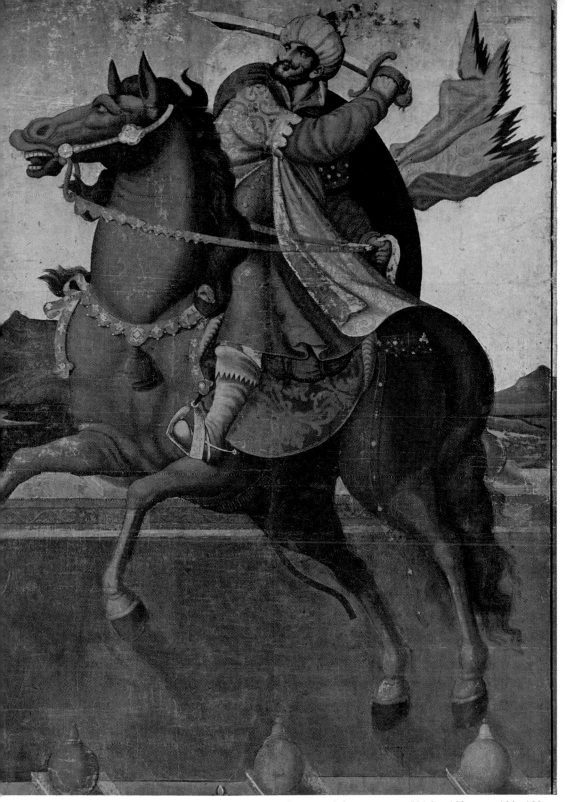

11. *Detail from a fourfold screen showing mounted princes. Colors on paper. Height, 162 cm.; width, 468 cm. Kōbe Municipal Museum of Namban Art, Kobe.*

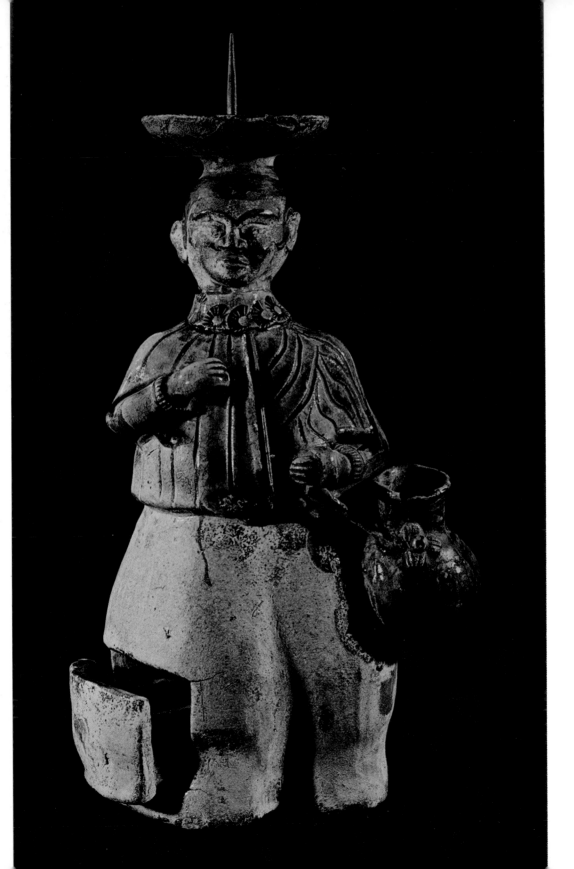

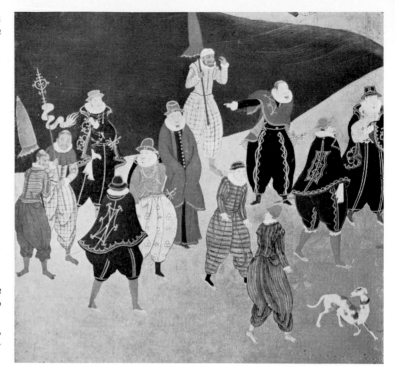

◁ *12. Candlestick in shape of a* namban *figure. Oribe ware. Height, 27 cm. Collection of Inosuke Setsu, Tokyo.*

13. Arrival of the Portuguese: detail from a pair of sixfold namban *screens attributed to Kano Naizen. (See also Figs. 96, 100.) Colors on paper; dimensions of each screen, 155.6 × 364.6 cm. Kobe Municipal Museum of Namban Art.*

drawn to the ports of these rulers. Ships stopped calling in Bungo Province after 1561, but thanks to the warm protection extended by the daimyo, Otomo Yoshishige, to the missionaries, it was for many years a center of missionary activity. However, in 1585 the Satsuma armies under Shimazu Yoshihisa invaded Bungo and laid the province waste, after which Christianity there went into decline.

In Settsu, Kawachi, Yamato, and other provinces of the Kinki region near Kyoto and Sakai, missionary activity was carried on from 1559, entirely unrelated to Portuguese mercantile endeavor. And since there were Christians among the powerful clans and merchant houses, many converts appeared in their domains or under their aegis. Thus it was that from the end of the Warring Provinces period through the Azuchi-Momoyama period (that is, up to 1603) Christianity enjoyed a rapid and continued spread from its centers of strength in western and northern Kyushu and the Kinki region throughout that part of Japan lying west of present-day Aichi Prefecture.

In 1581, at the end of the Azuchi period, there were in Japan a total of 75 Jesuit missionaries and over 200 churches. Converts are reported to have numbered 25,000 in Kinki, 10,000 in Bungo, and 115,000 in Hizen. It is thus easy to understand European astonishment that in a period of only thirty-one years, and despite constant, pervasive warfare and minimal travel facilities, it was possible to effect 150,000 conversions out of a Japanese population which fell short of twenty million. But growth did not stop there. In 1596 there were 134 missionaries, 8,012 converts were baptized in that year alone, and 24 new churches were established. The rate of growth was nothing short of phenomenal.

CHAPTER TWO

The Rise and Decline
of Japanese Christianity

FOR ALMOST seventy years, from the arrival of the first Portuguese ship in Nagasaki in 1571 to the rigorous enforcement of the policy of isolation by the Tokugawa shogunate in 1639, the city never lost its position as the port of call for the Portuguese. And thereafter for more than two hundred years, until the closing years of shogunal government, it continued its activities as the only port in Japan open to Dutch and Chinese shipping. This period naturally saw many changes, and it may be easier to grasp the essentials if we consider the sixty-nine-year period preceding total isolation in terms of four phases. The first would be from the opening of Nagasaki port to 1588, when the general Toyotomi Hideyoshi, having completed his pacification of Kyushu one year earlier, brought the city under his direct control. The second would be up until the Battle of Sekigahara in 1600, when Tokugawa Ieyasu's forces finally seized mastery of the country from the supporters of Hideyoshi. The third phase would take us up to 1614, when the proscription of Christianity was proclaimed; and the fourth would cover the remaining years up to the enforcement of almost total isolation in 1639.

THE EARLY YEARS Since the port of Fukuda, at which Portuguese had been calling from 1565 to 1570, was unsatisfactory, the pilots and the missionaries cast longing glances toward Nagasaki at the head of a bay that opened to the south (Fig. 15). In 1570, it was opened to them, and the next year the first ship put in. The ruler of the area, Omura Sumitada was a fervent Christian and granted the Portuguese many privileges and favors. He exempted trade between Japanese merchants and the Portuguese from taxation, erected a church and contributed to its maintenance, and forbade nonbelievers to reside in the town without the concurrence of the missionaries— just as he had, indeed, done earlier at Yokoseura and Fukuda. But there seems to have been one additional dividend that accrued to Nagasaki. Refugees—mainly Christians driven from their homes by anti-Christian lords in the Amakusa, Goto, Hirado, and Chikuzen areas of Kyushu, and later from Yamaguchi, and those rendered homeless by the ravages of the constant fighting—converged on Nagasaki and settled there.

About ten years later land grants were made to the Jesuits—Nagasaki by Lord Omura, and the neighboring villages of Uragami and Fuchi by Lord Arima—so that Nagasaki rested, in name as well as in fact, on Church land. In other provinces, the people lived under conditions of constant civil strife, and were subject to extortionate tax levies; the people of Nagasaki, on the other hand, were

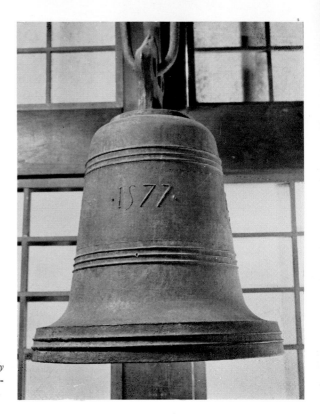

14. *Bell formerly in the Church of the Assumption of Our Lady ("Namban-ji"), Kyoto. Copper; height, 60 cm. 1577. Shunko-in, Kyoto. (See also Fig. 27.)*

exempted from the capitation tax and were not subjected to rigorous forms of punishment. No landowning was permitted except for actual living purposes, and the accumulation of large landholdings was prohibited. *Otona,* or elders, were chosen from among the citizenry to handle civic administration, in a system that seems to have been much simpler than that used after about 1600, in which other functionaries proliferated above and below the *otona.* There were even institutions for the care of the sick and relief of the poor. Out of these conditions grew a free port for foreign trade where the Christian faithful governed under Church authority on a basis of self-determination and equality, and where oppressive burdens and punishments were not imposed. In both form and essence, the social organization developed in Nagasaki was absolutely without precedent in the long history of Japan.

Yet all was not peaceful and uneventful in Nagasaki. In a period of several years after the opening of the port, several attacks were mounted by neighboring clans who were rivals of the Omura house, and who regarded Christianity as an abomination. That Nagasaki did not go the way of Yokoseura, which had fallen in the face of similar attacks over a period of two years, was due to the fact that, profiting from Yokoseura's disastrous experience, the Church and the faithful cooperated in constructing fortifications that succeeded in averting catastrophe by the narrowest of margins. There were also unending squabbles between the Japanese and the Portuguese—so dissimilar in ways of life, customs, and language—and from time to time these erupted into major riots. But we are told that on all such occasions the missionaries were at pains to restore calm.

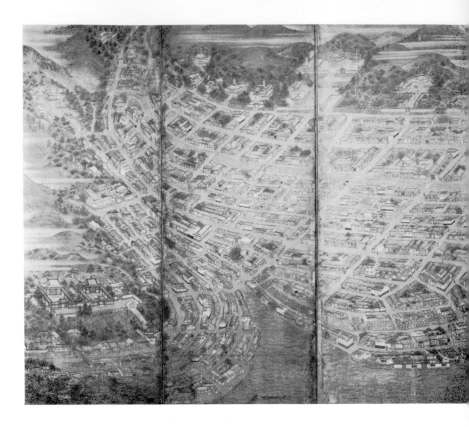

No accurate figures are known for the population of Nagasaki immediately after the opening of the port, but it is unlikely that the town held more than a thousand people. A report dated 1585 tells us that there were large numbers of new arrivals who brought their families with them and that, of these, more than three hundred per year were baptized. It is probable that by then the population surpassed four thousand. The report also noted that while there were among the population some who were not Christian, virtually every inhabitant profited either directly or indirectly from the Portuguese trade. The majority of those who came initially from other provinces had fled with only the clothes on their backs, and those who continued to swell the population year after year were no doubt in almost as dire straits. Nevertheless, reports tell us that after people spent ten or more years in Naga-

saki, earning their livings either directly or indirectly from the trade and blessed with the serenity and peace of believers in Christ, their standard of material existence showed rapid improvement. As far as may be ascertained, they had advanced beyond a hand-to-mouth existence and, unlike the average Japanese in other provinces, had adopted to some extent Western fashions of diet, dress, and domicile, so that from the viewpoint of the missionaries, they were able to pass their days in a very comfortable style.

A PORTUGUESE SHIP called in Nagasaki in every one of the eighteen years between 1571 and 1588, with the exception of 1579 and 1582, when one called in Kuchinotsu in the domain of Arima. Up until 1580, the annual ship would remain berthed in Nagasaki harbor from the time of its arrival, commonly in

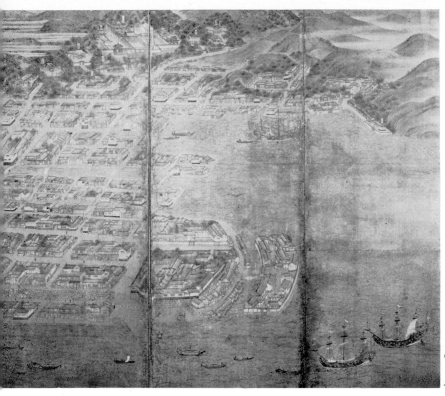

15. *Panoramic plan of Nagasaki harbor. Colors on paper; single sixfold screen, 157 × 361.8 cm. Kobe Municipal Museum of Namban Art.*

July, until it again set sail in September or October. In the following ten years or so, the ship would stay until December, or January of the next year, and from 1590 on it was usual for the ship to stay a full six or eight months in Nagasaki, until near the end of the northwest monsoons in late February or early March.

This lengthening of the stay in port was probably for reasons of trading convenience, but it may well be that the vicissitudes of Japanese politics exerted an influence. For Church rule in Nagasaki lasted only seven short years; immediately after Hideyoshi succeeded in subjugating Shimazu Yoshihisa, daimyo of Shimazu, in 1587, he issued from Hakata an order for the expulsion of the missionaries and in the following year confiscated Nagasaki from the Society of Jesus and brought it under his own direct rule.

HIDEYOSHI'S RULE OF NAGASAKI

His policy toward trade with the Portuguese was, however, one of encouragement. Since there were virtually no calls being made by ships of other foreign powers and few Japanese ships at that time ventured abroad, Hideyoshi, we may suppose, was not about to risk the loss of trade that depended on the call of a single ship. While suppressing the propagation of the Catholic faith, he seems to have regarded trade as quite another matter, and to have attempted to arrogate to himself the profits from it. It would therefore appear that he failed to understand that while the trade of the Portuguese was under the direct administration of the government of Portugal, the missionary work of the Jesuits enjoyed its indirect protection and favor, so that the two were inextricably linked.

16. *Inkstone case with* namban *figures. Gold lacquer on wood; 22.5 × 21 cm. Collection of Yoshiro Kitamura, Osaka.*

17. *Portuguese ship: detail from a pair of sixfold* ▷ *namban* screens by a follower of Tohoku. *Colors on paper; each screen, 154.5 × 350.8 cm. Yoshimatsu Tsuruki Collection, Tokyo. (See also Figs. 59, 62, 107.)*

The provinces of Kyushu had already ceased to be a theater of war, but Nagasaki became subject to the encroaching authoritarianism of Hideyoshi, and the trade of the Portuguese was no doubt subject to considerable interference. In 1586, the year before Hideyoshi's expedition against Shimazu, the annual Portuguese *nao*, in exception to recent practice, had put in at Hirado and was unable to settle its trade within the year due to the turmoil that embroiled all of Kyushu from the arrival of Shimazu's army of invasion until the arrival of Hideyoshi's forces. The ship stayed on into the next year, and as a result the voyage scheduled for 1587 was canceled.

There were several other incidents too. In the year Nagasaki was expropriated, the Jesuits, fearing that Hideyoshi's new supervisor and his retinue might take over as quarters and otherwise desecrate the churches and other ecclesiastical buildings,

entrusted their care to the ship, and deployed garrisons of sailors.

Hideyoshi also sent a deputy to attempt to buy the cargo of silks that the *nao* had brought from China out from under the Japanese merchants who came every year to trade. In this he was rebuffed by the Portuguese, but as luck would have it, his deputy was a Christian, Konishi Ryusa, and so the affair was resolved satisfactorily under the good offices of the missionaries. On that ship there were some dozen men who had accompanied Alessandro Valignano, the Jesuit visitor, to Kyoto in 1591 on a mission from the Portuguese viceroy of India to Hideyoshi. And since they were away from Nagasaki from December 1590 until the end of the following April, they obviously missed the departure of their ship in February.

On another occasion, Hideyoshi's two supervisors in Nagasaki, Nabeshima and Mori, acting

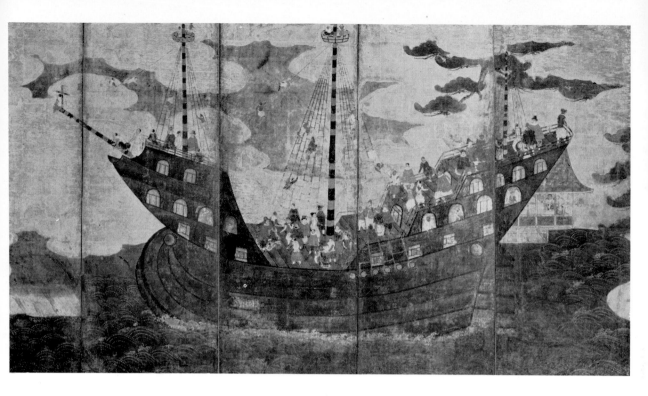

under his orders, attempted to corner the gold brought by the Portuguese ship that arrived in July. When they were rebuffed, trouble smoldered between the two sides, but a representative of the Portuguese captain journeyed to Kyoto and presented a note of protest directly to Hideyoshi. Finally, with the intervention of Valignano, a harmonious solution was reached, but these delays did postpone the ship's departure from the customary February or March date until October. The same factors also led to cancellation of the voyage of 1592 from Macao, and the succeeding cancellations of 1597 and 1599 were also in all probability due to this kind of harassment of trade.

But in the broader view, Portuguese trade actually developed to a greater extent after Nagasaki came under central administration than it had before. Hideyoshi was near the end of his campaigns of national unification, leaving only the Kanto and

Tohoku regions to be suppressed a year later. With pacification, conditions for commerce, both internal and external, were becoming extremely favorable. Nagasaki, now under central, not Church control, became the focus of the new age as the gateway for the imported goods that were in such strong demand by the people.

As the volume and variety of Portuguese trade increased, more and more time was required to negotiate prices, which varied considerably from one year to the next. Sometimes business could not be wound up even by March, the absolute deadline for setting sail, delaying the return to Macao beyond a full year and sometimes even forcing cancellation of the succeeding voyage.

With stays of more than six months in the town, there were many Portuguese merchants and seamen who rented houses where they set up housekeeping with Japanese women to make their sojourn

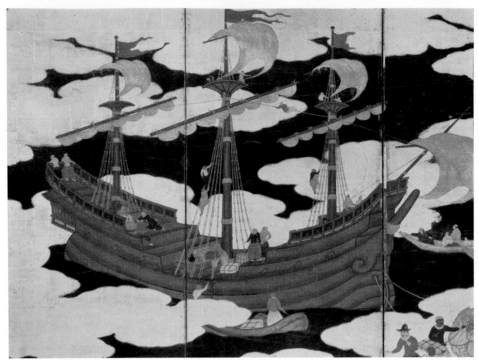

18. Unloading a Portuguese ship: detail from a pair of sixfold namban *screens by a follower of Kano Tomonobu. Colors on paper; each screen, 158.5 × 362 cm. Osaka Castle. (See Fig. 69 for matching screen.)*

more agreeable. According to reports of the Jesuits, the Portuguese seldom journeyed into the hinterland of Japan for either private or commercial pursuits: their dealings were carried on by attending the arrival of Japanese merchants. This unaggressive attitude is in contrast to the more active practices of the English and Dutch of some twenty years later, who visited major cities throughout the country. Nevertheless there is no doubt that the 1590s were the most prosperous period for the great *nao* that visited Japan. It also seems that the tradesmen and sailors of these *nao* were not only reticent in matters of trade but also largely unlettered, for they have left us not a single report or record.

When Nagasaki, which had grown up as a community of the faithful, was placed under central control in 1588, it was administered temporarily by two men, Nabeshima and Mori, who were direct appointees of Hideyoshi. But after 1592, Terazawa

Hirotaka was named *bugyo*, or governor. In accordance with Hideyoshi's orders, these men applied oppressive measures to the Church, but once Hideyoshi realized the intimate connection that existed between the trading and mission activities, even the *bugyo* had to turn a blind eye. The missionaries during this period paid lip service to Hideyoshi's proscription by refraining from open preaching, but it is likely that they were as active as they had been before the edict. This conjecture is supported by a report of the Society of Jesus dated 1596, which tells us that, "Thanks to the *nao* which arrive every year, refugees and those who have lost their means of livelihood come together here, so that the number of both people and houses increases day by day. The town has grown, until it is now some ten times larger that it was at first. Yet the missionaries are expending every effort to effect the Christianization of the newcomers, and the newcomers, for their

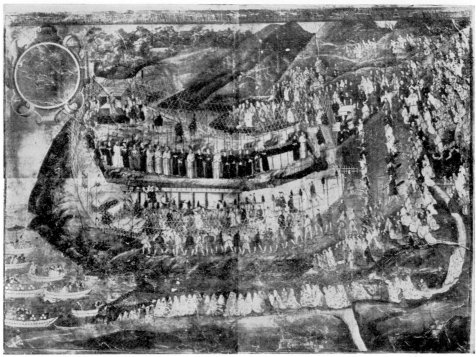

19. *The great Nagasaki martyrdom of 1622, by an unknown Japanese artist. Fifty Japanese and European Christians were executed before a crowd of 30,000 people. Colors on paper, 108.5 × 157.5 cm. Church of the Gesù, Rome.*

part, vie in their efforts to learn of Christianity and so come to an understanding of the way and receive baptism."

In 1582 an embassy was sent to Europe by the three great Christian daimyos, Otomo of Bungo, and Arima and Omura of Hizen. The four well-born and youthful emissaries sailed via Macao, Malacca, and India, rounded Africa, and arrived in Europe, where they visited Spain, Portugal, and the kingdoms of Italy over a period of nearly two years, and were received in audience by Pope Gregory XIII before making their return. In 1590, after an elapse of eight years, they landed again in Japan.

The enterprise was conceived and executed by the Jesuit visitor Alessandro Valignano as a means of acquainting the youths with conditions in the Christian West so that they could pass their impressions on to the Japanese and at the same time give

the aristocracy of Europe direct knowledge of the Japanese converts. As he had hoped, they were everywhere enthusiastically received, and upon their return increased awareness of the outside world among the intellectuals of Japan, Christian and non-Christian alike, and made an enormous contribution to the understanding of European civilization that was not even equaled more than twenty years later, when a second mission, led by Franciscans, was dispatched by Date Masamune daimyo of Mutsu (present Aomori Prefecture).

SPANISH EXPANSION INTO THE EAST Turning back to an earlier time, we find the Spaniards, who had been in control of the Philippine Islands from 1565, installing a governor in Manila in 1571. From that time on they entered increasingly into relations with the Chinese, since it was impossible for them

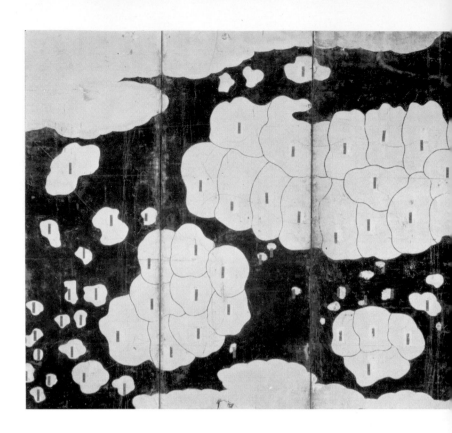

to obtain food from the native population of the islands, and they had to rely on supplies imported by junk. Initially about ten junks entered Manila with food and silks for the Spaniards, for which they were paid in silver from the New World. The Chinese thereupon began to increase their cargos of silks year by year, changing the surplus for silver which they then took back to China. They had found a profitable market, and the junks calling in Manila rose in number from twenty-odd in the 1570s to thirty-odd in the 1580s and exceeded forty in the 1590s.

Even before the Spaniards set up their administration in Manila, one or two Japanese ships had called along the northern coasts of Luzon almost every year to trade with the local inhabitants. Since these were remnants of *wako*, or pirate bands, they were continually raiding the hamlets of the coastal inhabitants, and the Manila government was at some pains over the next ten years or so to rid the area of them. Their cargos were Japanese silver and some foodstuffs, but both the number of vessels and the tonnages involved were insignificant in comparison with the trade of the Chinese.

From the 1580s, when a legate from Matsuura, daimyo of Hirado, went to the Philippines, peaceful trade was carried out in Manila by one or two Japanese ships. Since there was no longer any demand in Manila for Japanese silver, the ships brought foodstuffs and general cargo, returning with Chinese silks, gold, and medicines, but to the Spaniards in the Philippines, the voyages of the Japanese ships were of considerably less importance than the trade of the junks. During this period Spanish ships sailed every summer from Manila for Mexico, and they traversed the waters of the Pacific

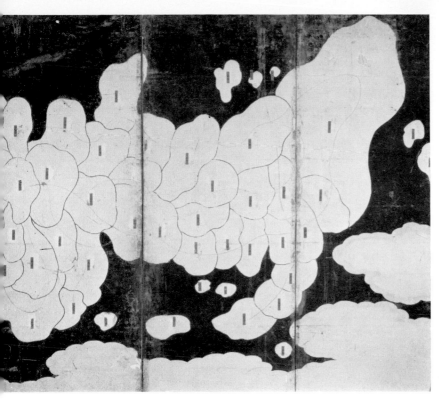

not far to the east of the Japanese islands. They never made Japan a port of call, although there were occasions up until 1590 on which Spanish ships sought refuge from typhoons in various Kyushu ports.

These, then, were the rather distant relationships between Japan and the Spaniards in the twenty-five years up to 1590. But in 1591, frequent diplomatic intercourse suddenly began. This sprang from Hideyoshi's attempt, in the year before he sent his troops into Korea, to have his emissary to the Philippines intimidate the governor into an alliance. By 1594, three missions were exchanged between the two nations, and the emissaries from the Philippines were always missionaries from various non-Jesuit orders. In spite of the *padroado* agreement of noninterference between Spain and Portugal and a papal brief forbidding the Spanish missionaries to preach in Japan, Franciscan, Dominican, and Augustinian friars were most anxious to proselytize the inhabitants of Japan and also of China and Indochina, where the higher cultural level was in contrast with the lack of spirituality of the Philippine islanders.

The Spaniards were envious of the success of the missionaries sent by Portugal to Japan and desired to insinuate themselves there. They coveted especially Japan, which had aroused great expectations in southern Europe for the spread of Christianity. Several Franciscan friars who had come with the second legation from the Philippine governor took the opportunity, after completion of their diplomatic mission, to invent pretexts on which to obtain Hideyoshi's permission to remain in Japan, and spent the next three years zealously propagating the faith in Kyoto, Nagasaki, and other centers. The

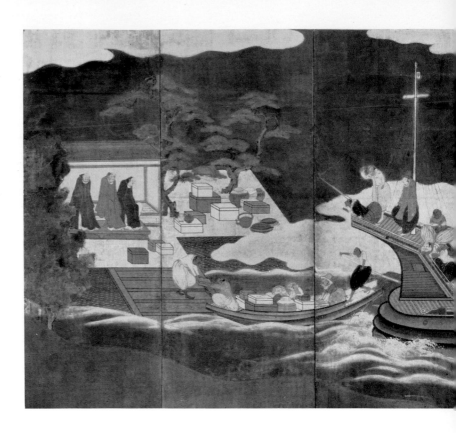

following year, three more members from the same order arrived with the same objective and joined the earlier group.

When in 1596, the *San Felipe*, out of Manila for Mexico, foundered in Urato harbor in the province of Tosa, missionaries on board took the opportunity to break Hideyoshi's edict of proscription by openly preaching the Christian faith. This resulted in the arrest, in the Kyoto region, of the Franciscans and their followers to the number of twenty-three, along with a Japanese Jesuit missionary and two followers who were also implicated. They were sent to Nagasaki in February of the next year, 1597, where they were crucified. This was the famous Twenty-six Martyrs incident. In 1597 a fourth mission came from the Philippines to ask for their remains. These events concluded relations between Japan and Spain during the sixteenth century.

TOKUGAWA IEYASU AND THE NAMBAN

The death of Hideyoshi in 1598 brought a gradual reappraisal of Japan's foreign policy. The Japanese armies of invasion were summoned home from Korea, putting an end to the war with that country and China, and the oppression of Christianity at home was moderated. When Tokugawa Ieyasu seized power at the Battle of Sekigahara in 1600, the improvement became pronounced, due to his coolly calculated self-interest, according to which he pursued a highly realistic policy.

Ieyasu summoned Jeronimo de Jesús, a Jesuit who had been in hiding in Japan since 1595, and requested his good offices in the opening of trade with the Philippines and Mexico, and before long had exchanged diplomatic communications with the governor in Manila. In response to Ieyasu's

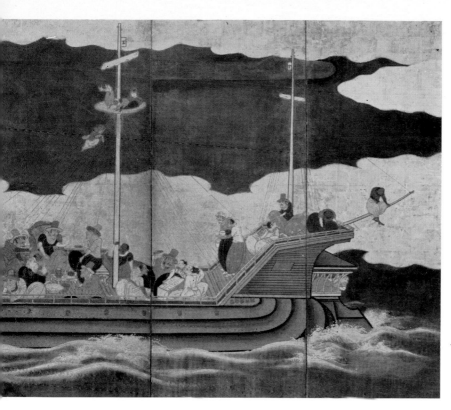

21. *A Portuguese ship comes to trade. Colors on paper; one of a pair of six-fold* namban *screens; each, 154 × 355 cm. Kano school. Otsu Branch Temple, Higashi Hongan-ji, Shiga Prefecture. (See Fig. 93 for detail of left-hand screen.)*

wishes, a Spanish ship entered the port of Uraga in the province of Sagami, near present-day Yokosuka, in 1608. Then in 1609, a ship bearing the retired governor of the Philippines, Rodrigo de Vivero y Velasco, on his return to Mexico ran aground on the coasts of Kazusa (present Chiba Prefecture). He was warmly received by the Tokugawa shogunate in Edo (present Tokyo), which assisted him by constructing a new ship for his return to Mexico, and he departed from Uraga in 1610. The following year a ship arrived in Uraga from Mexico bearing Sebastián Vizcaino, who conveyed thanks for the assistance offered to de Vivero, exchanged vows of mutual friendship and amity with the shogunate, and in 1612 once more put out to sea. This ship too was damaged at sea, however, and had to put back; the mission finally returned to Mexico in 1613 in a ship built by Date Masamune,

the great daimyo of the north, which carried the members of his mission to Europe.

During this interval, Spanish ships made several calls at Kyushu ports and at Uraga, and on at least three occasions were beached on Japan's coasts. And although Ieyasu's desires for trade with Manila and Mexico were repeatedly communicated to the Philippine authorities, the only concrete result was one call at Fukabori in Hizen in 1606, and another at Uraga in 1608.

William Adams was an Englishman who was a pilot aboard a Dutch ship cast up on the coast of Bungo in 1600, the year of Ieyasu's victory at Sekigahara. Ieyasu summoned him that very year and in later years bestowed great favor on him. The ship in which he had served was one of the third Dutch expeditionary fleet that appeared in Far Eastern waters at the close of the sixteenth century to con-

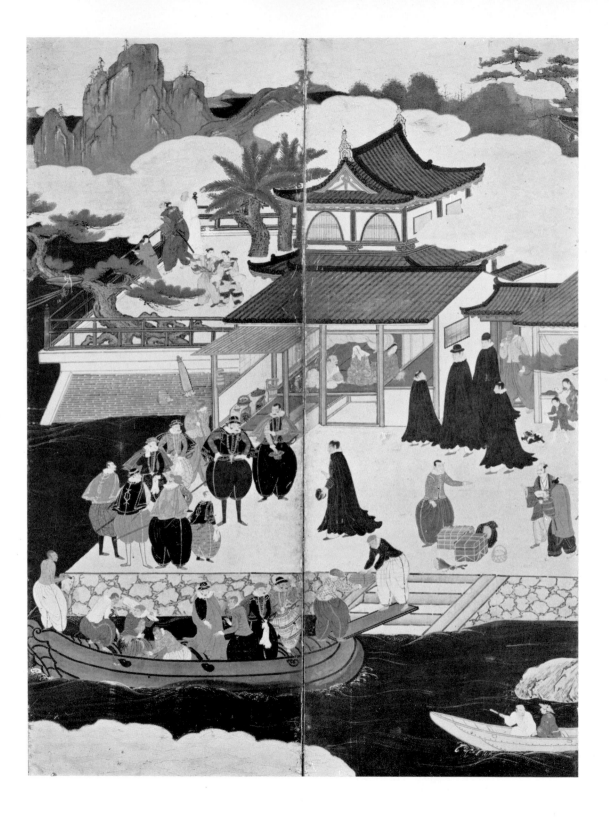

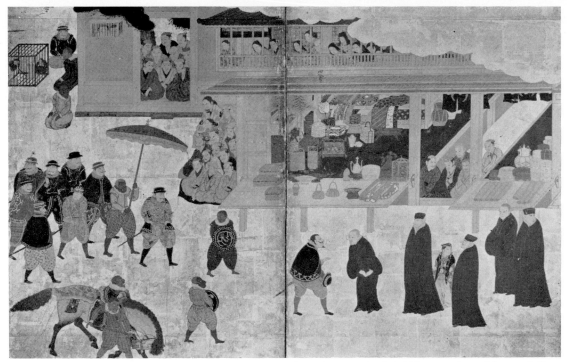

23. *Meeting of Portuguese traders and Jesuit missionaries: detail from a pair of sixfold screens by a follower of Kano Naizen. Colors on paper; each screen, 147.6 × 355.8 cm. Collection of Nihei Yashiro, Kyoto.*

front Spain and Portugal. This expedition led to the arrival at Hirado in 1608 of two ships of the powerful Dutch East India Company that had been chartered to combat Portuguese and Spanish influence, and again in 1613 of an English ship. Both groups sent embassies to the seat of government at Edo and to the Tokugawa seat at Sumpu (present Shizuoka City), obtained licenses to trade from the shogunal authorities, and opened factories in Hirado. Thereafter a succession of ships from both nations called at Hirado, while their factors opened branches in major cities and otherwise took an active interest in trade expansion.

The Portuguese ships that had for so many years been coming to Nagasaki were involved in their first major incident of the seventeenth century in the year 1610, when Arima Harunobu, who had by now renounced the Christian faith, burned the *nao* that had arrived the previous year in the roadstead of Nagasaki harbor. As a result of this, there was a temporary cessation of the voyages, but there was no move on the part of the shogunate to restrict trade relations with Portugal.

THE DECLINE OF PORTUGUESE INFLUENCE

In comparison with the ships of Spain, Holland, and England, which had no facilities for direct loading in China of the Chinese silks so much in demand by the Japanese, the Portuguese, with their direct route from Macao, had a virtually insuperable advantage. Before long, however, two other compet-

◁ 22. *Unloading of a Portuguese ship and a welcoming party of Jesuits: detail from a pair of sixfold* namban *screens by a follower of Kano Sanraku. Colors on paper; each screen, 156 × 358 cm. Suntory Art Museum, Tokyo. (See also Figs. 99, 117.)*

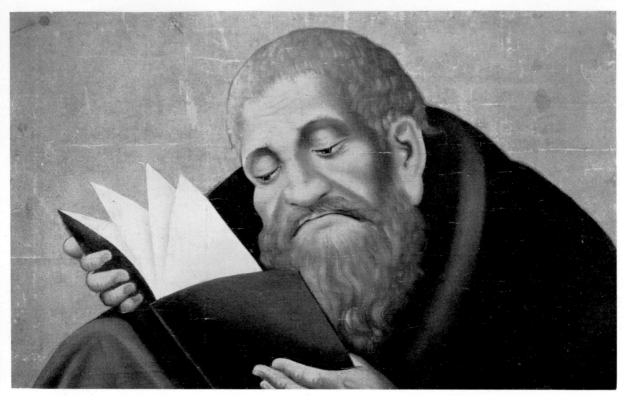

24. Old man reading, a painting attributed to Nobukata. Colors on paper, 35.2 × 56 cm. Collection of Ichio Kuga, Osaka.

itors appeared to challenge Portuguese suprem-
acy. These were the ships from south China, which
as the new century dawned once more began fre-
quent voyages to Nagasaki, and the Japanese mer-
chant houses and daimyos who, increasingly solvent
under the peaceful new order, learned shipbuilding
and navigation under the Portuguese and sent their
ships to the nations of Southeast Asia and to Macao
itself. No longer reliant entirely on the Portuguese
for foreign trade, the shogunate was not con-
strained, as Hideyoshi had been, to take special
care in its relations with them.

In its initial stages, then, this free-trade policy of
Ieyasu resulted in treatment of the Portuguese ships
no different from that during the earliest period of
the trade. In 1604, however, the annual *nao* brought
too much silk thread to be sold within the year, and
on this pretext the shogunate intervened to force

sales, at arbitrary prices, to specified merchants in
Kyoto, Sakai, and Nagasaki. Under this system,
known to the Japanese as *shiraito wappu* and to the
Portuguese as *pancada*, the price of raw silk thread
was subsequently set without reference to the wishes
of the Portuguese.

The period between 1601 and 1616 also saw a
number of years in which the great *nao* failed to ap-
pear in Nagasaki. On two occasions, in 1601 and
1607, because of the danger of capture at the hands
of the Dutch fleet, the *nao* stayed away and in 1603,
it actually was taken by the Dutch outside the har-
bor of Macao. The voyages of 1610 and 1611 were
canceled because agreement had yet to be reached
concerning the burning of the *nao* outside Nagasaki
in early 1610.

But despite the many difficulties that began to
plague the trade in Nagasaki, the *nao* of Portugal

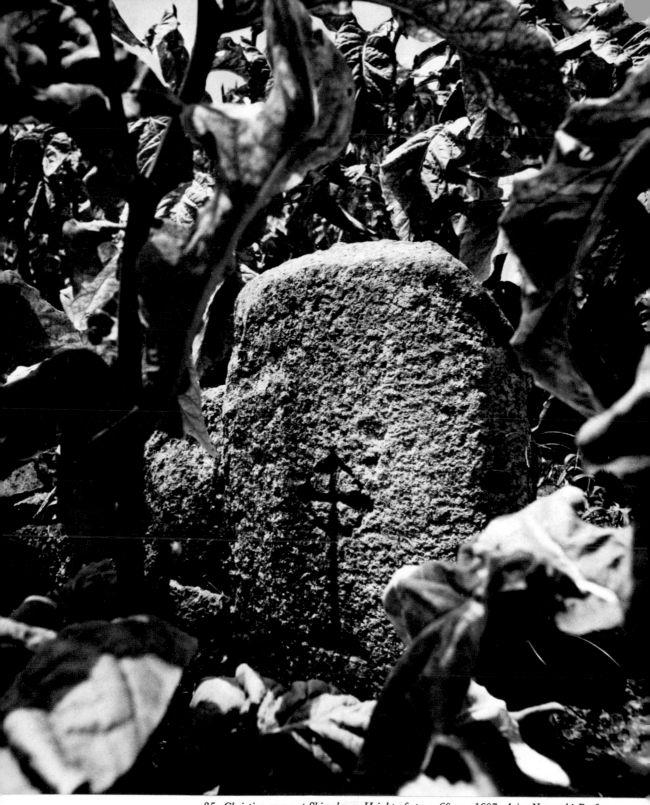

25. Christian grave at Shimabara. Height of stone, 60 cm. 1607. Arie, Nagasaki Prefecture.

26. *Sword guard with design of* namban *ship. Iron; diameter, 7 cm. Oura Cathedral, Nagasaki.*

27. *Bell formerly in the Church of the Assumption of Our Lady ("Namban-ji"), Kyoto. Copper; height, 60 cm. Shunko-in, Kyoto.* ▷
(See also Fig. 14.)

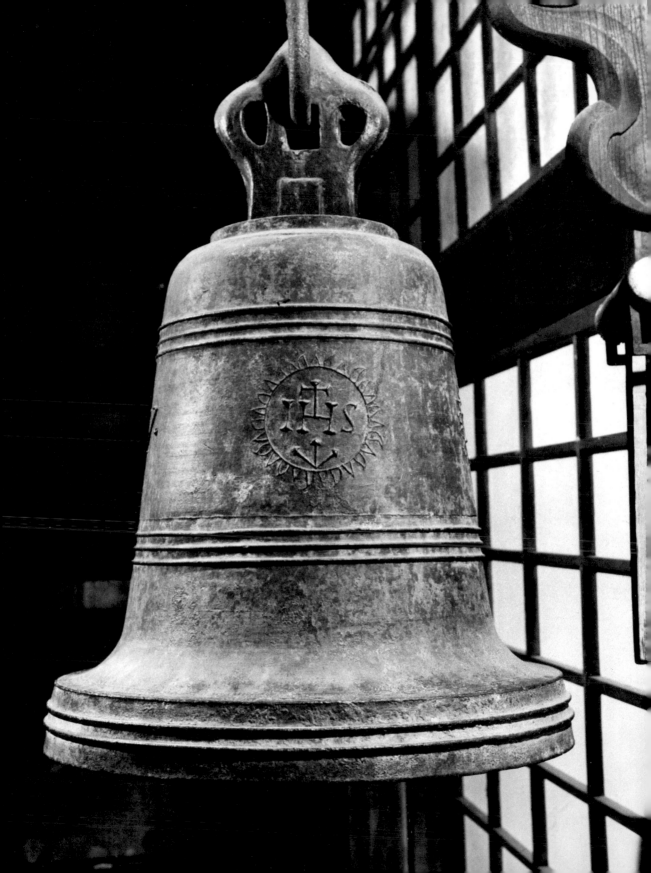

ARTE DA LINGOA DE IA-
PAM COMPOSTA PELLO

Padre Ioão Rodriguez, Portugues da Côpa-
nhia de IESV diuidida em tres
LIVROS.

COM LICENÇA DO ORDI-
NARIO, E SVPERIORES EM
Nangafaqui no Collegio de Iapão da
Companhia de IESV
Anno. 1604.

NIPPON NO IESVS
no Companhia no Superior
yori Chriſtan ni sŏtŏ no cotouari uo tagaino
mondŏ no gotoqu xidai uo vacachi tamŏ
DOCTRINA.

GO SVM VIA. ET VERITAS. ET VITA

IESVS NO COMPANHIA NO COLLE-
gio Amacuſa ni voite Superiores no von yuru
xi uo cŏmuri, core uo fan to naſu mono na
ri. Toqini go xuxxe no NENQI. 1592.

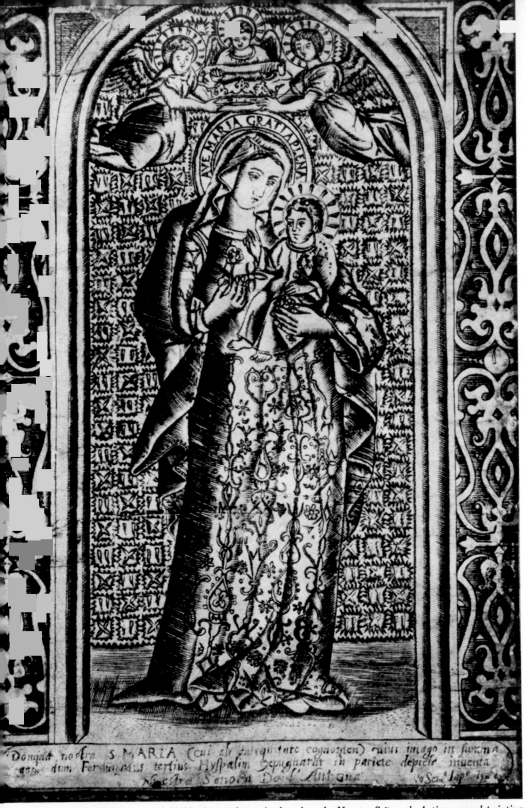

30. *Detail of Madonna and Child. Copperplate print based on the Nuestra Señora de Antigua mural painting in Seville Cathedral. Published in 1597 at Arie, Kyushu. 22 × 14.5 cm. Oura Cathedral, Nagasaki.*

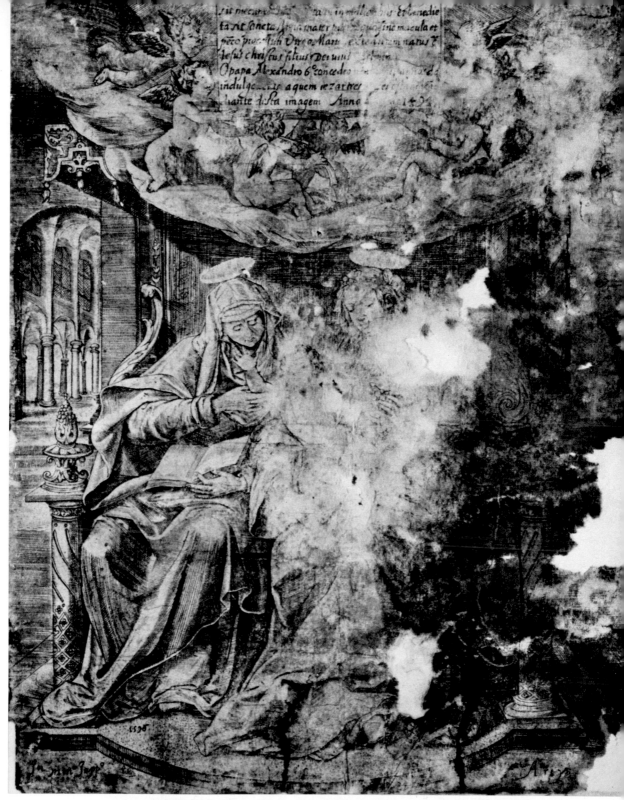

31. The Holy Family: detail of a copperplate print. 25.5 × 19.7 cm. Oura Cathedral, Nagasaki.

Maria puerpera in Purificat donis,
Petrus mare in Cathedra sacra,
Divus Matthias fervatur precibus,
Tum se Bacchanalibus malis occingunt.

Circumcisus Deminj, deinde Antonius,
Tres Reges, Apsi tum a trigima adorant,
Et cum Paulus in Vita fugnat,
Hoc mense primo tervar, feranda.

Thomas Aquinas primus mediatur solus,
Iosephus Virrones conia virge,
Gregorius olim Pontifex,
Et Gabriel Nuncians Maria.

FESTA APRILIS
FESTA MAII
FESTA IUNII

Demaschus Ieiunus quadraginta dielus,
Et interdum ferviat Marcus,
Passio Christi et Resurgens Redemptor,
Mense et se semper non celebrantur.

Iacobus et Philippus tuo die veniunt,
Et Helena veri inventa est Crux,
Ioannes euitisgnatur ad portam Latinam,
Et Ascendit in Caelum Christ Ius.

Divus Barnabas primus se offere,
Natiuitas Praecursor Christi Baptista,
Petrus cum Paulo deinde separantur,
Descendit Paraclitus die Pentecost.

FESTA IULII
FESTA AUGUSTI
FESTA SEPTEMBRIS

Mariam visitat diua Elisabeth,
Magdalena de peccatis poenitet,
Iacobus et Christophorus sese offerunt,
Tum venit Anna Virginis mater.

Dat arcu perifsimo precibus virgo
Te Laurentius e premit Maercuri,
Deinde Virgo, Bartholomeus Apostolus,
Et Assumitur ad Coelis Maria.

Virginis Mariae grata Natiuitas,
Huic Exaltatio Crucis IESU,
tinine Laurentius Michael Archangelus,
Apostolus Matthaeus et Euangelista.

FESTA OCTOBRIS
FESTA NOVEMBRIS
FESTA DECEMBRIS

Offert se Franciscus patriarcha Minorum,
tim Remigius Galliarum Apostolus,
Simon et Iudas connexa graduntur,
Lucas Euangelista exoritur solide.

Sancti omnes te primum offerunt,
Resurgens Morto, sequitur Marcellus,
Martinus teni, deinde Catharina,
Et debetorbus accundenda Andreas.

Diuo Nicolao precos Cleros concinnat,
Dei Parcenti Anna Conceptio Mariae,
Thomas Natiuitasque Christi nuncieat,
Visione Stephanus, Ioannes, et Innocentes.

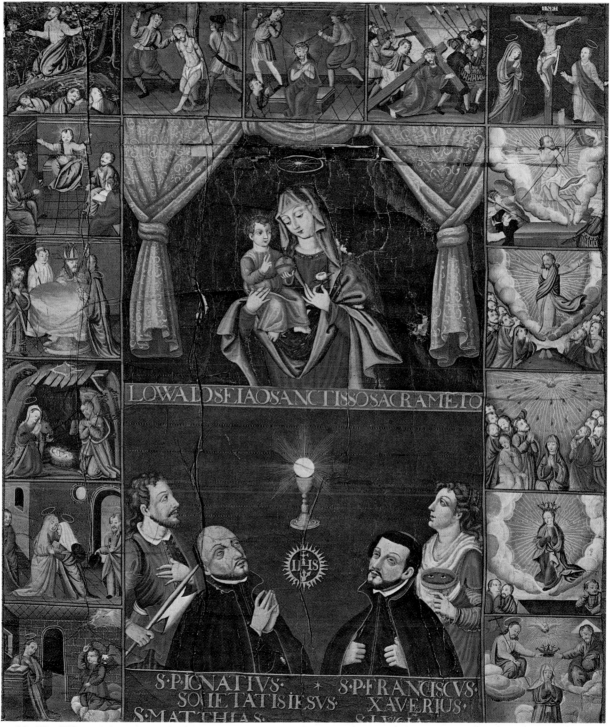

Within the illustration the following text appears:

LOWALDSEIAOSANCTISSOSACRAMETO

S·PIGNATIVS·
SOCIETATIS·IESVS·
S·MATHIAS·

S·P·FRANCISCVS·
XAVERIVS·
S·LVCIA·

33. The Fifteen Mysteries of the Rosary. *In the lower foreground, from left to right, are the saints Mathias, Ignatius, Francis Xavier, and Lucy. Colors on paper, 75 × 63 cm. National Historical Study Center, Kyoto University.*

◁ **32.** *Detail of illustrated Western-style calendar. Drawings show the origins of the Church's major feast days of each month. Copperplate print. 75 × 37 cm. Kobe Municipal Museum of Namban Art.*

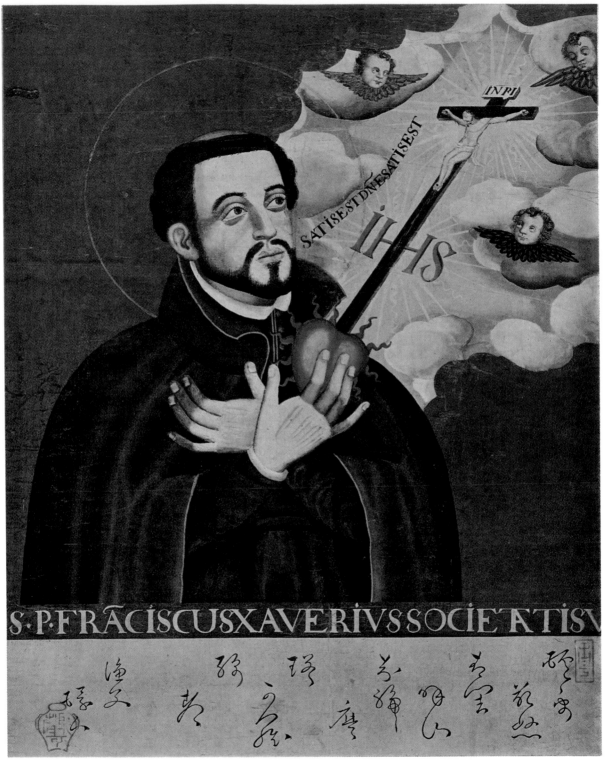

34. St. Francis Xavier. *Colors on paper, 61 × 49 cm. Kobe Municipal Museum of Namban Art.*

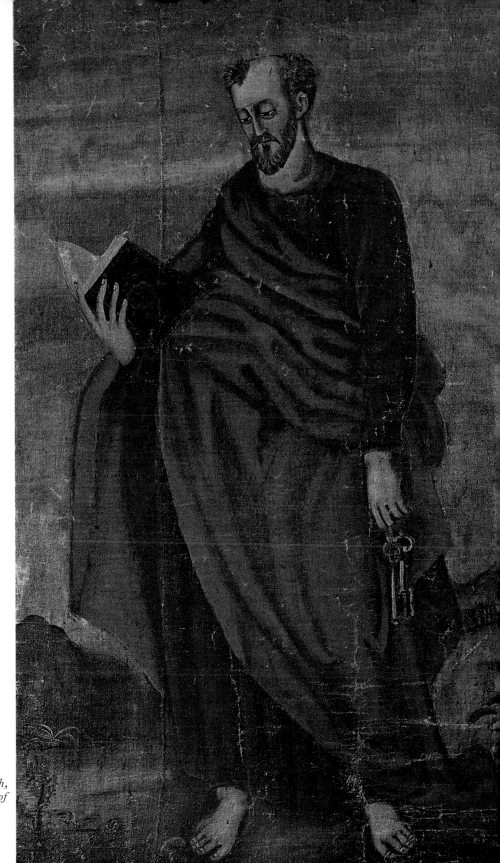

35. St. Peter. *Oils on cloth,*
119 × 69 cm. Collection of
Yoshiro Kitamura, Osaka.

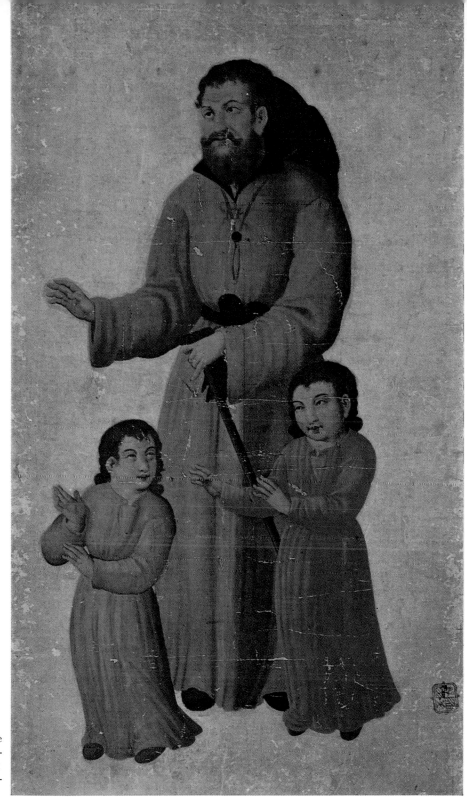

◁ *36*. Maiden Playing the
Lute, *attributed to Nobu-*
kata. Colors on paper, 54.6 ×
36.6 cm., Yamato Bunka-
kan, Nara.

37. Cleric and two children. *Possibly once part of a screen painting. Attributed to Nobukata.*
Colors on paper, 115 × 54 cm. Kobe Municipal Museum of Namban Art. (See also Fig. 127.)

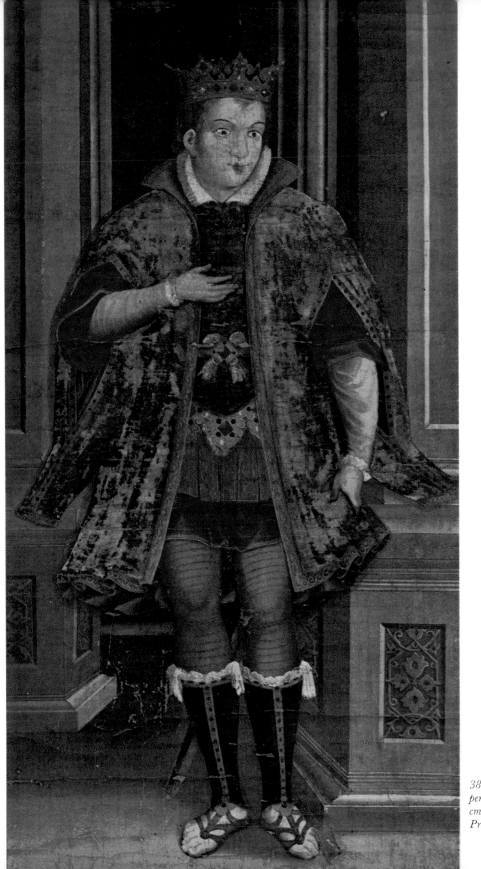

38. European Prince. Tempera on paper, 57.5 × 130.5 cm. Mampuku-ji, Gumma Prefecture.

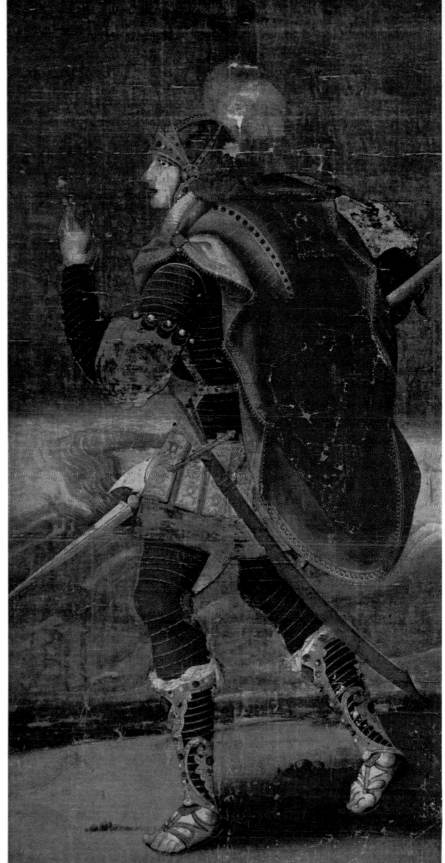

39. *European Warrior. Tempera on paper, 57.5 × 130.5 cm. Mampuku-ji, Gumma Prefecture.*

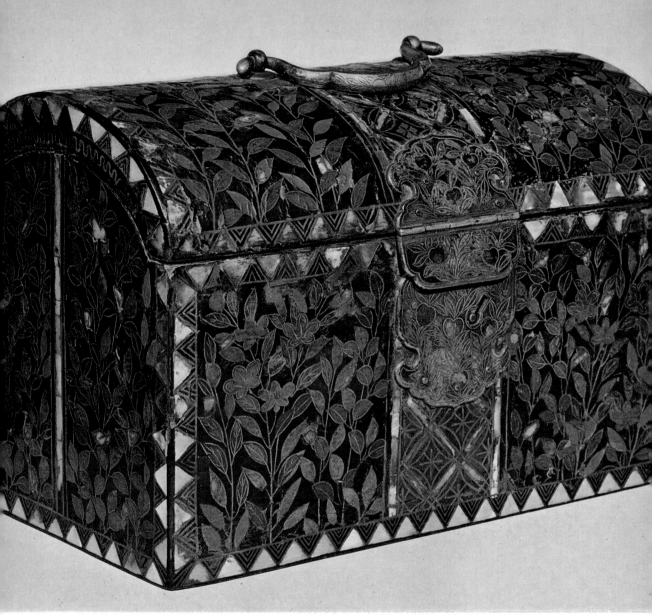

40. Reliquary. Gold and black lacquer on wood with mother-of-pearl inlay. Length, 22.5 cm.; width, 15.2 cm; height, 13 cm. Tokyo National Museum.

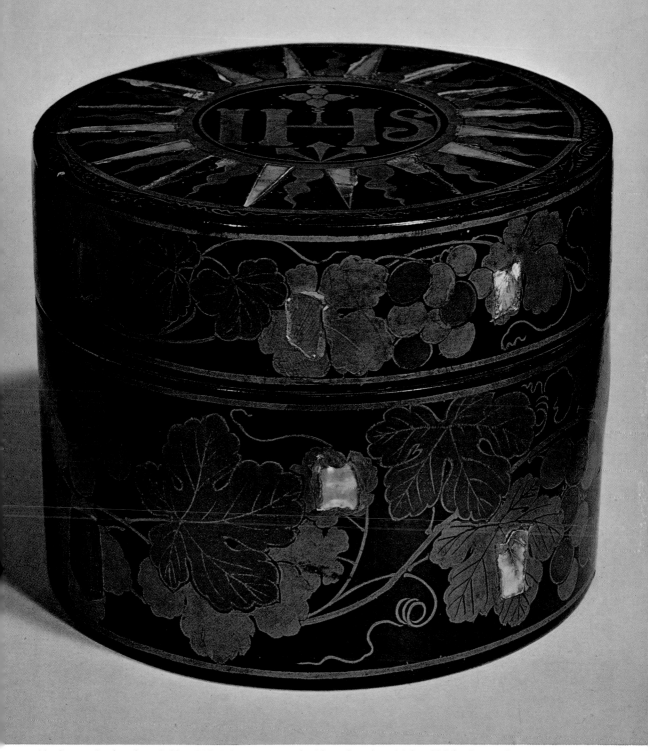

41. *Communion host box. Gold and black lacquer on wood with mother-of-pearl inlay. Height, 9 cm.; diameter, 11 cm. Tokei-ji, Kanagawa Prefecture. (See Fig. 70 for top view.)*

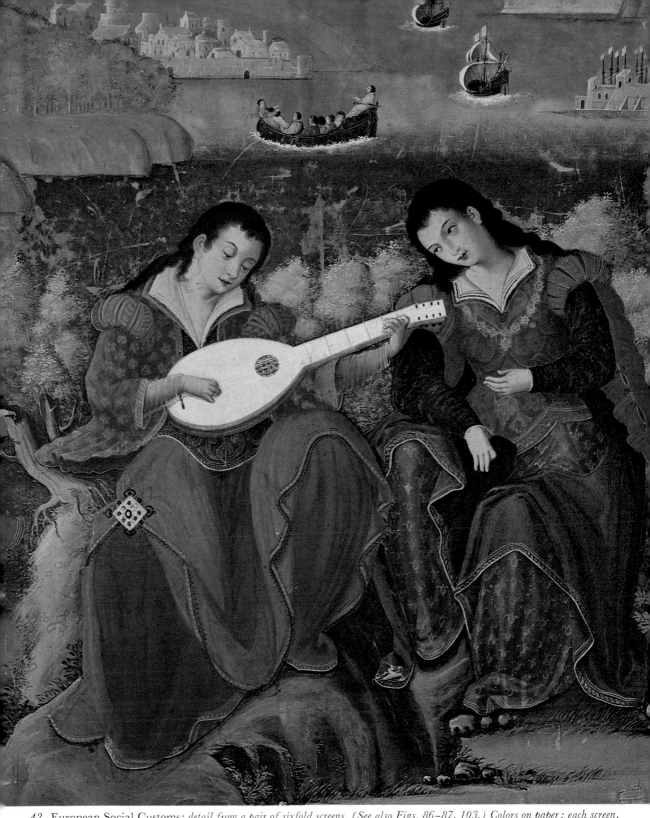

42. **European Social Customs:** *detail from a pair of sixfold screens. (See also Figs. 86–87, 103.) Colors on paper; each screen,*
93 × 302 cm. Collection of Moritatsu Hosokawa, Tokyo.

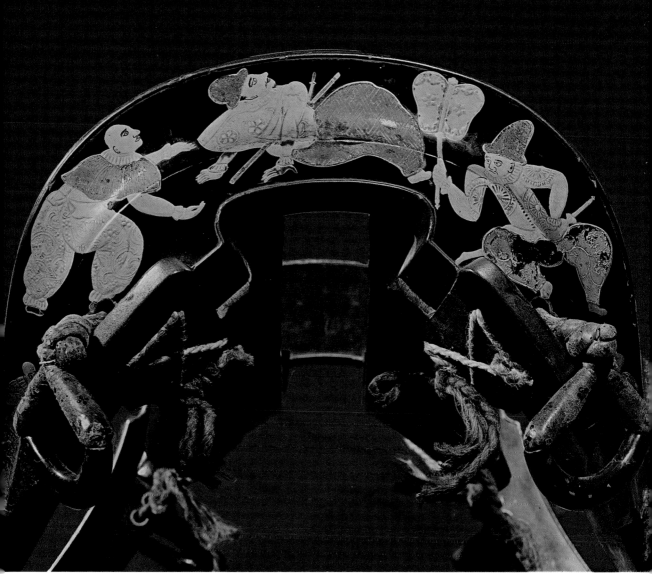

43. Saddle with namban *figures. The man on the right holds a* gumbai uchiwa, *a fan used as a symbol of authority. Gold and black lacquer on wood. Height, 26.8 cm. Kobe Municipal Museum of Namban Art.*

44. *Box with namban figures. Gold and black lacquer on wood. 42 × 42 cm. Collection of Ichio Kuga, Osaka.*

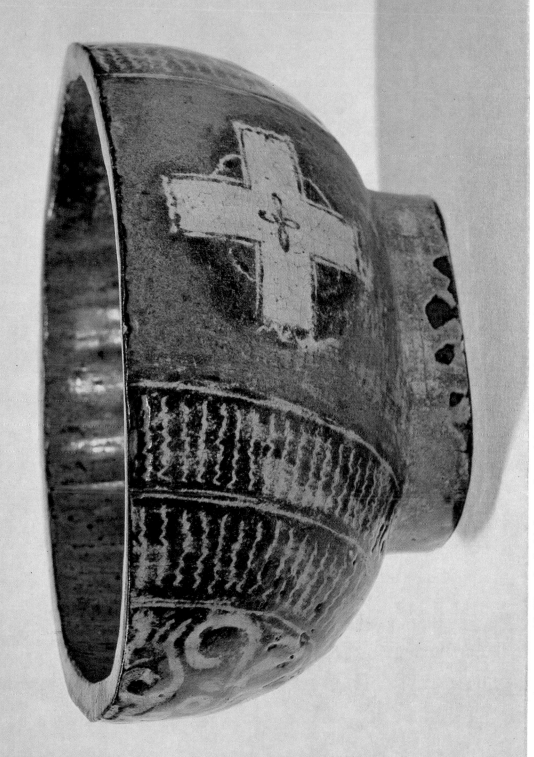

45. *Water bowl with flower and cross designs. Height, 10.3 cm. Kobe Municipal Museum of Nambon Art.*

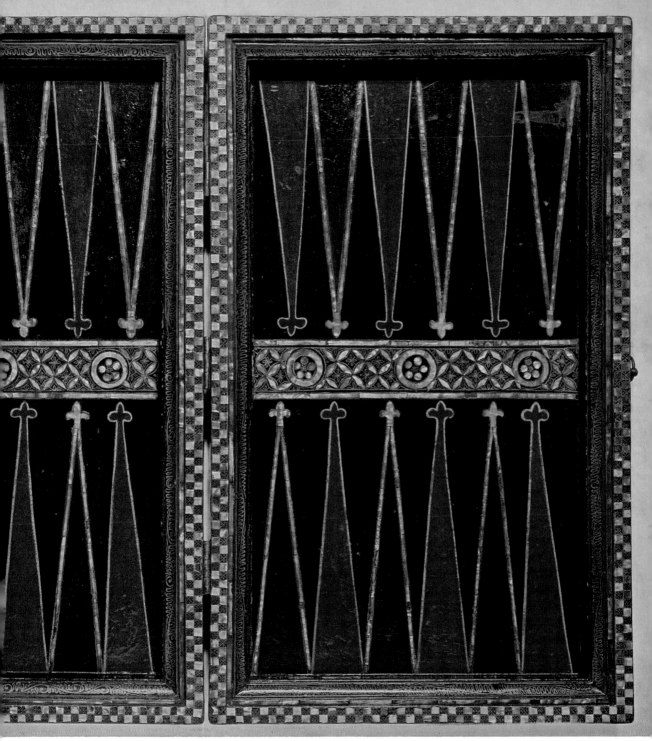

46. Detail of playing surface of a backgammon board. Gold, black, and red lacquer on wood inlaid with mother-of-pearl. Length, 53 cm. Collection of Katsumi Yamagata, Tokyo.

47. Detail of table with flower and cross designs. Wood inlaid with mother-of-pearl. Surface, 60×30 cm. Ichio Kuga Collection, Osaka. ▷

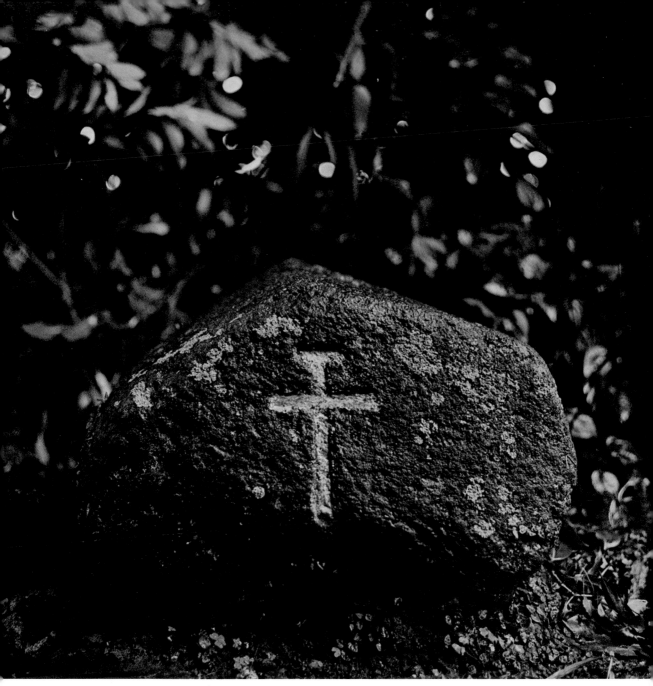

48. Christian grave at Shimabara. Height of stone, 30 cm. Arie, Nagasaki Prefecture.

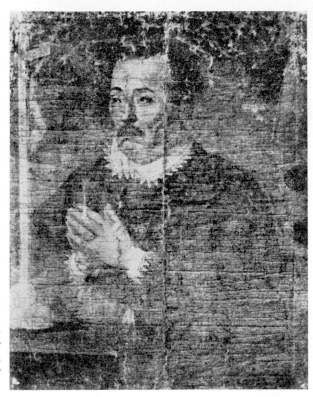

49. Portrait of Hasekura Tsunenaga (1561–1622), a Christian samurai and head of Date Masamune's mission to Europe in 1613–20. Hasekura brought this painting back from Rome, where he had been honored with the title of Roman citizen by Pope Paul V. Oils on cloth.

continued to lead the ships of all other nations in the value of their cargos. Nagasaki continued to be the most flourishing of the trade ports, its population increased yearly, and the town itself became more substantial and imposing. From 1618, in order to minimize the risk of capture by the Dutch on the high seas, the single large *nao* used on the Japan route was replaced by four to six *galliots,* a smaller ship of about 200 tons displacement.

As in trade, so also in the propagation of Christianity, the beginning of the seventeenth century saw withdrawal from the Portuguese (or from their Jesuit protegés) of their monopoly position in Japan. After the martyrdom of the twenty-six Christians at Nagasaki in 1597, the two or three Franciscans remaining in Japan continued secret missionary activities, and with the Tokugawas' assumption of power, the apostolate received tacit approval. But once Ieyasu availed himself of the efforts of the Franciscan de Jesús in opening trade relations with the Philippines, missionary activity was carried on openly.

This was followed in 1602 by the arrival of five Dominicans in Satsuma and two Augustinians in Hirado. In the Philippine Islands, the Jesuits too were active in spreading the faith under the aegis of the Spanish government; the Spanish Jesuits, however, did not press on to Japan; instead they obeyed the two papal briefs: one to the effect that Jesuit activities in Japan should be left to the Portuguese Jesuits, who were already there, the other forbidding the dispatch of missionaries to Japan or China by way of the Philippines and the New World.

Yet papal authority had been flouted by the other three orders, and this led to deep misunderstanding and mutual antagonism between them and the Jesuits. Thereafter, there was a consider-

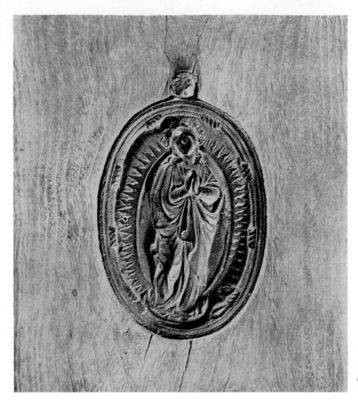

50. Fumi-e *depicting the Virgin Mary. Holy pictures and plaques such as this were used in the rite of trampling* (e-fumi) *as a sign of rejection of Christianity. Height, 11.6 cm. Tokyo National Museum.*

able increase in the number of missionaries from the other orders, but they were no match for the Jesuits, whose half-century of experience gave them a great familiarity with conditions in Japan and whose missionaries, numbering well over one hundred, had gained nearly 300,000 converts in all social strata from the feudal aristocracy to impoverished peasants.

But even in this new century, the Tokugawa shogunate was by no means favorably disposed toward the Christian religion; indeed they viewed it with a certain measure of enmity. Konishi Yukinaga, daimyo of Higo, Kyushu, who had been regarded as a leading protector of Jesuit activity, was defeated and killed at the Battle of Sekigahara in 1600, and two Christian daimyo of Hizen had apostatized—Omura Yoshiaki in 1605 and Arima Harunobu in 1610. These men turned on the mis-

sionaries, forcing the Jesuits to remove from their domains all the schools and other institutions that were so vital to their mission and made them concentrate them in Nagasaki.

At first, the Japanese mission had been under the archbishop of Goa. Then, in 1587, a separate diocese was established, but the bishop in charge of the administration of the Church in Japan only took up his residence in Nagasaki in 1596. This man was a Portuguese and a Jesuit, Pedro Martins, and he was succeeded in 1598 by another Jesuit, Luis de Cerqueira. These two bishops ordered the non-Jesuits to leave, in accordance with both the papal briefs and the edicts of the king (for at that time the thrones of Spain and Portugal were united). The friars refused. They claimed an equal right to minister in Japan, and their petition to the pope for open recognition of this claim was granted.

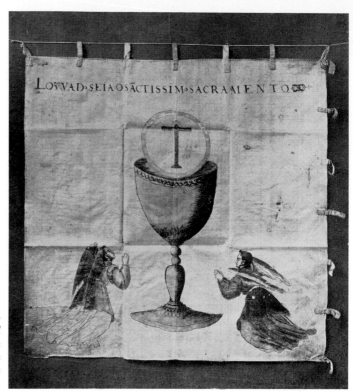

51. *Flag used in the Shimabara Rebellion of 1637–38 and said to have belonged to the Christian rebel leader Amakusa Shiro. The Portuguese inscription reads: "Praised be the blessed sacrament." Colors on linen, 108.6 × 108.6 cm. Collection of Okayama Binshi, Saga Prefecture*

This brought about a long period of discord between the Jesuits and the other orders.

THE PROSCRIPTION OF CHRISTIANITY

Until the year 1612 the Tokugawa government was not concerned with Christian missionary activity, with the result that both the Jesuits and the mendicant friars left their footprints in every region, gaining converts from the northernmost parts of the main island of Honshu to the southernmost shores of Satsuma in Kyushu. There is no doubt that this period was the most productive for the apostolate.

But in 1613–14 the shogunate determined to embark on a strict proscription of the religion and oppression of its converts. Many noted Japanese Christians were banished to Macao or Manila, and not a few of the missionaries and their flock fled of their own accord. And we need not detail here the many times after the great persecution of 1614 that the shogunate arrested and put to a hideous death the missionaries who, from their places of hiding, had contrived to encourage the faithful, and the ordinary believers who staked their lives to keep their faith.

The English, succumbing to Dutch competition, closed their factory at Hirado in 1623 and left Japan, and the shogunate turned back an envoy from the Philippines in 1624 on charges that he had surreptitiously brought in proscribed missionaries, and announced the breaking of relations with Spain. Fifteen years later, the Portuguese were refused entry on similar grounds, and at the same time Japanese ships were forbidden to go abroad by the promulgation of the third and final isolation order.

CHAPTER THREE

The Development
of Namban Culture

NAGASAKI AND THE NAMBAN VOGUE

We can imagine the surprise with which the local inhabitants beheld the enormous bulk and strange configuration of the Portuguese ships when first they put into Japanese ports. They must have been equally surprised at the appearance of the men aboard, at the clothing they wore and the language they spoke. Even in areas accustomed to the sight of Chinese ships and sailors, there must have been considerable wonder about the origin of the Portuguese, who were so completely different from Orientals. And then there were the Jesuit missionaries, alike in physiognomy to the laymen, but wrapped in the frugal simplicity of their long-skirted black cassocks. Who could not feel amazement at seeing them in city thoroughfares and country lanes mixing with the people and expounding their doctrine? How was it possible that the people of that time, exhausted as they were by constant civil war, had room in their hearts for the new faith?

The reports of the Jesuits tell us that after seeing the rich decoration of the Portuguese ships, the gorgeous clothes of the captains and their officers, and the trade they conducted in an abundance of rare goods, the Japanese concluded that these were men who manipulated untold treasure, and who had achieved a standard of wealth to which they themselves could never hope to attain. Many came to respect the Jesuits, who were so much more devout in their observance and ardent in their preaching than the Buddhist clergy, and gradually some of the Japanese became adherents.

With the Portuguese ships coming year after year to the same port, it is reasonable to expect that some of the people who dealt with them arrived at some degree of understanding of the thinking of the Portuguese and came to know them on intimate terms, and that some even went so far as to offer their services as interpreters. From this time, the people began to imitate the Portuguese, adopting elements of their diet, clothing, and furnishings into their own lives, and bringing into their speech Portuguese words of everyday use. Converts to Christianity would have learned, in church, Latin and Portuguese religious terminology, Biblical quotations, and the nomenclature of ritual paraphernalia, some of which they would carry on their persons.

The period during which the Portuguese ships were visiting Hirado, Funai, Yokoseura, Fukuda, and other ports was short. Even Funai, which was a center of missionary activity for over twenty years, could not achieve the degree of maturity of *namban* manners and taste both in trade and religion with which we are concerned here. It was only in Naga-

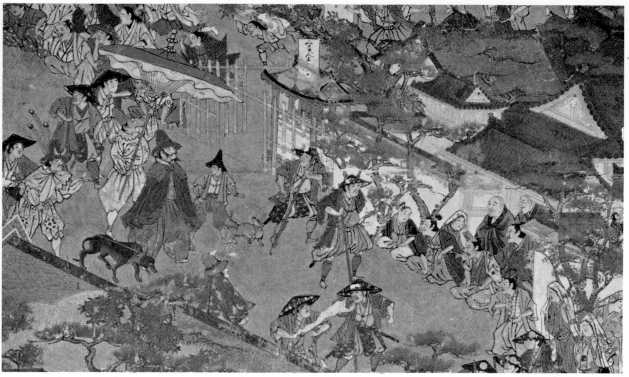

52. Procession of Portuguese entering Miyako: detail from a pair of sixfold rakuchu *("in Kyoto") screens. Colors on paper. Tokyo National Museum.*

saki, the permanent port of call, the community of believers, the headquarters of church activity until the outbreak of the great oppressions, that all the major conditions were present that made possible the efflorescence of the *namban* vogue.

For the sixty-nine years from its opening until Japan's final isolation, Nagasaki was a port of trade for the Portuguese, and for some thirty-five years it was the seat of the leaders of the Society of Jesus. Besides their residence, which was the headquarters of their mission, the city had a number of churches, and later on a bishop was in residence. And since Nagasaki had, from the first, grown up as a community of the faithful, the majority of its annually increasing population also became converts. Even in the more than twenty years between the imposition of central government control and the enforcement by the shogunate of its edict for the proscrip-

tion of Christianity and the extermination of its adherents, the town grew by leaps and bounds, population increase accelerated, and the percentage of Christians continued to grow larger.

Even before Nagasaki came under Church rule, there may well have been a developing appreciation of things Western, and there is no doubt at all that as the years passed the people came, in their daily lives, to a greater understanding of that larger world in which the Portuguese moved, and began to incorporate, to a greater or lesser extent, their customs. No definite date can be assigned to the start of this process; it was one that grew with every passing year. But there is no doubt that by the time Hideyoshi confiscated Nagasaki from the Jesuits in 1588, the city was set clearly apart from other centers because of its Westernization.

Other cities, lacking these close relations with

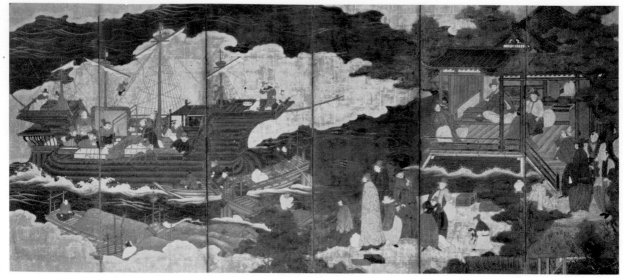

53. *Portuguese ship in port: left-hand screen of a pair of sixfold* namban *screens. Old Kano school. Colors on paper; each screen,* 155.8 × 334.5 cm. Imperial Household Agency. (See also Fig. 94.)

the Portuguese, could hardly have started a vogue for *namban* style and taste. It is thus our purpose here to examine two important points: first, to what extent, and second, by what means this vogue spread from its origin in Nagasaki to other parts of the country. For this the ground had to be prepared, and in this connection, I would like to quote first from the Jesuit report of the year 1592.

"The following morning [February 27, 1590] the Portuguese, clad in the finest clothing, formed ranks and moved out [from Toba]. It was a wonderful sight to see the throngs of people who had gathered from far and near to view the strange procession before it reached Miyako [or "the Capital," as Kyoto was then called]. As we neared the city, every street through which our procession passed was filled with countless people, and all who were observing the entry into the city of this orderly procession of exotic and unaccustomed persons decked out in resplendent garments, were most astonished and spoke to one another, saying that every one in the procession must be a Bodhisattva descended from the heavens. We were to them most amazing beings, for they knew little of the Portuguese. Heretofore Portuguese had been known only

through the annual visits to Nagasaki, and far from striking the Japanese as distinguished and refined, we were understood rather to be a people skilled in trading. Further, our customs being contrary to those of the Japanese, those citizens of Miyako who had heard the reports of the Japanese merchants who returned home after journeying to Nagasaki to trade with the *nao*, had been led to believe that the Portuguese were worthless and undeserving of respect."

This return of the Jesuit visitor Alessandro Valignano together with the embassy of the Kyushu daimyos in the summer of 1590 marked his second visit to Japan. He was now accredited as ambassador from the Portuguese viceroy of India to Toyotomi Hideyoshi, and in order to fulfill this mission left Nagasaki in December of 1590 and reached Kyoto the following February. On March 7, he proceeded from the quarters reserved for him by Hideyoshi to the court at the Juraku-dai. The party consisted of four missionaries, the four young envoys, twelve Portuguese laymen, and attendants. Since there had been a Jesuit presence, albeit small, in Kyoto since 1559, the long black cassock was not unknown, but there is no doubt that it was the first

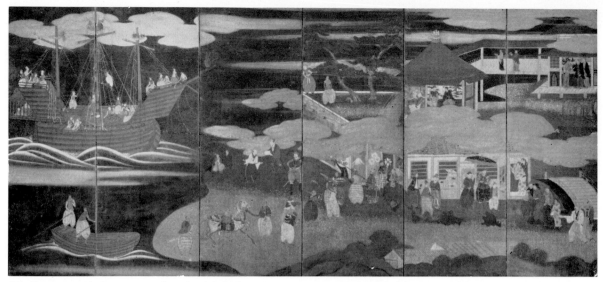

54. *Portuguese ship in port: one of a pair of sixfold* namban *screens. Colors on paper; each screen, 151 × 349 cm. Private collection, The Netherlands.*

time that Kyoto had ever seen a stately procession of twelve luxuriously bedecked Portuguese and their two magnificent steeds, each attended by an Indian groom attired in gorgeous costume and carrying a gigantic parasol. And the people in Kyoto at this time included not only its inhabitants high and low, but numerous feudal lords and their retinues who had come up to the capital for the occasion.

The report quoted earlier also notes that the people of Kyoto had said that a Korean mission of over fifty persons that had been received at the same Juraku-dai several months before "were of inferior quality, exposed the lower leg, and ate as they walked." And although they were no doubt expecting these "*namban* from India," which was indeed at the limits of the world known to the average Japanese of that time, to be no better, actual observation led them to great admiration for their appearance, clothing, and bearing; hence the rumors that they were like Bodhisattvas.

Somewhat later, after the largest church in Nagasaki was dismantled at Hideyoshi's order, it was feared that the Portuguese would abandon their visits to Japan if they should hear of his part in the event. In worried debate the counselors who surrounded the military dictator voiced deep misgivings. As a result, Hideyoshi immediately moderated his policy of merciless suppression of Jesuit missionary activity, and in the summer of that year of 1593 he invited the captain of the *nao* then in Nagasaki port, along with his company, to Nagoya Castle in Hizen, the headquarters for the mounting of his Korean invasion campaign, where with a view to mollifying them, he laid on generous hospitality.

A party consisting of the captain, two missionaries (one of them the interpreter, João Rodrigues), ten Portuguese laymen, and their Negro attendants proceeded from their quarters in the mansion of Terazawa Hirotaka to the castle. These details of the meeting are described in the Jesuits' report of 1593. For more than two months after the captain and the rest of the party returned to Nagasaki, Rodrigues remained in Nagoya to represent Portuguese interests in the continuing negotiations. Correspondence sent by him to his superiors in Nagasaki reads as follows:

"When [Hideyoshi] left Nagoya to attend his stricken mother in Kyoto, all the daimyos who were in Nagoya, with their retinues, accompanied him to Miyako, attired in the manner of our country. The

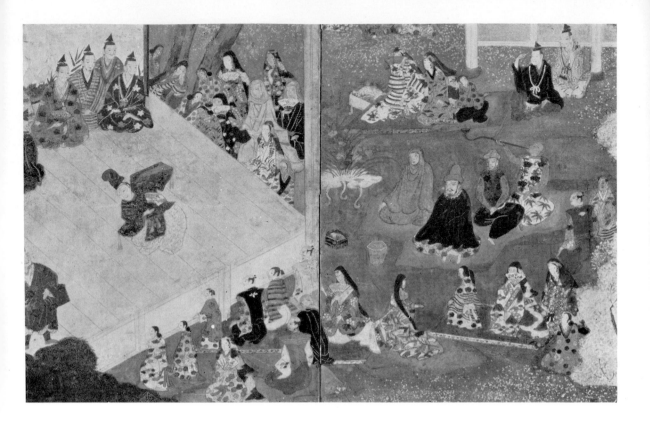

tailors of Nagasaki are all so busy that they have not a moment to spare, yet they also accompanied him to Miyako. Recently, amber jewelry, gold chains, and buttons have become popular among them. Our foods are to their liking, particularly hen's eggs and beef, which the Japanese used to detest. Hideyoshi himself has grown to like these foods greatly. It is quite astounding how so many things of the Portuguese have come to have such good report among them."

Since virtually all the feudal lords in Japan had assembled at Nagoya Castle in response to Hideyoshi's directive, the captain and his entourage were received in audience by Hideyoshi in the presence of his tributaries large and small. And as most of them were encountering the Portuguese for the second time, having been present at the audience three years before at the Juraku-dai in Kyoto, it is likely that there were a number of people who had

satisfied their curiosity enough to pass beyond admiration to a more discriminating examination of the customs and behavior of the Portuguese, achieving some understanding of the vastly different way of life of the Westerners. This meeting may have been the start of the widespread aping of the customs of the Portuguese.

Of course there were already daimyos who had been in contact with the Portuguese in Nagasaki, and these can be divided into three groups. The first of these was composed of men like Konishi Yukinaga, Omura Yoshiaki, Arima Harunobu, and others with domains in the provinces of Hizen and Higo. These men were Christians and intimates of the Jesuits, and they and their retinues often visited Nagasaki, where they were no doubt well received by the Portuguese. *Namban* styles, particularly those related to the physical accouterments of the Christian faith and the terminology of church observ-

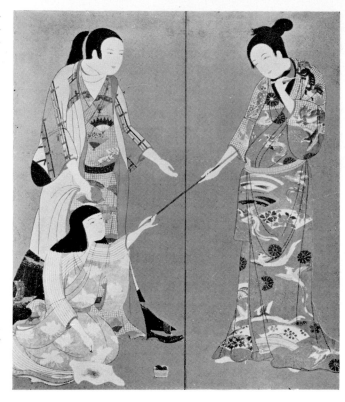

55. *Detail from a screen showing spectators in* namban *attire at a Noh play. Colors on paper; single six-fold screen; height, 106.7 cm. Kobe Municipal Museum of Namban Art.*

56. *Detail of* Fujo Yuraku *(Women's Entertainments), a pair of sixfold screens. Tobacco from the Americas was introduced by the* namban *traders and soon became a part of the vogue for Western manners. Colors on paper; each screen, 153 × 363 cm. Yamato Bunkakan, Nara.*

ance, became prevalent within their domains but were probably confined to these areas. In the year 1593, the men of this first group had gone to the war in Korea and so were not at the Nagoya meeting.

The second group was composed of clans such as Matsuura and Goto, also of Hizen, and clans possessing domains in which, in former days, Portuguese ships had called and missionaries had been active. These clans were, however, hostile to Christianity, and probably less than deferential to the Portuguese. The daimyos of this group were also away in Korea at this time.

The third group consisted of Nabeshima Naoshige of Saga Castle in Hizen and Mori Yoshinari, lord of Kokura Castle in Buzen, whom Hideyoshi had appointed as supervisors of Nagasaki immediately after he imposed direct rule there, and Terazawa Hirotaka of Karatsu Castle, Hizen, who had become *bugyo* of Nagasaki in 1592. Their

primary duty was the suppression and eventual extirpation of the Christian religion in Nagasaki, but they also intervened in the trade of the Portuguese—which Hideyoshi was actually encouraging—in order to corner the cargoes of silks and gold, precipitating an antagonistic situation. It may therefore be presumed that they were antipathetic to *namban* influences.

It appears, then, that in 1593 elements of the *namban* vogue had already won a measure of acceptance by Hideyoshi, the high officials around him, and the western daimyos and their suites, a trend encouraged by the geographical proximity of Hideyoshi's Nagoya headquarters to Nagasaki.

Nagoya Castle was rushed to completion in an extremely short period of five months in 1591 and early 1592. It was a grand and imposing edifice, with a circumference of about 1800 meters, and an area of 6.9 hectares. The Kyushu lords who were

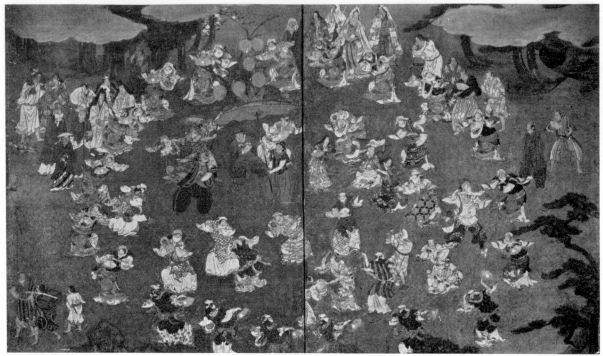

57. *Detail from a cherry-blossom-viewing screen showing dancers attired in* namban *style. Colors on paper; pair of sixfold screens; each, 149 × 352 cm. Kobe Municipal Museum of Namban Art.*

ordered to undertake its construction made levies of materials not only in their own domains but in neighboring provinces as well. Nagasaki was under Hideyoshi's direct rule, and perhaps because it was also a city of believers of the forbidden Christian religion, the levies were pressed with particular severity, or so we are told by the 1592 report of the Jesuits. Several churches were dismantled and the material carted away, and carpenters, stonemasons, and other artisans were without exception pressed into service. This led to repeated trips between Nagoya and Nagasaki for the officials in charge of construction and for the chamberlains of the feudal lords.

We are told in the report of 1593 that a good number of officials came to Nagasaki, even after the departure of the troops for Korea, to requisition materials, and further that in the two months Hideyoshi was in Kyoto attending his mother, who died that year, and later making postfuneral arrangements, several of the lords—both Christian and non-Christian—who were encamped at Nagoya journeyed to Omura to meet with the Jesuit missionaries. Even nonbelievers wore rosaries and carried reliquaries on the visit to show that they had not come in enmity to spy. There is no doubt that at this time they went on from Omura to Nagasaki, which lay at no great distance. Thus, in the two or three years following the construction of Nagoya Castle, considerable numbers of officials, feudatories, and their chamberlains must have paid visits to Nagasaki.

The Jesuit report of 1592 was doubtless correct in noting that under the influence of Japanese mer-

58. *Detail from* Hokoku Suirei Zu Byobu *(Screen Picturing Scenes from the Hokoku Festival) by Kano Naizen showing several* ▷ *participants attired in* namban *style. Colors on paper; single sixfold screen; 166.9 × 362 cm. Toyokuni Shrine, Kyoto.*

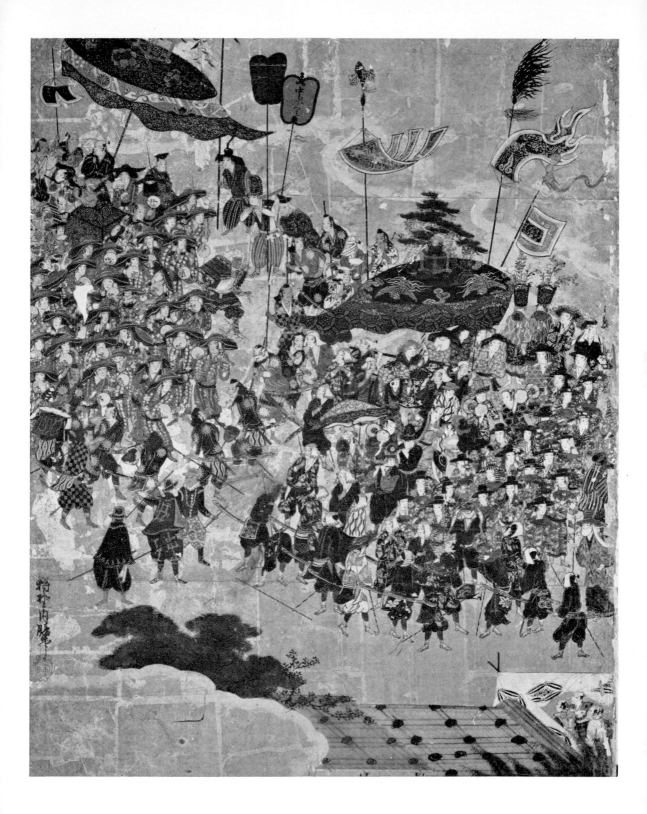

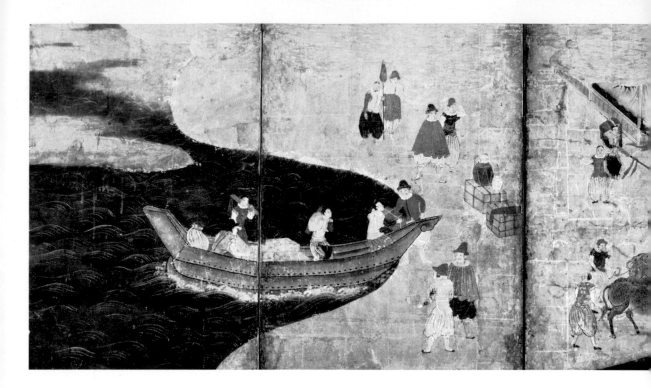

chants who returned from dealing with the Portuguese in Nagasaki, the people of Kyoto had come to consider them not as "distinguished and refined" but rather "a people skilled in trading" and therefore "worthless and undeserving of respect." The Japanese and foreign merchants haggled ferociously for even the most minor advantage, and the daily behavior of the Portuguese in Nagasaki was not always above reproach. The Japanese merchants passed on their criticism and disdain, but, as the report also notes, both commoners and aristocrats changed their opinion when they came face to face with the Portuguese in Kyoto in 1590. When the captain paid his call at Nagoya in 1593, the Portuguese party was received with the greatest good will, so it would seem that in all strata, attitudes toward the Portuguese had come around.

It is probable that Japanese merchants who traveled to Nagasaki had also, under this new influ-

ence, come to develop different attitudes. And the merchants who came and went each year to trade with the Portuguese ship were not the only ones acquainted with the Nagasaki of the 1590s. Besides the officials, daimyos, and retainers who were in Nagoya, there were no doubt a number of favored merchants, Noh actors, tea masters, painters, and other practitioners of the fine arts who, having been summoned to Nagoya, desired to make a brief reconnaissance of neighboring Nagasaki either on their own or in company with their patrons to satisfy their curiosity.

As Japan's long period of civil strife drew to a close under the Hideyoshi regime, marketing and distribution channels began to open throughout the country, and great wealth came to be concentrated in the hands of the merchants of the great cities. Accordingly their social position rose, their style of life became luxurious, and they quite naturally

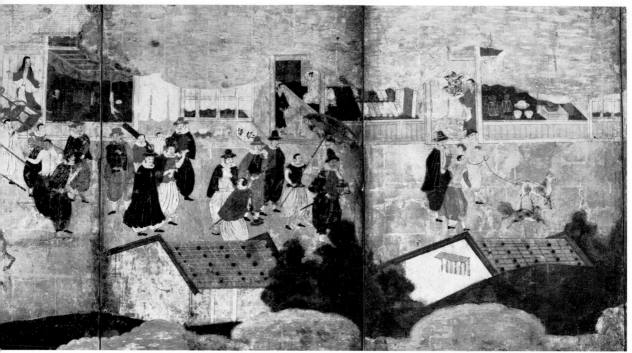

59. *Procession of Portuguese leading camels (center foreground): detail from a pair of sixfold* namban *screens by a follower of Tohoku. Colors on paper; each screen, 154.5 × 350.8 cm. Yoshimatsu Tsuruki Collection, Tokyo. (See also Figs. 17, 62, 107.)*

began to turn their eyes toward outward manifestations of the cultured life. They were, of course, interested in traditional art forms, but there were many who were equally drawn to the novelty of the *namban* taste, though no doubt a desire for knowledge of the outside world and a nose for business opportunities were not entirely absent.

The merchants who early frequented Nagasaki were of course the pioneers in popularizing *namban* tastes. And it comes as no surprise that when the warriors and merchants returned to Nagoya from Nagasaki, where they too had seen the Portuguese and their ships and become acquainted with Church ritual, a *namban* vogue spread among the people of all classes who were encamped there. This is borne out by the Jesuit report of 1592, which informs us that the daimyos developed a great desire for the reliquaries that believers carried, and in a letter sent by a missionary, Francisco Pasio, in September

of 1594, we find the following passage: "[Hideyoshi] has a great liking for Portuguese clothing, and the members of his retinue, in emulation, are often attired in the Portuguese style. The same is true even of those daimyos who are not Christian. They wear rosaries of driftwood on their breasts, hang a crucifix from the shoulder or waist, and sometimes even hold a handkerchief. Some, who are especially kindly disposed, have memorized the Our Father and the Hail Mary, and recite them as they walk in the streets. This is not done in ridicule of the Christians, but simply to show off their familiarity with the latest fashion, or because they think it good and effective in bringing success in daily life. This has led them to spend no small sums in ordering oval earrings bearing the likeness of Our Lord and the Holy Mother."

This surely shows how the new taste had permeated the warrior class. Despite the fact that until

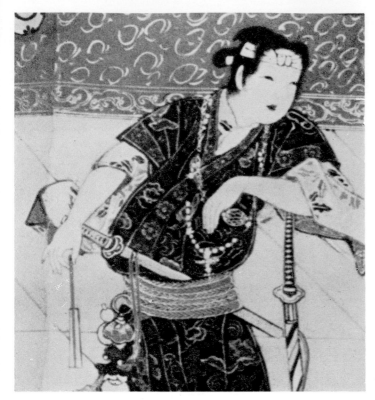

60 (left and opposite page). Two details from a work called The Kabuki Storybook Scroll (Kabuki Soshi Emaki). The actress leaning on a sword is wearing a crucifix. Colors on paper; full size, 157 × 35 cm. Tokugawa Reimei-kai Collection, Nagoya, Aichi Prefecture.

a year before the public wearing of these symbols of the faith was forbidden, the warriors availed themselves of Hideyoshi's relaxation of the policy of proscription, and even nonbelievers showed no hesitancy in wearing them. This was because the changing times had brought a broadening and deepening of interest in *namban* culture, extending its influence from Nagoya to Kyoto and Osaka, and with the passage of years, throughout the country.

The adoption of foreign terms was already well under way from the time the citizens of Nagasaki began to take up Western ways of life, and from around 1593 one route of the spread of the *namban* vogue was from the warriors and merchants at Nagoya to Kyoto, Osaka, and other centers. There is no way, however, to discover what proportion of the Portuguese words current in Nagasaki found general acceptance.

NAMBAN INFLUENCE IN PAINTING AND GEOGRAPHY

More interesting even than depictions of Japanese in *namban* attire, so characteristic of the *namban* screens, are the people dressed in this style who appear in such genre media as *rakuchu fuzoku-zu* (scenes of life in Kyoto; Fig. 52), depictions of the Noh drama (Fig. 55), cherry-blossom-viewing pictures (Fig. 57), and in *The Kabuki Storybook Scroll* (Fig. 60). Until recently these have always been thought to be foreigners who had settled into the Japanese way of life, sharing its enjoyments. Now, however, though we cannot be absolutely sure, study of original materials suggests most convincingly that they were Japanese who had completely adopted *namban* modes of dress.

Since the taste for *namban* culture was based on curiosity about the customs of alien lands and a

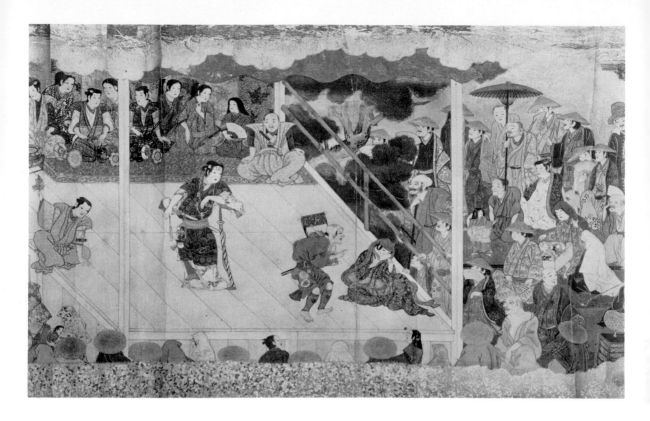

desire to emulate them, it did not stop with the direct influences on life, language, and manners that resulted from the Portuguese trade and Christian missionary work, but was channeled into a strong interest in the unknown world outside Japan. The missionaries of this period were better educated than other Europeans, and their reports often refer to the way in which they made use of easily understood explanations of astronomy and geography to increase the effectiveness of their preaching.

For the Japanese, whose world comprised Japan, China, and India, knowledge of the nations of Europe—to say nothing of the East and West Indies, South Asia, Africa, and the New World—and information about their climates, inhabitants, and products quite naturally produced the greatest astonishment. With the abatement of Japan's internal turmoil, the merchants involved in foreign

trade, the government officials who were looking expectantly overseas, the daimyos and scholars who had negotiated with the foreigners or been converted to Christianity, all were no doubt seized by the same deep interest. And the most convenient means for them to satisfy their curiosity was by studying maps and globes. Just when foreign maps and globes were first brought to Japan is not known, but it seems that Japanese traders had opportunities to see Portuguese navigation charts and the printed world maps kept in the Jesuits' residence. Even with the use of these charts, however, Japanese merchants probably found it difficult in the beginning to understand world affairs.

The event that did make an enormous contribution to extending knowledge of the world was the return in 1590 of the Kyushu daimyos' envoys. The reports of Valignano, who conceived the mission,

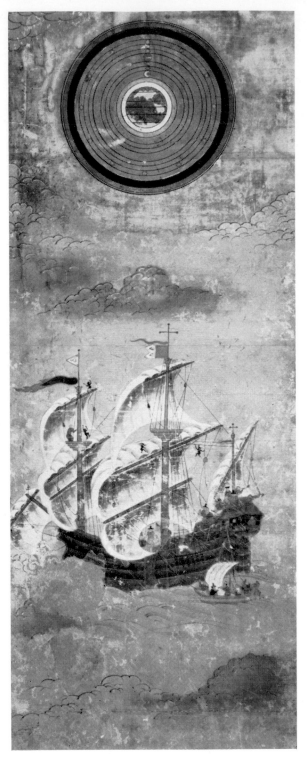

61. *Circular world map and Portuguese ship: detail from a* namban *screen. Colors on paper; full size, 54 × 140 cm. Kanshin-ji, Osaka.*

make clear his conviction that these youthful converts could, by telling their countrymen of their experiences, give great impetus to the propagation of the faith. Not only did they inform their close relatives, the three Christian daimyos who had sent them—Otomo, Arima, and Omura—and the inhabitants of their domains, but when they went with Valignano to Kyoto in 1590–91 they were also active in communicating their experiences to those they met.

We are told that on February 17, 1591, when Mori Terumoto and other western daimyos stopped at the Inland Sea port of Murotsu after journeying to Miyako to pay their respects on the occasion of the lunar new year, they took the opportunity to pay a call on Valignano and his retinue. The daimyos took a great interest in the maps, charts, globes, and astrolabes that the young envoys showed them, as well as in the detailed explanations of the route the youths had traveled and the conditions they found in each country. We are also told that the envoys showed and explained to the daimyos a map of Italy, copies of which they had obtained at Macao on their way home, as well as a new plan of the city of Rome.

And somewhat more than a month later, when Hideyoshi conversed with the young envoys, they described their travel experiences to him and the high officials in attendance. There can be little doubt that after the visit of Valignano's group to Kyoto, Hideyoshi and a large group of daimyos and other powerful figures retained a rough picture of the world and had a somewhat improved understanding of conditions overseas. During the Korean invasion, dispatched by Hideyoshi two years later, the battle reports sent back to Japan served to give Japanese leaders a certain awareness of the geography and local conditions of the Korean peninsula. They must also have stimulated further interest in expanding Japanese knowledge of the rest of the

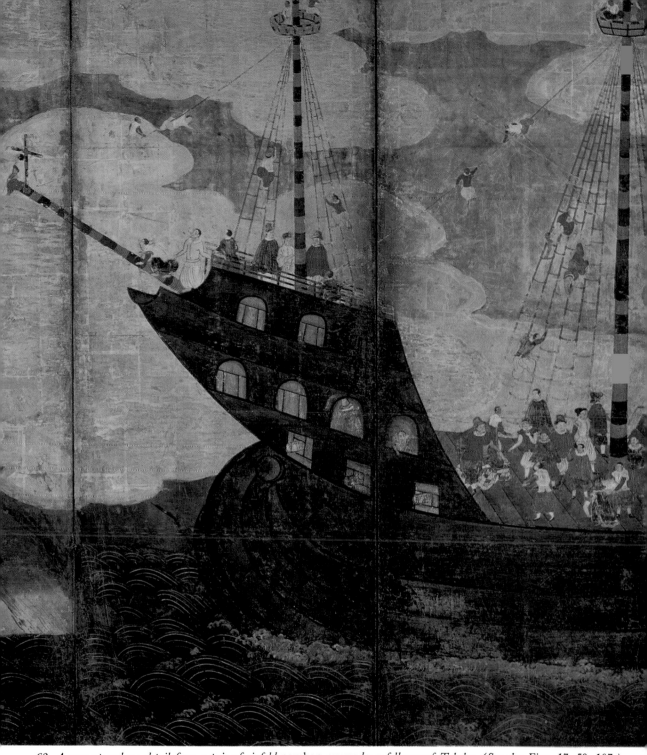

62. A nao at anchor: detail from a pair of sixfold namban *screens by a follower of Tohoku. (See also Figs. 17, 59, 107.) Colors on paper; dimensions of each screen, 154.5 × 350.8 cm. Collection of Yoshimatsu Tsuruki, Kyoto.*

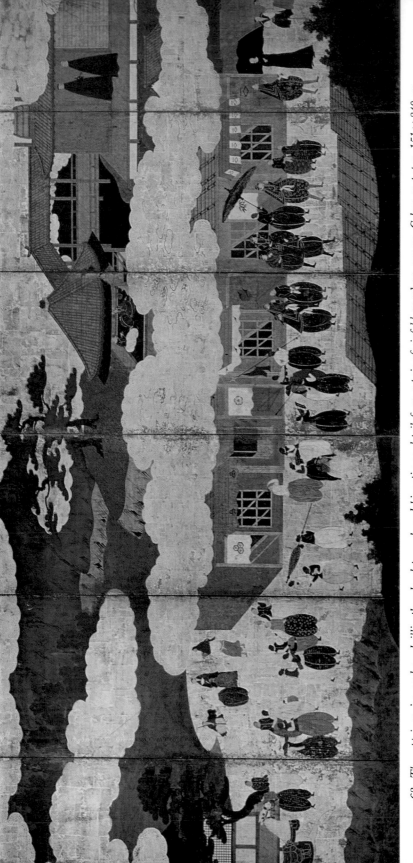

63. *The captain-major, under a brilliantly colored parasol, and his retinue: detail from a pair of sixfold namban screens. Colors on paper, 151 × 349 cm. Private collection, The Netherlands.*

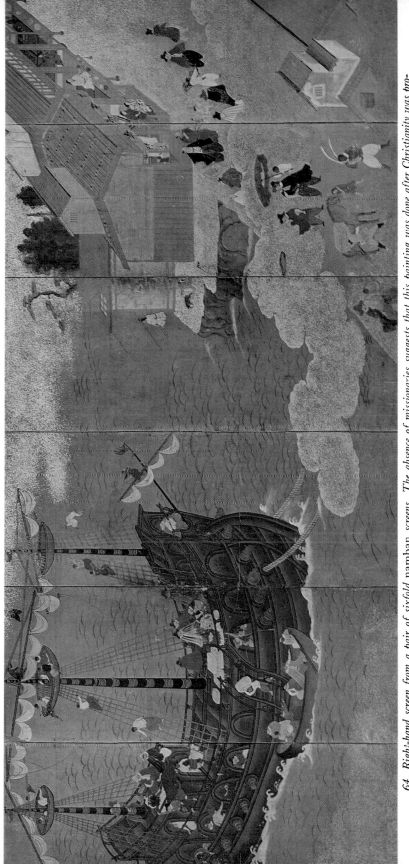

64. *Right-hand screen from a pair of sixfold namban screens. The absence of missionaries suggests that this painting was done after Christianity was proscribed. Colors on paper. Boston Museum of Art.*

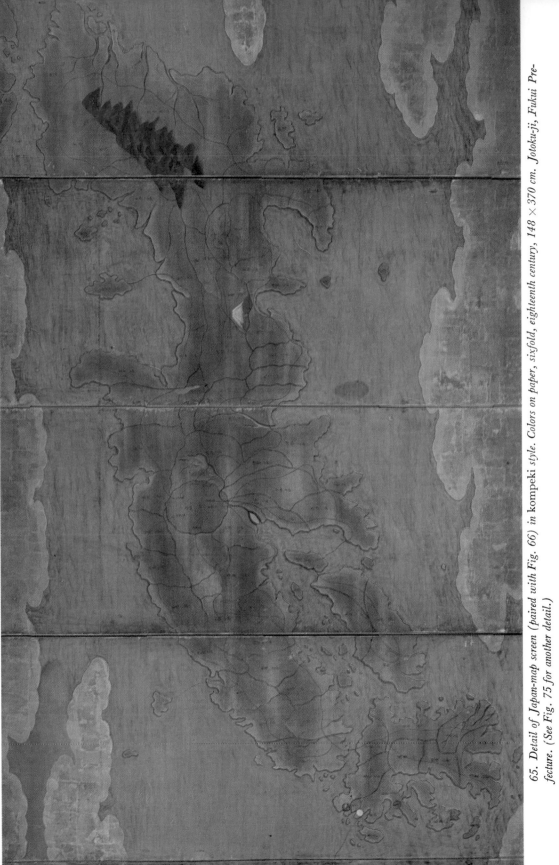

65. *Detail of Japan-map screen (paired with Fig. 66) in kompeki style. Colors on paper, sixfold, eighteenth century, 148 × 370 cm. Jotoku-ji, Fukui Prefecture. (See Fig. 75 for another detail.)*

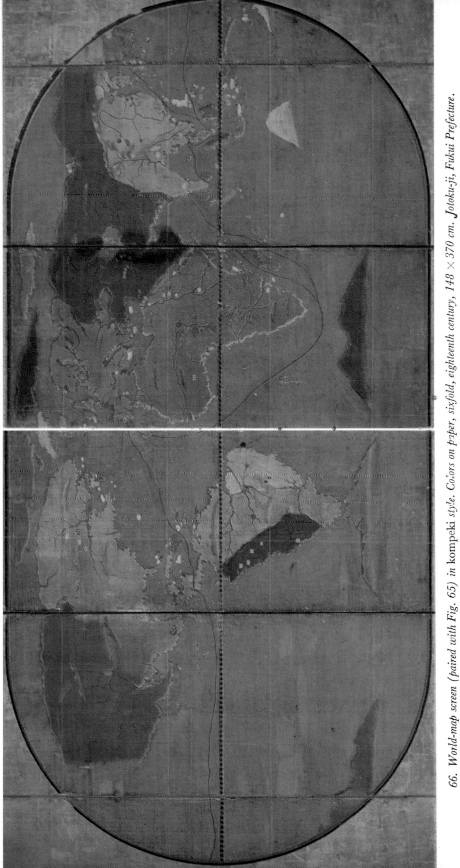

66. *World-map screen (paired with Fig. 65) in kompeki style. Colors on paper, sixfold, eighteenth century, 148 × 370 cm. Jōtoku-ji, Fukui Prefecture.*

67 (overleaf). *Lisbon (left) and Madrid: detail from* Four Great Cities of the West *(Figs. 81, 120). Paired with world map in Figure 114. Colors on paper; eightfold screen; each screen, 158.7 × 466.8 cm. Kobe Municipal Museum of Namban Art.*

▷

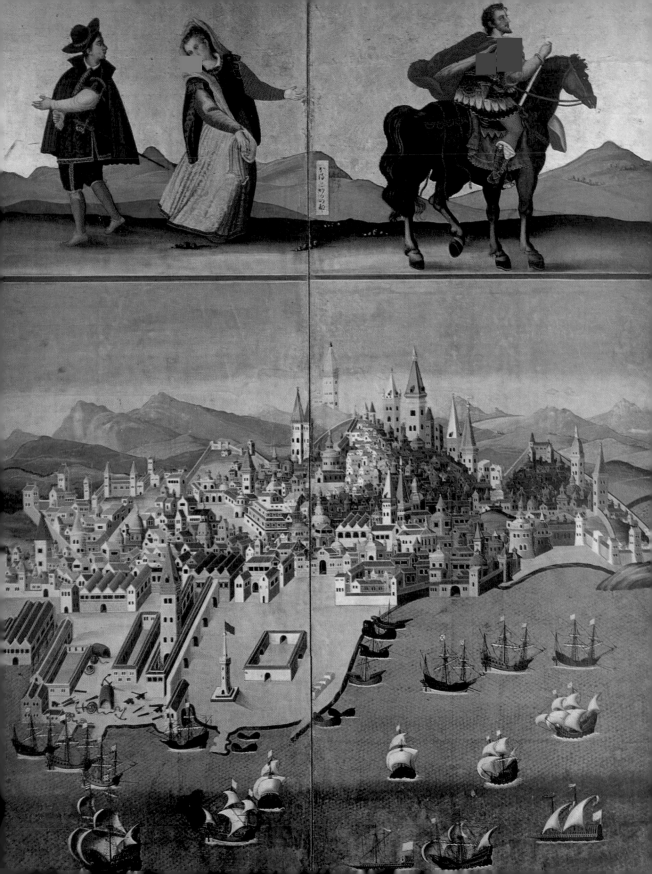

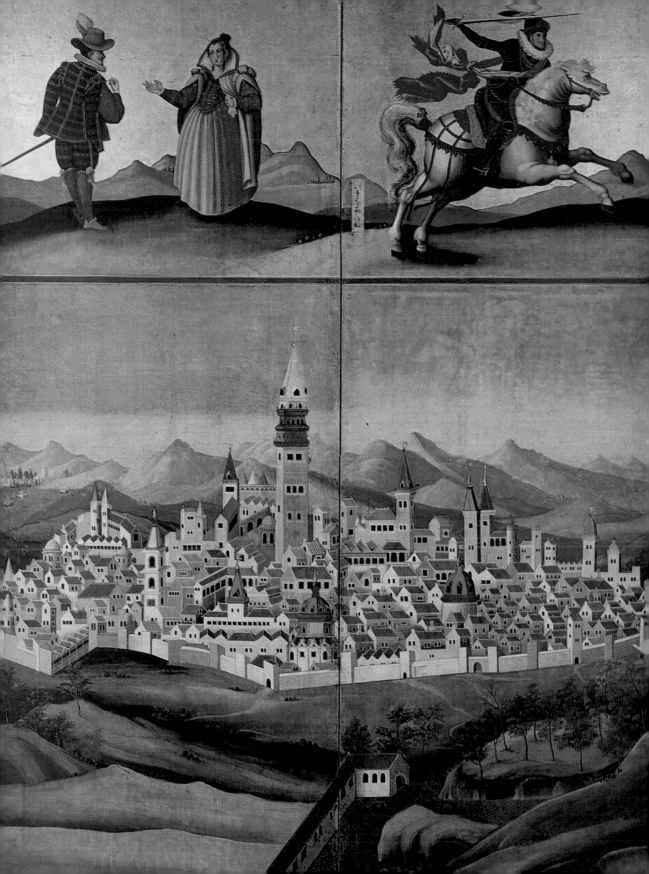

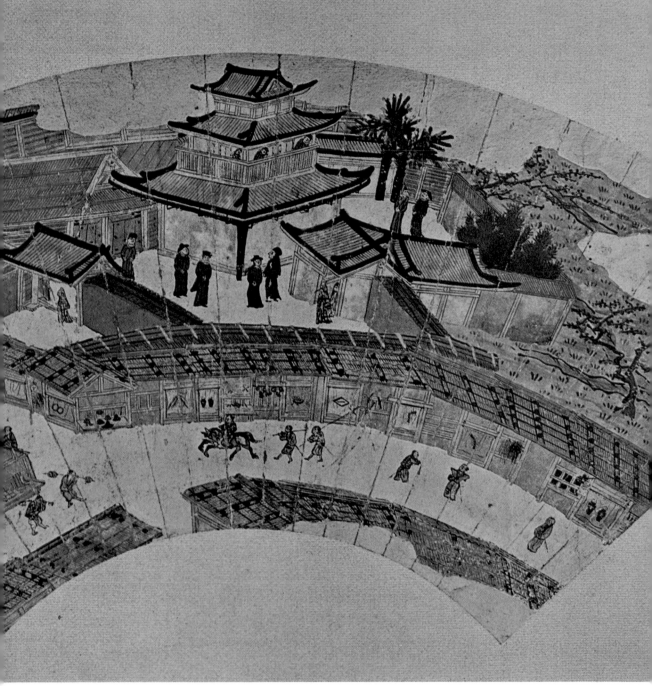

68. *Detail of a fan painting by Kano Motohide showing the Namban-ji ("Southern Barbarian Temple"), the Japanese name for the Church of Our Lady of the Assumption built in Kyoto in 1576. Colors on paper; width, 50.3 cm. Kobe Municipal Museum of Namban Art.*

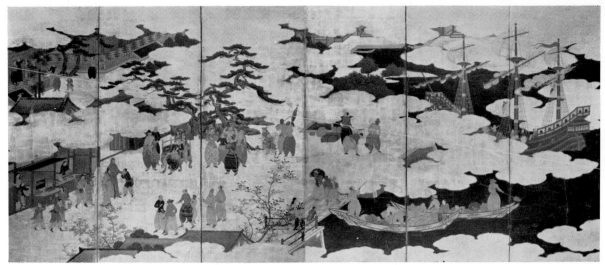

69. *Foreign port scene as imagined by a follower of Kano Tomonobu. Colors on paper. Pair of sixfold screens, each 158.5 × 362 cm. Osaka Castle. (See also Fig. 18.)*

world. The Japanese had had long-standing misconceptions about the Philippines and China when contacts with the Spanish colonials and Chinese diplomats, during the Korean war, were established, but at long last the gradual process of correction got under way. A great part of this advance can be traced to the increased geographical knowledge of the government officials, daimyos, and merchants who, during these years, traveled between Nagoya and Nagasaki.

It is of course impossible to be sure of the numbers of persons who visited Nagasaki during the period before and after the Korean expedition. The Jesuit report of 1596 tells us that two retainers of Tokugawa Ieyasu visited Nagasaki on their master's business and were converted and baptized. Their names are unknown, but the fact that even such unlikely figures as retainers of Ieyasu—who was absolutely unconnected with the Church—became believers indicates there must have been at least a few visitors to Nagasaki during the expeditionary period who were converted to Christianity, and a greater number who did not believe yet entered into close relationships with the missionaries. And it can hardly be doubted that there were many who

had personal contact with the Portuguese through the missionaries.

Among the people who knew of Nagasaki were painters and other artists, who had come there either on their own, or as part of the retinue of daimyos or wealthy merchants. The painters, at least, were strongly stimulated by the Portuguese seamen and ships and by the maps of the world and of Japan that they were shown at the Jesuit residence. It is not known whether the folding-screen representations of ships at anchor and of maps of Japan and the world were the result of sheer creative drive or were made at the behest of powerful lords or merchants with an interest in the *namban* vogue. Probably both factors operated. There are indications that some of these painters were acquainted with the Portuguese and with the Church, but direct proof has not been forthcoming, there being a total lack of references in Jesuit reports to any relationships with Japanese painters. We can, however, be assured by the composition of the screens that the artists had knowledge of the Portuguese ships at Nagasaki, and they also seem to have been familiar with the interiors of churches and the activities of the missionaries.

70. Communion host box with Jesuit IHS (Iesus Hominum Salvator) monogram. Gold and black lacquer on wood with mother-of-pearl inlay; height, 9 cm.; diameter, 11 cm. Tokei-ji, Kanagawa Prefecture.

When we consider that the backing papers of one screen yielded more than ten letters by Jesuit missionaries as well as other related documents, we may safely conclude that there were in the 1590s makers of screens who had an intimate relationship with the Jesuit society, and we may further deduce that there were among them some who had come to the bosom of the Church.

It is noteworthy that the ships depicted on the *namban* screens are structurally identical in every detail with the Portuguese *nao* of the sixteenth century, that the clothing of the captain-major and his retinue are precisely the colonial style current in the Portuguese East Indies at the time, and that the missionaries who came down to greet the party were attired in the same Jesuit habit that can be seen to this day. These facts show clearly that the painters had made direct observation of the small-

est details of their compositions in Nagasaki and attest to how accurately they put them on paper. The Jesuit residences were normally of Japanese style, but the churches, because of the necessity to adhere to European tradition, were represented on the screens with only a little Japanese stylistic influence.

A single example will serve to show that the painters were not necessarily content with mere external observation and may actually have gone inside the churches to obtain their knowledge. A screen in Osaka's Namban Bunka-kan (Fig. 116) shows a Jesuit building in one room of which a missionary sits facing his Japanese lay assistant. They are reading from parallel catechisms in Latin and Japanese script, and the verisimilitude of this depiction of life within the cloister is striking. The screen, a work dating from the two decades around

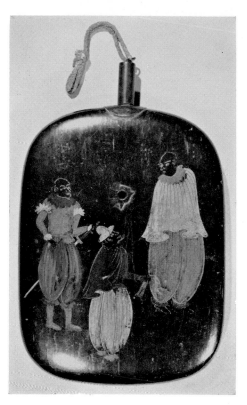

71 (left). *Stationery box with* namban *figure. Gold lacquer on wood, 9.1 × 21.2 cm. Kobe Municipal Museum of Namban Art.*

72 (right). *Gunpowder flask with* namban *figures. Lacquer on wood, 28 × 36 cm. Tokyo National Museum.*

the start of the seventeenth century, suggests that the man who painted it must have had intimate knowledge of his subject matter.

Of the more than sixty pairs of *namban* screens that have come to light, the majority consist of one screen showing a foreign ship at anchor and the crew coming ashore and, on the other, the foreign merchants and seamen and Japanese assembled at the dockside along with occasional missionary figures, separated by stylized clouds from a group of church buildings. With the exception of two or three later examples, things unconnected with the Portuguese and the Jesuits are not depicted, although there are occasions where the presence of a Franciscan indicates some Spanish influence. Among map screens, there are many examples in which maps of the world and of Japan are paired, as well as single screens showing Japan, but there

also were occasions on which a map was combined with a screen portraying a *namban* vessel. And though it is largely true that most *namban* screens are of similar composition, we can recognize points of individuality in each and every one.

A large number of works painted in such a stereotyped fashion is unique in Japanese art, and since many examples must have been lost during the more than two centuries of Japan's isolation, the actual number made may well have been double what survives. The appearance of so many stereotyped works in such a short period proves a process of copying in pursuit of a fad, and there must have been a social background that would permit this kind of faddish imitation.

It seems safe to say that the *namban* screens, made in answer to the demand for art during the *namban* vogue, date from 1590 and later, and that the many

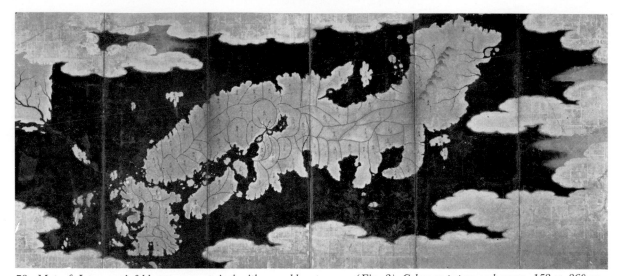

73. *Map of Japan, a sixfold map screen paired with a world-map screen (Fig. 2). Colors on paper; each screen, 153 × 360 cm. Collection of Ataru Kobayashi, Tokyo.*

74 *(opposite page, left). Detail of world-map screen (Fig. 66) showing Japan, Korea, and parts of China and Manchuria.* ▷ *The enigmatic name "Orankai" appears in the center. (For discussion of this problem see pp. 92–95.)*

75 *(opposite page, right). Detail of Japan-map screen (Fig. 65). The line drawn between Nagoya in Hizen, Kyushu, and* ▷ *southern Korea most likely represents the invasion and supply routes used by Hideyoshi's army in 1592–93.*

existing examples of articles of everyday use decorated with *namban* figures and with foreign motifs were the products of the same period. There are a number of historical bases for speculation concerning the dating of these works, but to go into each of them would occupy many pages and unduly try the reader's patience. For these reasons I will limit myself to a single venture into this area.

MAP SCREENS AND THE PROBLEM OF "ORANKAI"

The point to remember concerning the maps of the world that appear on *namban* screens is that the shape of the Japanese islands and the contours of the northeastern portions of Asia are drawn in a new way, one not found in contemporary world maps. Since the European-style world maps produced by the Jesuits' art students also show the same outlines and can be assumed to have been originated by the Society itself, one feels the Japa-

nese painters must have had some connection with the Jesuit missionaries in order to produce these revised maps.

The earliest examples of map screens are a sixfold world map (Fig. 123), a pair showing Japan and the world (Figs. 2, 73), an eightfold single screen in the Hiraemon Kawamura Collection, and a pair belonging to Jotoku-ji temple in Fukui Prefecture (Figs. 65, 66, 75). The Jotoku-ji screens bear the signature (of questionable authenticity) of Kano Eitoku (1543–90). Lavish with golden clouds of dazzling radiance and giving the fullest expression to the beauty of deep, rich tones, these paintings surely qualify to represent the screen art of the Momoyama period (1568–1603).

Of all the screens referred to, those of Jotoku-ji have been a particular subject of a long controversy concerning their date. Because they bear Kano Eitoku's seal, the theory that they date from the last years before his death prevails.

A noteworthy feature of the Jotoku-ji map of Japan (Fig. 75) is a line drawn between Nagoya in Hizen and the southern part of Korea. Without doubt this represents the route Hideyoshi's troops took to Korea and by which their supplies were transported. Since Hideyoshi's plan for the subjugation of Korea was of long standing, it is reasonable to assume that the screen bearing such a line was produced before the dispatch of the expedition; that is, before 1592. This dating would also agree with the closing years of Eitoku's life and further bolster the theory.

In refuting this theory, we should give particular attention to Orankai, a place name associated with the Korean expedition and inscribed in Japanese phonetic script on this world map (Fig. 74). The inscription appears on the coast of the present-day Maritime Province of Siberia, adjacent to northeastern Korea. This name was applied during the war to a tribe of the Tungus people living along the

upper reaches of the Yalu River and in eastern Manchuria who were generally referred to as *orankae*, or barbarians, by the Koreans.

In the summer and fall of 1592, the forces of Kato Kiyomasa pressed northward into and through Hamgyong-do Province, crossed the Tumen at Hoeryong, and invaded Orankai. This was reported to Hideyoshi and his advisers at the headquarters at Nagoya Castle as well as to Ukita Hideie at his forward command post in Kyongsong (Seoul), and after the return of Kato's armies to Kyongsong in a regroupment of all the Japanese forces, their invasion of Orankai was widely spoken of as a major exploit. The references to Orankai in Kato Kiyomasa's reports, the papers of Hideyoshi, and the communications of field commanders in Korea indicate that the term was understood to refer to the territory occupied by the tribe, forming part of the present Chien-tao region of eastern Manchuria. However, there are also numerous ambiguous

76. *Detail of a Japanese copy of a chart from the Spanish ship* San Felipe. *The copier has reversed the original chart's directions, putting south at top, north at bottom, east at left, and west at right. At the center bottom is "Eso" (Ezo, or Hokkaido) and at bottom right Fuzankai (Pusan, Korea). 1596. Kochi Prefectural Library.*

references to Orankai, sometimes as the name of a country, sometimes as the tribe itself. In the reports and communications of the Jesuits after 1594, the word Orankai appears on several occasions. Particular attention should be given to the Jesuit report of 1594, which describes Orankai, along with Tartary, as adjoining the north and northeastern perimeter of Korea and defining the fringe of the continent, forming a large gulf north of Japan, and in its northern portion, lying close to the upper part of Ezo (present Hokkaido). It would seem that this refers specifically neither to a geographical point nor to the name of a tribe.

At any rate we may be sure that Kiyomasa's forces first heard the name from the Korean inhabitants of Hamgyong-do as they pressed northward in the winter of 1592, and that the word was misapplied to the area that is present-day Manchuria only after the arrival of his report. It thus becomes impossible to believe that the name was already known in Japan before the war began, in 1592, two years after Eitoku's death. And it is

equally certain that these screens cannot possibly have been made before 1593, the year the reports reached Japan. (Unfortunately, space limitations require that discussion of the problem of the seal of Kano Eitoku be omitted from this book.)

Going further into the dating problem of screens, on the Jotoku-ji map the coast of Asia extending to the northeast beyond trans-Tumen Orankai is drawn in a way not seen in previous European maps. In contrast to this, the coastline seen on maps such as the world map (Fig. 76), copied with north and south reversed from the charts of the Spanish galleon *San Felipe* (wrecked in Urato, Tosa Province, in October 1596), on the various world map screens in *namban* style already referred to, on the world map screen (Fig. 114) in Western style paired with the *Four Great Cities of the West*, and finally the world map screen (Fig. 77) and its paired *Battle of Lepanto*, show them all to be of earlier date.

All these screens are also related by the Orankai mistake, which sprang from the wartime report of Kato Kiyomasa. When we consider that not one of

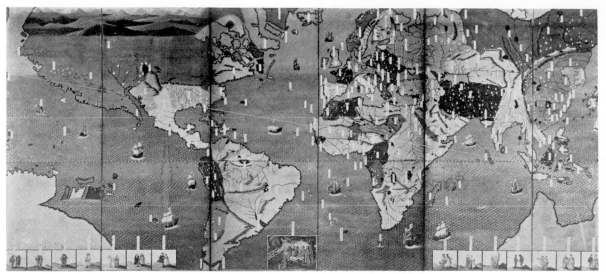

77. Western-style map of the world painted in the Jesuit art classes. Sixfold screen paired with The Battle of Lepanto. *Oils on paper; each screen, 135 × 370.4 cm. Collection of Chokyo Murayama, Osaka.*

the numerous writings over the next half century that dealt with the Korean campaign failed to devote space to Kato's Orankai incursion, we can see the high repute in which it was then held. It is therefore likely that the Jesuits, who became acquainted with Kato's report through Christian daimyos at the front, guessed at the geographical location of this Orankai, as we have already seen in the report of 1594, and at their studio undertook the revision of that part of their existing European maps that covered northeast Asia, extending the contour to the northeast and inscribing the name Orankai on a portion of it. It is also probable that Japanese painters had occasion to see the revised versions at the Jesuits' residence in Nagasaki. The map on Hideyoshi's fan (Fig. 122) is a partial copy of such a map and the 1596 copy of the *San Felipe's* chart (Fig. 76) may well have incorporated some modified features of a revised world map.

The stereotyped representations of ships that appear on the *namban* screens cannot tell us the earliest possible date that can be assigned to them as is possible for the map screens. But just as we have shown reason to suppose that the map screens postdate 1593, it is also reasonable to assume that the depiction of ships on the *namban* screens that form a paired unit with these maps were done at the same time. And while, due to the fact that many of the *namban* screens are not paired with map screens, it is impossible to be sure that they were exactly contemporaneous, it is surely unlikely that they predate them by any great period. The great fad for works of art that accompanied the spread of the *namban* vogue among the daimyos and powerful warriors, wealthy merchants, and famous names in the arts who traveled from the capital district to Kyushu after Hideyoshi's mounting of the Korean expedition and construction of Nagoya Castle (1592), was clearly directed at the *namban* screens and the associated map screens.

CHAPTER FOUR

Japanese Christian Art

THE DEMAND FOR SACRED ART It is certain that St. Francis Xavier and his party, arriving by junk in Kagoshima, Japan, in 1549 brought with them articles to use in their mission and to exchange as presents, and that among these were pictures of Christ and the Virgin Mary. No sacred pictures had as yet been produced in Goa, however, and because Xavier, the first missionary to visit Japan, knew little of conditions there, the number he brought was limited. Soon after his arrival the mother of Shimazu Takahisa, daimyo of Kagoshima, asked him for a picture. Reporting the incident later, he said, "We had no means of making a copy of the picture in this country, and there was no way to accede to the lady's request."

The Jesuit missionaries who followed him (by 1581, twenty-two years after the introduction of Christianity, there were in Japan seventy-five missionaries) also brought a number of pictures. Considering those priests who returned to India after a number of years and those who died in Japan, the total must have exceeded eighty, so that the number of works they brought to Japan can by no means have been small. Moreover, with each year after the introduction of the faith, the strength of evangelistic activity increased in Hizen, Bungo, the Kinki district, and other areas, and the number of converts increased rapidly until in 1581 it reached 150,000, necessitating the maintenance of 200 churches.

The evangelization of Japan, held to be the greatest success of the Jesuits in the Far East, soon outstripped the supply of religious art brought by the missionaries. Since the Japanese were in the habit of placing representations of Shinto gods and Bodhisattvas in their household altars, and of keeping a set of ritual utensils, they were, the missionaries reported, continually importuning them after their conversion to Christianity for small representations of the Savior, Virgin, or saints to replace these articles as a focus for their faith. This presented the Jesuits with not only an immediate emergency but also with a major problem of long duration—how to supply the utensils of the faith required by the expected growth in the number of converts, and in the number of churches needed to serve them. And since Goa and other mission fields in India, Malacca, and Macao were also troubled to some degree by the same kind of shortage, there was no possibility of looking to them.

Japanese artists had sometimes been set to copying religious art brought over by the missionaries, and many of the resulting works were said to be extremely well executed, well enough to be sent with the embassy of the Kyushu daimyos for presentation to the Spanish court. Since the majority appear to have been made in Kyoto or Sakai, it is likely that it was the artists of the Kano and other important schools who received the commissions. These works, however, were somehow unsatisfying as works of church art, and their numbers were

78. *Our Lady of Sorrows. Oils on canvas, 52.5 × 40 cm. Namban Bunka-kan, Osaka.*

79. *Michael the Archangel. Colors on paper; 30.3 × 33.4 cm. Formerly hung in the Urakami Cathedral, Nagasaki, this painting was destroyed.*

limited. Finally the missionaries in Japan petitioned the Jesuit Curia in Rome to provide them with religious art, but since it was seven or eight years from the dispatch of this order until delivery, the immediate problem remained unalleviated.

The requests to Rome for religious pictures during this period were repeated several times, and the need in Japan for 50,000 works, given in the Society's report of 1584, can have been no exaggeration.

Yet it was quite impossible for Rome to satisfy these requests. For we are told that when a certain missionary bound for Japan was entrusted with one thousand paintings, his artworks were preempted in India, Malacca, and other points en route, so that virtually none were delivered to Japan. Religious prints from copper printing plates were also in great demand for the faithful, and in the Jesuits' reports and correspondence of 1584 and 1587 strong requests are made that some be sent. This in itself indicates that there were then few copper-plate prints in Japan.

ART, PROPAGATION, AND EDUCATION The requests of the Jesuits in Japan were not confined to religious art. They early became aware that in order to extend the Christian religion it was absolutely essential for them to provide convincing and irrefutable comparisons between Europe and Japan in regard to the Church's authority, the power and dignity of temporal princes, and the prosperity and affluence of the cities. It was to this purpose that Alessandro Valignano set himself.

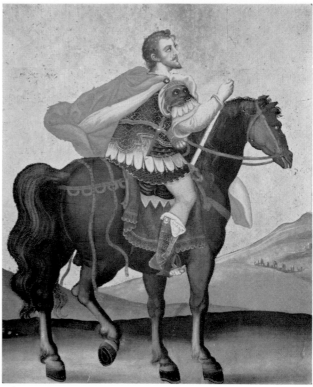

80. Two knights, a painting attributed to Nobutaka, Colors on paper, 114 × 53 cm. Kobe Municipal Museum of Namban Art.

81. Mounted prince: detail of Four Great Cities of the West *(Figs. 67, 120). Colors on paper; sixfold screen; full size, 158.7 × 466.8 cm. Paired with world-map screen (Fig. 114). Kobe Municipal Museum of Namban Art.*

The Jesuits' visitor and their highest official in the Far East, Valignano began his tour in Japan in July 1579, and after a stay of nearly three years, departed with the Christian daimyos' embassy, going with them as far as Goa. No sooner had he arrived there, than he took numerous occasions to direct—both in letters to his superior, which he entrusted to the envoys, and in his instruction to the missionaries who accompanied the group— that the young envoys be shown how mighty the Church, the princes, and the cities of Europe actually were. He also expressed a corresponding desire for pictures to be used to educate the Japanese. The Jesuit report of 1587 requested illustrations of the city of Rome and of pontifical masses to be used to instruct the faithful in the majesty of the Catholic church, and stated his desire to obtain

pictures of European knights and warfare, these being very popular among the Japanese. Obviously these desires were not to be easily met.

In this connection Valignano had begun in 1579 a thorough inspection of conditions relating to the propagation of the faith, and subsequently solicited the missionaries' opinions of its future. Some of the policies he evolved to rectify deficiencies in the program are given briefly here. One of these was to establish preparatory schools for Japanese aspirants to religious vocations, those who would be compatible intellectually and socially with the growing population of converts. Such institutions were established at Azuchi, the headquarters of Oda Nobunaga, predecessor of Hideyoshi; at Funai and Usuki in Bungo Province, the domain of Otomo Yoshishige, who was the most important supporter

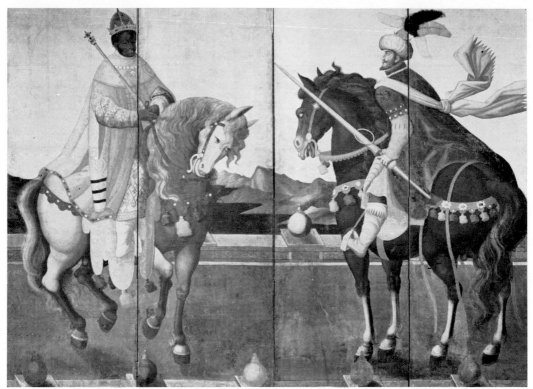

82. *Mounted princes: detail from a pair of fourfold screens. Colors on paper; each screen, 168 × 231 cm. Collection of Akira Fujii, Hyogo Prefecture.*

of the Society; and at Arima, Hizen, in the domain of Arima Harunobu, a fervent Christian and admirer of Valignano. Another policy was that the Society of Jesus in Japan become self-sufficient in producing literature by doing their own editing and printing. This was because it would require inordinate labor if each missionary or student handcopied the school texts and the many works required by the faithful, while to obtain them from Europe would not only be extravagantly expensive and difficult, but would fail to provide works tailored to the needs of the Japanese. As part of this program a catechism was translated from Latin, carried by the young envoys to Europe, and published in romanized Japanese at Lisbon in 1586.

Whatever Valignano may have done during his stay in Japan for correcting the scarcity of art ob-

jects is not mentioned in the Society's reports. It may well be that the requests to the Curia for getting artworks were at his instigation and that he also planned to give, in the schools at Azuchi, Funai, Usuki, and Arima, instructions to the Japanese in art and crafts as well as in the more conventional subjects, thereby producing a cadre of experts. But since there was no one among the missionaries with sufficient talent to impart such techniques, we are left in doubt about whether these plans ever came to fruition.

Valignano left Japan the first time in February 1582, and during his stay in Macao, which lasted from March until the end of the year, he made the acquaintance of the young Italian painter and Jesuit Giovanni Niccolo, who was being sent by the Jesuit Curia to Japan. Niccolo arrived in

83. Martyrdom of the Three Saints, *a painting attributed to the Italian Jesuit Giovanni Niccolo who was a resident in Japan from 1583 to about 1614. Oils on cloth, 154 × 100 cm. Tokyo National Museum.*

84 (opposite page, left). Title page of Sanctos no Go Saguio *(Acts of the Saints). St. Peter is shown at center. Published in 1591. Copperplate print. Bodleian Library, Oxford University.* ▷

85 (opposite page, right). Title page of an abridged and simplified version of the Japanese classic Heike Monogatari *(Tales of the Heike), published by the Jesuit press at Amakusa in 1592. Copperplate print. British Museum, London.* ▷

Macao from India in early August of that year and remained there until late the following spring. His presence there coincided with that of Pedro Gomez (1535–1600), later to become a vice-provincial, and of Francisco Pasio. Valignano called all of them for discussions on various aspects of the evangelization of Japan. It is likely that the perennial problem of art and artworks came up, and possible that Valignano directed them in some related policy.

Niccolo, with his two superiors, Gomez and Pasio, reached Nagasaki in the summer of 1583. It seems that for some years after his arrival, he was not blessed with good health and was unable to devote himself fully to painting. Available knowledge suggests that in Macao he painted, in addition to his Savior, a map of Italy in oils. The many works he did in Japan include a Christ painted for the faithful of Nagasaki and another for those of Arima, both

dated 1583, and in 1584 a figure of Christ for a newly built church in Arima. Also in 1584 he painted a Mary in oils on heavy panels for the church in Usuki in the fief of Otomo Yoshishige, but this was destroyed when the Shimazu armies invaded Bungo Province in that year. He was commissioned by the vice-provincial Gaspar Coelho to paint a large and splendid representation of the Savior for dispatch to Macao, and he also turned his hand to producing a number of copperplates, and even an oil of Stephen the Apostle. But the unfortunate fact is that not one of these has come down to us today.

Niccolo died in Macao in 1626. A letter written from there that year by one Palmeiro, a missionary, tells us that he stood head and shoulders above the other missionaries in Japan and China, "possessing great gentleness and probity, having a special talent for mathematics, painting, and clock-

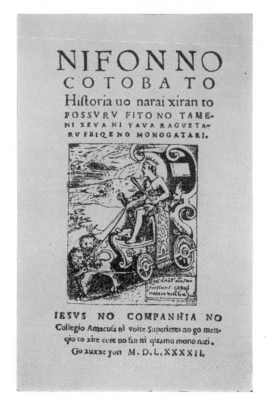

making, instructing students in painting, and providing religious pictures for the churches." This indicates that he was a man of many parts, exemplifying the artist of Renaissance Italy. And it is probable that with his recovery of good health, about the time of Hideyoshi's proclamation expelling the missionaries, he taught painting and woodblock printing to the Japanese students at Hachirao, in Arima. If it is true that he received instructions from Valignano at Macao in 1582, they no doubt were in reference to the teaching of students of painting.

Whether he did or not, nothing whatever is known about the Jesuits' activities in art instruction until 1590, when Valignano returned to Japan armed with a diplomatic commission from the viceroy of India. In August he assembled the missionaries for a meeting at the Jesuit theological college at Katsusa, on the southern end of the Shimabara peninsula. At that meeting it was decided to print textbooks using the presses and types that the mission had brought from Europe, and, with an eye to the future, to cast Japanese types as well; printing was begun forthwith, in October.

I mentioned earlier that Valignano sent a catechism manuscript in romanized Japanese to Lisbon with the Christian daimyos' embassy, where it was printed in 1586 for use in the Jesuit schools in Japan. And at Macao, on his way back from India, he had printed, for the same purpose, Bonifacio's *Education of Children* in 1588, and a record of the embassy in question-and-answer form in 1590; both were in Latin. This work was accomplished by having members of the mission in Lisbon trained in the casting of type and the techniques of printing, and by bringing back type and presses.

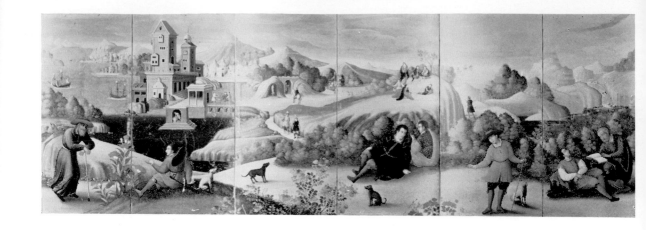

Even before this, at the end of 1588, there were in the preparatory school at Hachirao some 75 Japanese students, and by 1596 the number had grown to 112, so that the problem of supplying texts was not an easy one. With the return of the mission, the means for overcoming the difficulty came to hand. Thanks to Valignano's careful planning, in 1591 the first work ever printed with movable metal type in Japan, *Sanctos no Go Saguio* (Acts of the Saints) (Fig. 84), was published at the college in Katsusa And from then on, works were published almost every year.

It is likely that provision had been made for the production of works of art, as it had for the printing of texts, but no mention is made of this in the Jesuits' reports. Quite probably Niccolo and the returning members of the Christian daimyos' envoys brought into Japan materials for Western-style painting and the chisels and other tools used in the working of copperplates; but even if they did, the amount must have been insufficient, requiring the printers to use domestically produced materials.

At the October 1590 conference in the college at Katsusa, where it was decided to undertake the printing of textbooks, consideration was probably given to the production of works of art, and steps were soon taken to begin instructing students. And while it seems obvious that the training was begun with the students copying religious works, it is unlikely that such nonreligious themes as cityscapes and portraits were neglected.

THE BEGINNINGS OF WESTERN-STYLE PAINTING IN JAPAN

No materials exist that would enable us to fix the precise date when the Japanese study of Western painting began, but a clue is provided by the screen painting *Four Great Cities of the West* (Figs. 67, 120) belonging to the Kobe Museum of Namban Art. As we have seen, Valignano's embassy from the viceroy of India stayed for about two months in the Japanese port of Morotsu on its way to Kyoto around the beginning of 1591. And it is reported that during the talks on conditions in Europe that the members of the Kyushu daimyos' embassy gave to the many lords who visited them, they displayed many objects, among which was an exquisitely executed work showing Rome and other cities. One cannot state with certainty that the Kobe Museum painting is the one they displayed; they may have had a reduced-scale copy made for easier carrying. But any such paintings would have

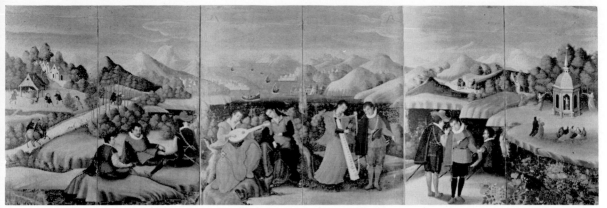

86–87. European Social Customs. *Colors on paper; pair of sixfold screens; each screen, 93 × 302 cm. Collection of Moritatsu Hosokawa, Tokyo. (See also Figs. 42, 103.)*

been produced at the section of the Jesuit school devoted to Western painting either by Niccolo, working alone or assisted by his Japanese students. If it was done at the school, it must have been completed by early December, when Valignano's party set out from Nagasaki. It follows then that the copying of Western-style painting had begun by the fall of 1590. And since it had long been the desire of the Jesuits to show to the Japanese people works depicting the city of Rome, it is safe to say that they proceeded with the copying as soon as humanly possible after the return from Europe of the envoys.

There is, then, virtual certainty that Niccolo started teaching Western painting along with copperplate engraving. In that part of the Jesuit report of 1592 dealing with the school at Hachirao in Arima's domain, we find that, "among the students are some who, in accordance with their own interests, practice other disciplines [not on the standard curriculum]. For example, some study painting, while others learn printing or the engraving of copperplates. Their technique is very fine, for they have the most excellent and rare skill and one can only be amazed to see the ease with which they comprehend. If Your Paternity [the Jesuit general] were to

see the things produced by these inexperienced youths, you could not but be pleased." And that both paintings and copperplate prints began from the copying of originals brought back by the Christian daimyos' envoys is made clear in the report of 1593. Since this is a most important passage, I would like to quote it here at length.

"The fact that a number of the students at the Hachirao school are painting pictures and engraving metal plates is greatly to the advantage of the Church. Eight of them are painting with Japanese colors, [eight] others in oils, and five are engraving copperplates. They are, without exception, making great progress and astonishing us greatly. For there are among them students who have made copies of the best works brought by the Japanese princes from Rome, and these copies are so nearly perfect in both color and shading as to be almost like the originals. Many of the fathers and brothers associated with them cannot tell which were made by the students and which brought from Rome, and although this may be thought an exaggeration, there are even some who insist that the work produced by the Japanese was brought from Rome. . . . And some of the Portuguese, seeing the works, and not knowing them to be made in Japan,

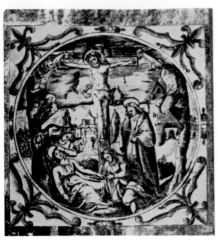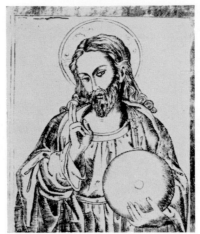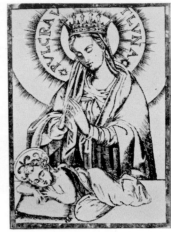

88–92. *Copperplate illustrations from* Cruz no Monogatari *(The Story of the Cross). From left to right: the Passion of Christ, the Savior, Madonna and Child, St. Jacob, and St. Peter. Compiled by Manuel Baretto and published in 1591. Vatican Library, Rome.*

S. Iacobus

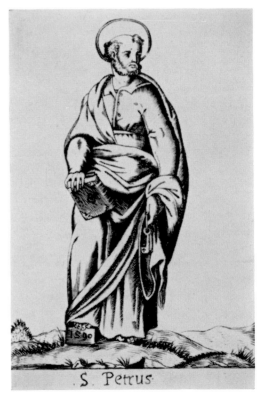

S. Petrus

93. *Procession of the captain-major: detail from a pair of sixfold* namban *screens. Kano school. Colors on paper; each screen, 154 × 355 cm. Otsu Branch Temple, Higashi Hongan-ji, Shiga Prefecture. (See also Fig. 21.)*

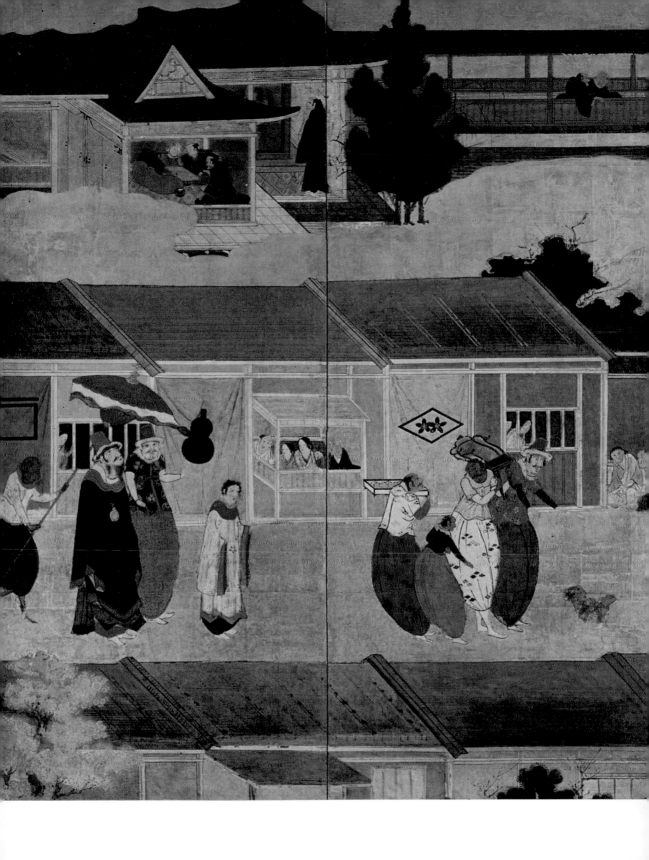

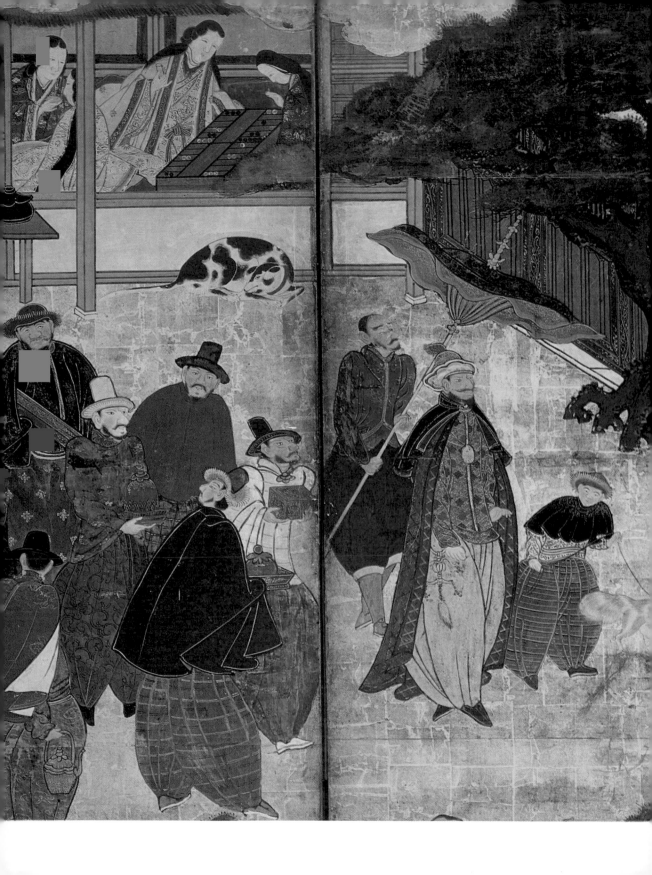

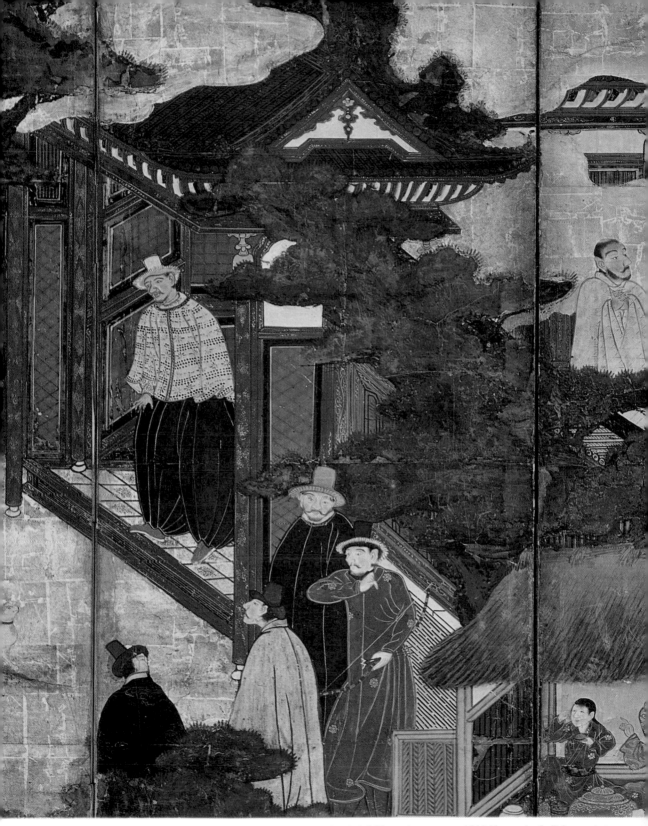

94. *The captain-major at the gate of a chapel: detail from a pair of sixfold* namban *screens. Old Kano school. Colors on paper; each screen, 155.8 × 334.5 cm. Imperial Household Agency. (See also Fig. 53.)*

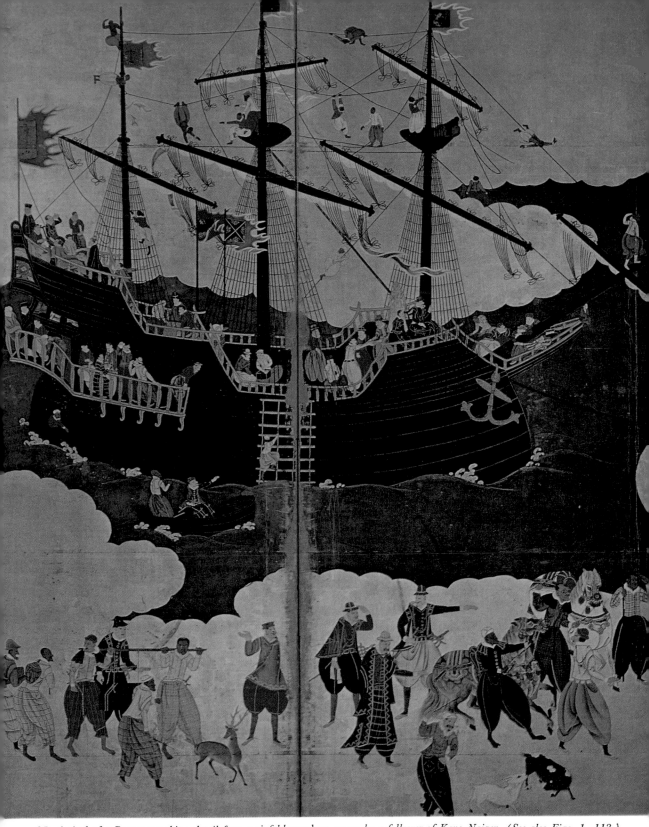

95. *Arrival of a Portuguese ship: detail from a sixfold* namban *screen by a follower of Kano Naizen. (See also Figs. 1, 113.)* Colors on paper, 156 × 330 cm. Toshodai-ji, Nara.

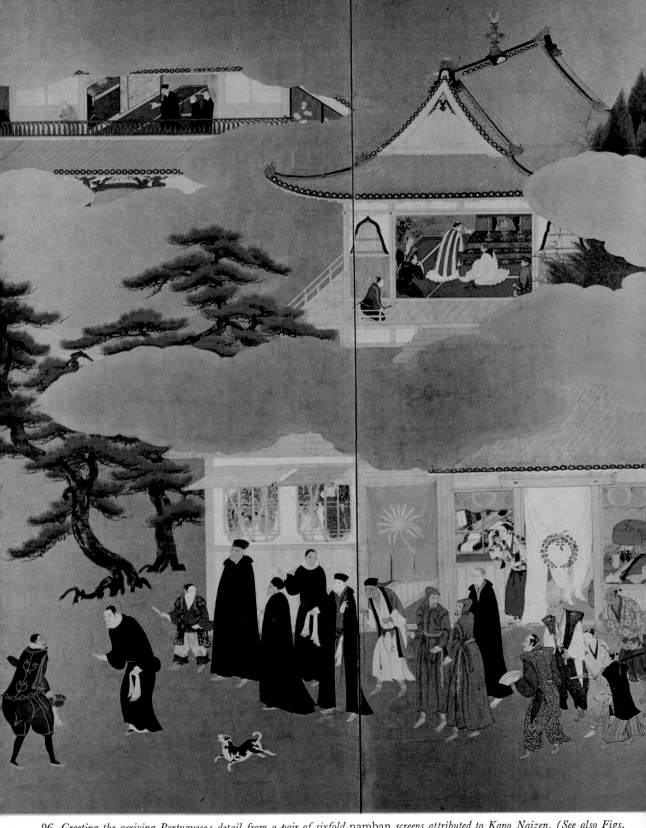

96. *Greeting the arriving Portuguese: detail from a pair of sixfold* namban *screens attributed to Kano Naizen. (See also Figs. 13, 100.) Colors on paper; each screen, 155.6 × 364.6 cm. Kobe Municipal Museum of Namban Art.*

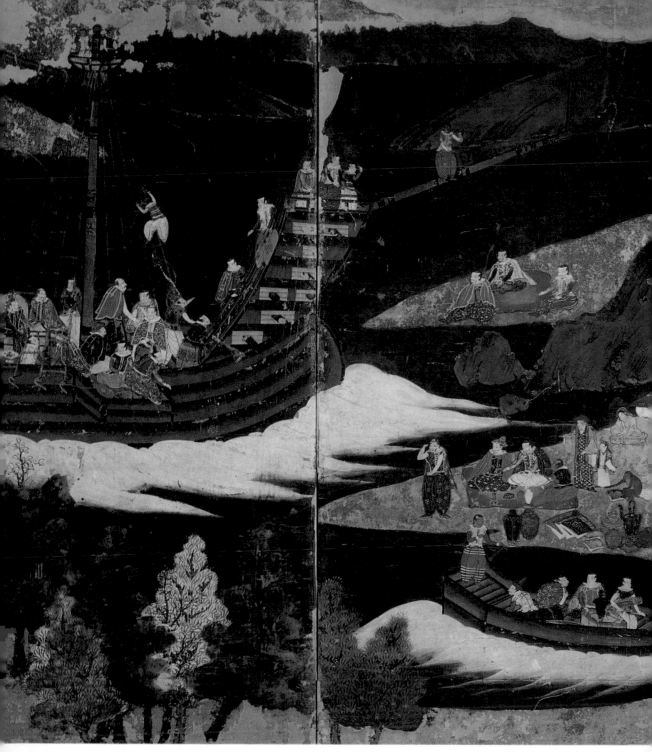

97. *Unloading cargo from a Portuguese* nao: *detail from a sixfold* namban *screen in* yamato-e *style. (See also Figs. 101, 110.) Colors on paper, 106 × 312 cm. Muro-ji, Nara.*

98. *Watching the arrival of the Portuguese: detail from a pair of sixfold* namban *screens. (See also Figs. 111, 112.) Tosa school.* ▷ *Colors on paper; dimensions of each screen, 154 × 364 cm. Collection of Ataru Kobayashi, Tokyo.*

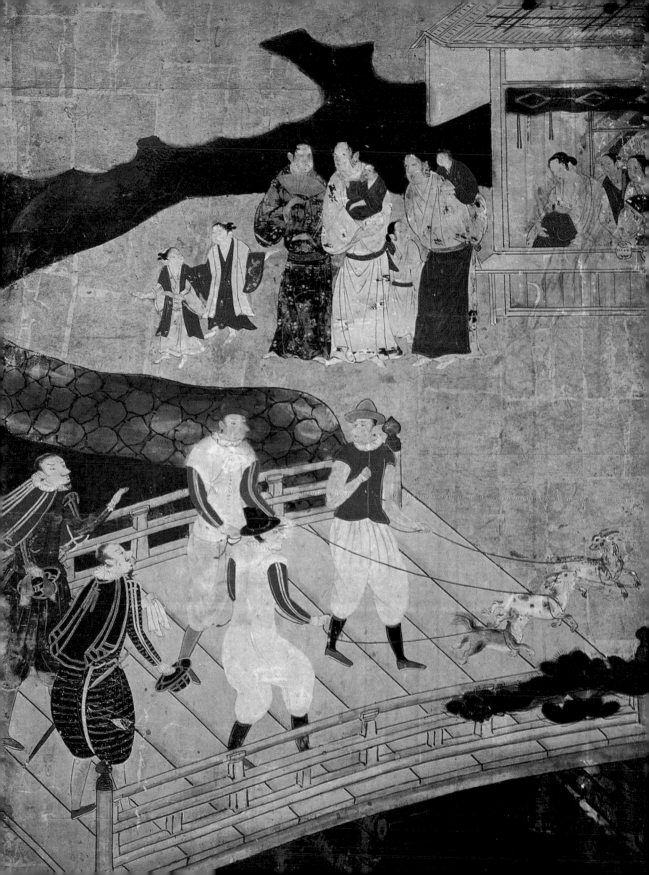

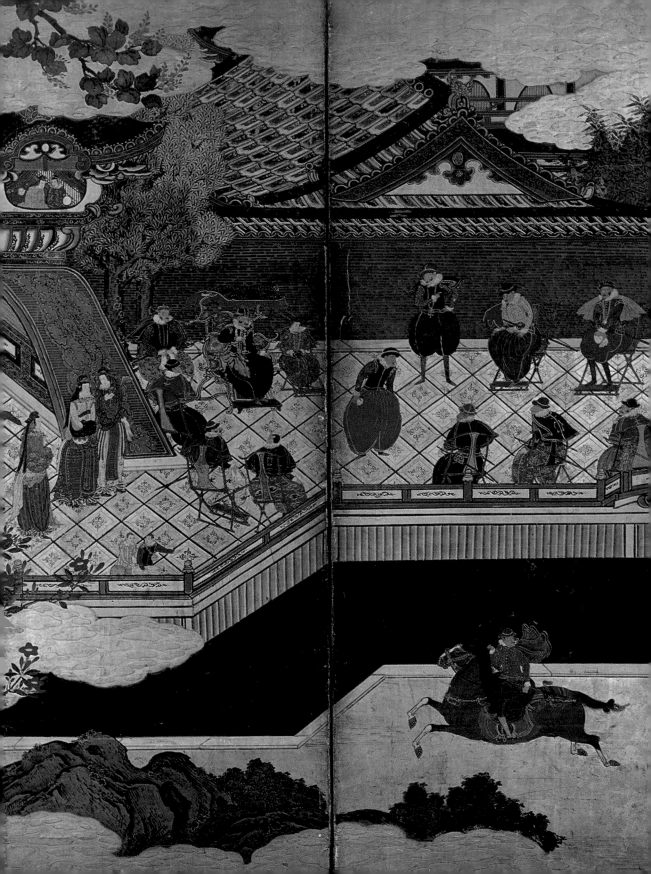

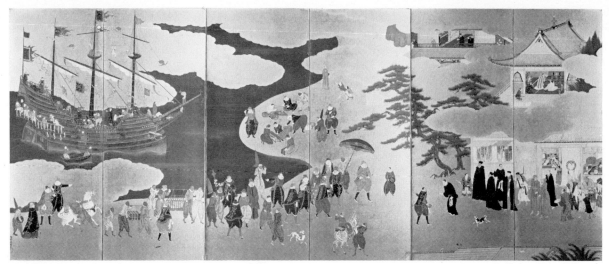

100. Namban *screen showing the arrival of a* nao *in Japan: detail from a pair of sixfold screens attributed to Kano Naizen. Colors on paper; each screen, 155.6 × 364.6 cm. Kobe Municipal Museum of Namban Art. (See also Figs. 13, 96.)*

have said that they can only have been made in Rome. If we are thus blessed by Divine Providence, we shall have people who hereafter will fill our many churches with fine paintings, making glad the faithful lords and gentlemen. Engravers of copperplates apply themselves diligently at their place of work. For in making engravings in perfect likeness of those brought from Rome and printing from them, they can give great joy and satisfaction to the faithful. The pious desire of the faithful to have pictures in their own houses, which was so long unattainable, is now in the process of being achieved."

This report shows that the Japanese students were intent on making faithful copies of Western works, and had not added any peculiarly Japanese flavor. This was not only because they were in the early stages of their studies but also because the Church wished that as few changes as possible be made in the originals. They did, however, take pains, both in the making of paintings and copperplates, to develop a method of copying which provided some changes in posture or in the number of auxiliary figures, so as not to be confined to stereotyped reproduction of a small number of originals.

◁ 99. *Portuguese traders in a foreign land as imagined by a follower of Kano Sanraku: detail from a pair of sixfold* namban *screens. Colors on paper, 156 × 358 cm. Suntory Art Museum, Tokyo. (See also Figs. 22, 117.)*

Namban Art
in the Momoyama Period

MOMOYAMA GENRE PAINTING AND NAMBAN SCREENS The art that has been grouped together as *namban* comes, it is true, from the totally dissimilar streams of Japanese and Western painting. Yet both owed their origins to separate historical demands, and so in endeavoring to approach the essence of each it may well be best to take a historical view of their development.

In the Momoyama period (1568–1603), when Toyotomi Hideyoshi and his vassal lords were vying in the construction of magnificent castles and mansions, there was a strong movement toward utilizing the broad surfaces of decorative screens and sliding partitions (*fusuma*) for the creation of richly textured works called *shobyo-ga*. And in addition to the traditionally popular simply drawn landscapes, still life and wildlife done in India ink, there arose suddenly at this time a new style—*kompeki-ga,* in which brilliant reds and greens are set against a gold ground—that combined *yamato-e* techniques with Chinese-style painting. The masters of the Kano school, the most renowned painters of the Momoyama period, were especially active in these two styles of painting and extended them to genre works representing the lives of the common people.

In the genre paintings, with their unified composition and regular positioning of human figures and buildings, the realistic style of brushwork is readily apparent. This is particularly true of the work of the *machi-eshi,* or "town painters," of the Kano school, who made their living by producing, rich and gorgeously colored paintings in the *yamato-e* style that no doubt found their largest market among the affluent merchants who were then building imposing shops and mansions in the major cities.

To exemplify the Japanese stream of *namban* art, then, we have the *namban* screens, a type of genre painting of the Momoyama period, largely executed by the Kano school. But when we look at these skilled compositions portraying the Portuguese and their ships, Christian churches, and missionaries, we realize that the inspiration for them could only have been gained at Nagasaki, where foreigners came and traded, and we further realize that these painters worked not from imagination but from personal observation. Some of the painters probably became friendly with the missionaries, gaining acceptance among the Portuguese so that they attained a measure of understanding of their customs and usages and recorded these in their work.

COMPOSITION OF THE NAMBAN SCREENS It is important to understand that *namban* screen paintings of the port of Nagasaki did not follow the conven-

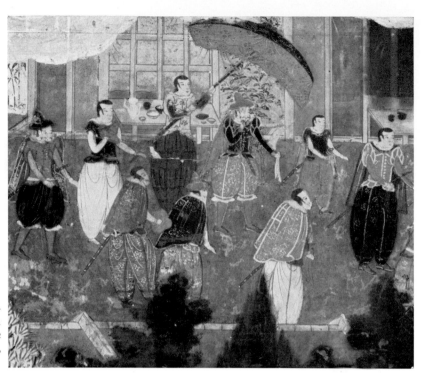

101. The captain-major and his re-
tinue: detail from a sixfold namban
screen in yamato-e style. Colors on
paper, 106 × 312 cm. Muro-o-ji,
Nara. (See also Figs. 97, 110.)

tional canons of Western realism, involving a panoramic view, variations of light and shade, and the use of perspective. Rather they were executed in the *yamato-e* style, which emphasized detailed representation of individual persons, buildings, and utensils, and careful arrangement of these over the broad area of the screen. And this subject matter, incidentally, was taken up by artisans of similar tastes and transferred—either as direct copies or in symbolic representations—to *namban*-figured and gold-decorated lacquerware, and to engraved or cast vessels of copper or iron.

Works of the indigenous stream of *namban* art were no doubt freely turned out on the basis of designs by the original artist. Even if a painter journeyed to Nagasaki with a patron who under-stood the flavor of *namban* culture and painted by commission, it is clear that he chose his own subjects and mode of composition. It also seems safe to say the first who tried their hand at this style were by

no means mediocrities, even by the high standards of the Kano school, for there are among the earliest of these screens works that must receive the highest critical acclaim. Unfortunately, because it was not customary at this time for painters to sign their works, there is no way today we can confirm the authenticity of a work, even though it may seem to be from the hand of a famous master.

It is likely that other art patrons who saw the early screen masterpieces and became interested in *namban* themes would have commissioned the paint-er, or one of his colleagues in the Kano school, to do another work of similar composition.

In this way, as *namban* themes became popular, generations of similar screens were copied out. In the most extreme examples the artist, having ab-solutely no knowledge of Portuguese ships and no understanding of the missionaries, would simply sit down to imitate previous screen paintings and give free play to his imagination. Two pairs of screens,

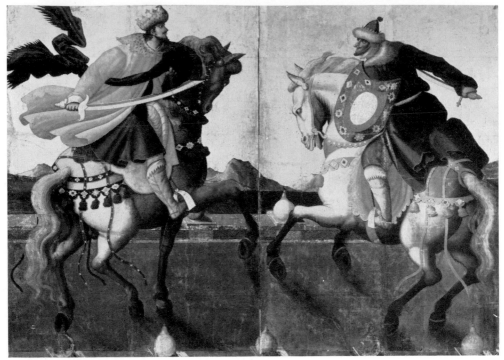

102. *Detail of a screen showing mounted knights. Colors on paper; single fourfold screen; full size, 162 × 468 cm. Kobe Municipal Museum of Namban Art. (See also Fig. 11.)*

one formerly at the Shaka-do and one belonging, until destroyed by fire in 1945, to the Okazaki Library, are typical. As time went on copies of the copies, possessing very little artistic merit, continued to appear until the process finally came to an end about 1650. The later screen paintings were not very spontaneous creations but rather mechanical reproductions of set subject and construction, inexorably faithful to the model.

Generally, the stereotyping extended only to the overall arrangement of ships, human figures, and buildings, with the painter altering the position of individual elements, the attitude and number of human figures, and the size and orientation of buildings according to his point of observation as he worked. And these variations of attitude and shape also appear in craft products, lacquer and ceramic wares, at least in the case of human figures and utensils.

COMPOSITION OF THE MAP SCREENS The map screens are of a piece with the other *namban* screens in that all are of similar general artistic construction; yet in each can be discerned some variations. In the case of the world maps, these variations occur because of the use as sources of two or perhaps three families of maps of differing content and style. The maps of Japan, in contrast, all seem to have been copied from one family of originals. Another source of variation in both the Japan and world maps lies in the painter's technique and in his choice of the place names included. Thus map screens are fundamentally different from the *namban* screens, for each copy of the latter was made different by the differing point of view of the painter.

It is clear that the style in which the world-map screens were painted is not that employed in mak-

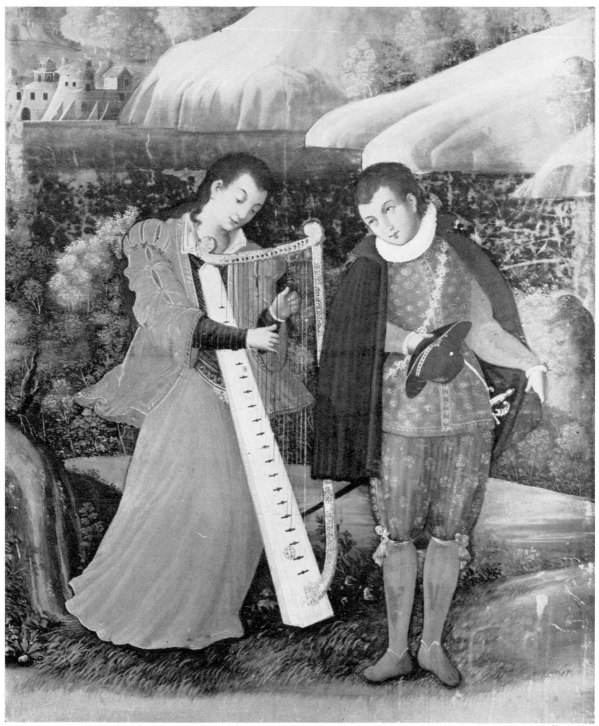

103. European Social Customs: *detail from a pair of sixfold screens. Colors on paper; each screen, 93 × 302 cm. Collection of Moritatsu Hosokawa, Tokyo. (See also Figs. 86–87.)*

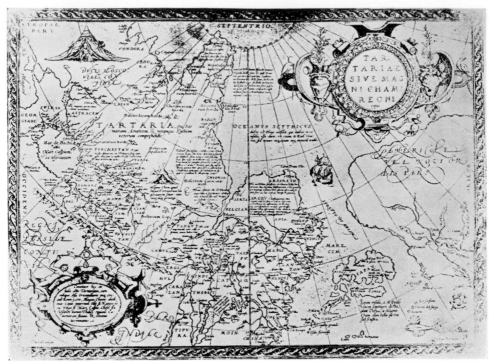

104. *Map of Tartary and China by Abraham Ortelius from his* Theatrum Orbis Terrarum. *Also shown are some of the islands of "Iapan" (Japan). Published in 1574.*

ing Portuguese navigational charts, but owed its origin to world maps published in western Europe in the period 1570–90. The Christian daimyos' embassy brought back from Italy a map by Abraham Ortelius (Fig. 104) published in the 1570s, and Japanese map screens must have been made by copying it. One can imagine, too, that there were other printed maps that came into the hands of the Jesuits in Japan, and that these were also in demand by painters as source material.

The most important point to be noted in connection with the map screens is that each and every one of the world maps agrees, with differences in detail only, that Korea should appear as a peninsula and that the coastline of northeastern Korea should continue in a straight line to the east or northeast. This extension of the contours of northeast Asia (the present Maritime Province of Siberia and north-

ward) was fairly close to reality, and represented a major advance over European maps of the period.

On maps published in Europe, the islands of Japan were grotesquely distorted, showing an oval or spindle-shaped main island, with a group of smaller islands trailing away to the south and west. And even when Honshu, Shikoku, and Kyushu were differentiated, the upper half of Honshu was shown to veer southward. In contrast, the map screens depicted Honshu in a form reasonably consistent with reality, and its upper part was appropriately oriented toward the east or north. And this view of Japan is repeated in the large on the map screens that showed Japan alone.

All the world- and Japan-map screens also show, in one form or another, an island to the north of Honshu identifiable as Ezo (present Hokkaido).

These revisions of the northeast Asian coastline

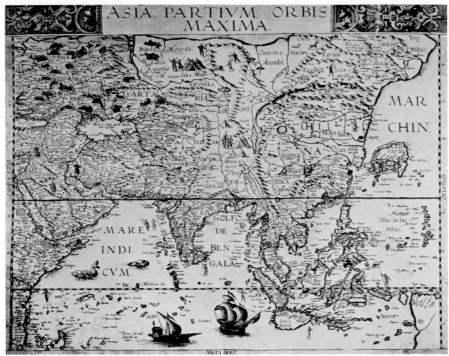

105. *Cornelius's map of Asia. As in Ortelius's map, Hokkaido is not shown, and Honshu, the largest Japanese island, is severely truncated. Published in 1581.*

and the orientation of northern Honshu can be seen in the fan map (Fig. 122) that belonged to Hideyoshi (said to have been made during the Korean campaign) as well as in the India-ink copy of the chart of the *San Felipe* (Fig. 76), the original of which showed Honshu in its former distorted configuration, and in world maps (Figs. 77, 114) done in oils in the Jesuit art classes. All these maps probably made use in one way or another of a common ancestor. Making revisions of this sort on the European world maps was probably beyond the competence of the Japanese of that day, and we can only conclude that it was accomplished with the assistance of technically expert Portuguese, and with map makers among the Jesuits who had seen reports from the Korean theater. The final touches may even have been provided by the artistic and talented Giovanni Niccolo.

It is certain that the Jesuit model for these new world maps, which were based on published European versions, was in existence before 1596, and the map fan, the *San Felipe* copy, a variety of *namban* screen maps, and the map done in oils by the Jesuit artists were in all probability related, more or less closely, to this revised Jesuit map. Both the European maps and the charts made by Japanese that appeared subsequently were similarly patterned after it.

This uniformity, deriving from reliance on the revised map, is common to the vast majority of map screens. For the painters, either as a result of receiving commissions from patrons conversant with the *namban* taste and highly interested in conditions abroad, or out of their own interest and understanding, may well have traveled to the Jesuit establishment in Nagasaki to see their maps, and may even

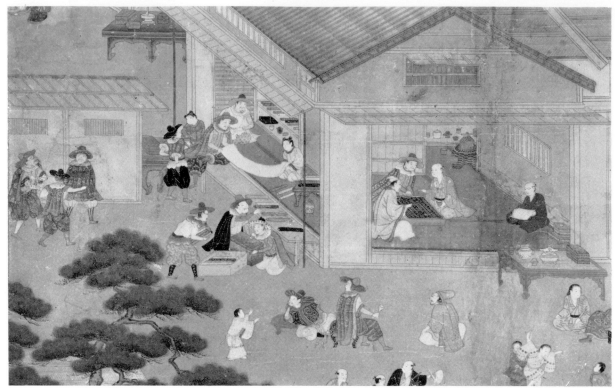

106. Portuguese merchants in a Japanese town: detail from a namban *screen. Colors on paper; full size, 86.8 × 153 cm. Kobe Municipal Museum of Namban Art.*

have borrowed them for the purpose of copying. And since the map screens also served to satisfy the increasing curiosity and hunger for information about foreign lands, stereotyped screens were produced almost immediately by these artists or their acquaintances. The fad for *namban* fashions, then, is yet another reason for the appearance of such a large number of similarly structured works.

THE WESTERN STREAM OF NAMBAN ART

The term *namban* art should, in a rigorous sense, mean "Western-style art," since it was brought by aliens, along with an alien religion, into a Japan that was previously totally unaware of it. We have already noted the Jesuits' need for quantities of religious art as Christianity spread through Japan, and how, to

assist their ministry, they greatly desired to deepen the understanding of the Japanese by the use of pictures portraying the way of life in the Christian West, the magnificent ceremonials attending its pope, and the majesty of its kings and princes. It was however, impossible to bring pictures from Europe in the quantities required, so that when a small number of works came to hand, there was no other course than to arrange for them to be copied in Japan. Out of this need the so-called Western stream of *namban* art began, giving rise to the training of Japanese in the arts of Western-style painting and engraving at the educational facilities founded by the Jesuits.

The trainees were not free to select the works they copied, and the techniques they could use were limited to those they were taught by their Jesuit

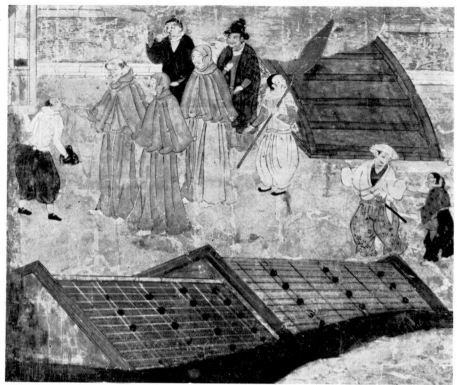

107. *Franciscan monks: detail from a pair of sixfold namban screens by a follower of Tohoku. Colors on paper; each screen, 154.5 × 350.8 cm. Yoshimatsu Tsuruki Collection, Tokyo. (See also Figs. 17, 59, 62.)*

masters. Of course it may well be that this way was better for the students, and indeed, since qualified masters numbered only one or two, no other way can have been feasible. And while they were fortunate in having as models many of the works brought back by the daimyos' embassy, these works had not, after all, been chosen for their suitability for reproduction in Japan. Rather they were, without exception, the gifts of European royalty and nobility, and only a limited number of these were suited to the needs of the copiers.

Among the paintings and prints brought back by the daimyos' envoys, there were some by the great masters of the closing years of the Renaissance. The student artists who copied them could hardly have been aware of this, however, and since the Jesuits' objectives did not include educating the Japanese

to an appreciation of the fine points of European art, it seems that works were selected and copied without regard to artistic merit. It being impossible to produce a great variety of work worthy of the name of church art, it seems that the only aspect they concentrated on was the production of as many pictures as possible in order to keep up with the demand. Toward this end the artists copied individual works over and over, and since this inevitably became monotonous, they made minor changes in portions of the original.

Slavish imitation was the most conspicuous characteristic of the works of the young artists of the Society, and even after they attained the maturity to choose the materials from which to work, it remained a glaring and ubiquitous defect in their works until the decline of Western-style art that

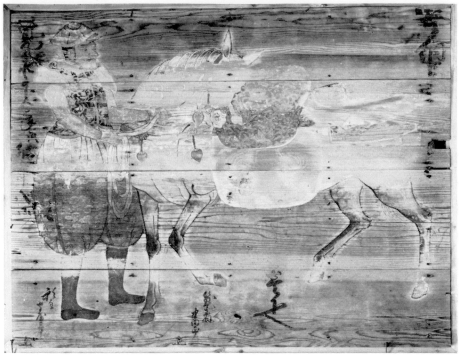

108. *Votive tablet (*ema*) depicting a* namban *figure and a horse. Colors on wood, 114.5 × 150.5 cm., 1638. Jion-ji, Yamagata Prefecture.*

resulted from the Tokugawa shogunate's suppression of Christianity.

CONTRASTS BETWEEN WESTERN AND INDIGENOUS STYLES In comparing the indigenous and Western streams of *namban* art in terms of style, we can say that the indigenous stream makes most effective use of the vibrant gold, red, and green *kompeki* color scheme, with its traditional, strong India-ink delineation inherited from Chinese painting. The Western stream, on the other hand, used the oils and tempera of Western painting and attained the effects of perspective and shading by means of variations in color and textural depth. The unusual style and colors of Western painting served to make the human figures, cities, battles, and other features

characteristic of Europe real to the Japanese, and proved worthy of an appreciation among them that surpassed all expectations. And the copperplate prints, for their part, were probably most welcome as representations of a devout faith.

In terms of subject matter, the works done in the indigenous style—that is, the *namban* screens—were virtually limited to the Portuguese and the Jesuit missionaries, and their daily lives in Nagasaki, where they came into contact with the Japanese. Western-stream works, whether religious or secular, were by contrast not devoted to capturing the affairs of a single country; rather the artists sought to represent the universal Christian faith and the civilization influenced by it.

However, the maps, both Western and indigenous, differed from these works of art in that they

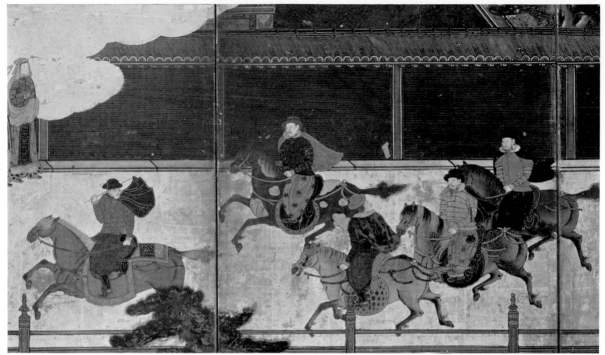

109. Detail from a pair of sixfold namban *screens in traditional Japanese style by a follower of Kano Tomonobu showing mounted foreigners. Colors on paper; each screen, 153 × 364.8 cm. Tokyo National Museum.*

followed common models, and were based entirely on European maps and European knowledge. Since their primary function was the practical one of imparting to the Japanese knowledge of other countries, it is hard to describe them as works of art in the fullest sense, and they hardly provided a means by which the fine points of the painter's technique could be expressed.

Nevertheless, the convoluted outlines of oceans and continents copied with exquisite precision across a sixfold screen, and even more, the bright and gorgeous colors of the Western-style maps surely had a major role in making this world of the unknown more attractive, and of allowing the beholder to give free rein to his imagination. Thus they must be recognized as having a claim to artistic appreciation in no way inferior to that accorded the pictorial screens.

Commentaries on the Major Illustrations

NAMBAN SCREENS Figures 53, 94. The existence of this pair of screens was made known shortly after the restoration of imperial power in 1868 when they were presented to the imperial collection by the Tokugawa family. Over the years the pair has been displayed at frequent exhibitions and is held by scholars, both Japanese and foreign, to be an excellent example of Kano-school *namban* screen painting.

In the right-hand screen (Fig. 94), the captain-major of the Portuguese vessel with his retinue, wearing distinctive headgear and long capes, are moving in procession toward the gate of a typical church building located in the upper-right-hand corner. In the chapel beyond the gate a picture of the Savior, surrounded by missionaries, is hung. Thatched-roof shops catering to foreigners line both sides of the road down to the dock. The simple houses of the citizens of Nagasaki can also be seen. In the right foreground, *bombacha*-clad figures of three samurai in a shop provide an excellent example of the taste for European styles that was to spread out from Nagasaki.

The left-hand screen (Fig. 53) shows the *namban* ship and the Portuguese who have landed and are about to enter the church at upper right.

The screens are crowded with a profusion of people and things, rather like a stage setting. Traders, seamen, and missionaries crowd the ship and are jumbled in and among the buildings that cover two-thirds of the screen surface, with the remaining space filled with stylized clouds and pine trees. This congested grouping of people, buildings, the sea, and the ship is anything but natural, giving the impression that it is a work of mediocrity. One can easily see, by its immaturity of composition, that the work is the artist's first attempt at this sort of screen, and probably reflects a desire to crowd in everything with *namban* connotations. Certainly the three ladies who are playing a backgammonlike game at the upper-left corner of the right-hand screen seem to be an inconsistent afterthought.

Figures 21, 93. This pair of screens is reputed to be the gift of Tokugawa Ieyasu, and despite doubts about the authenticity of this claim, can date from no later than the end of the sixteenth century. Its balanced and brilliant use of color and its well-organized India ink-delineation show it to be outstanding among surviving screens.

The great *nao* that rests on decoratively embellished waves in the right-hand screen (Fig. 21) does not seem to float naturally; rather it gives the impression of being set before us on a stage. Another incongruous element is that, despite the fact that three Jesuit missionaries are seated on the dock at the left waiting to welcome the ship, the captain-

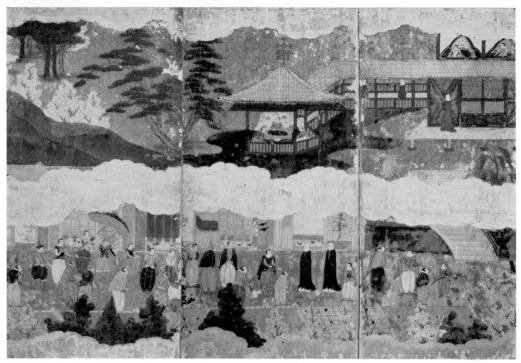

110. Detail of a sixfold namban *screen in* yamato-e *style. Colors on paper, 106 × 312 cm. Muro-o-ji, Nara. (See also Figs. 97, 101.)*

major and his retinue, who have just landed, are proceeding toward the ship from the town. Is it possible that this kind of situation actually occurred? By contrast, the wooden-roofed row buildings that house shops, the people observing the passage of the Portuguese, and the church shown above the separating device of stylized clouds all appear faithful to reality.

A few brief comments on the church buildings appearing in *namban* screens will not be inappropriate here. The kind of construction shown in Figure 93, with the chapel at the left connected to a rectory or residence on the right by means of a covered passage, recurs regularly in many *namban* screens (Figs. 54, 63, 110). In most of these, the covered passage connects to the right of the chapel, although in some cases we find it at the rear. The chapel has been constructed in virtually the same way in all the screens, while in each case the residence shows a

degree of variation. This can be explained in either of two ways: 1) either the great residence of the Jesuits, which was said to stand on a wooded promontory in Nagasaki, actually looked like this, and the many *namban* artists copied it, each adding his own embellishments, or 2) later artists simply followed the arrangement an earlier painter had set down. One tends to feel that the former speculation is the more likely. And this would give us the possibility of imagining, in general terms, the structure of the Jesuits' Nagasaki residence at this time.

The screen in Figure 96 shows the opposite of the arrangement we have just discussed: the chapel to the right of the residence. Whether compounds conforming to various plans existed or whether the artists rearranged the buildings in their works can no longer be determined.

FIGURES 98, 111, 112. The *nao*, human figures, and buildings are all good representations, and the

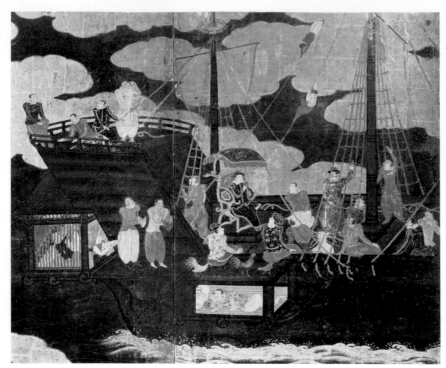

111. *Traders and sailors aboard a nao: detail from a pair of six-fold* namban *screens. Tosa school. Colors on paper; each screen, 154 × 364 cm. Collection of Ataru Kobayashi, Tokyo. (See also Figs. 98, 112.)*

112. *Detail of a* namban *painting showing Portuguese procession through a Japanese harbor town. Tosa school. Colors on paper; pair of sixfold screens; each screen, 154 × 364 cm. Collection of Ataru Kobayashi, Tokyo. (See also Figs. 98, 111.)*

composition, skillful arrangement of pines, and the fishing boat in the distance are all exquisite. This is surely one of the best pairs of *namban* screens.

One is led to believe that the painter had ample opportunity for observation and sketching in Nagasaki before painting this pair of screens. And yet it is possible that he was not particularly intimate with the Jesuits and the other Portuguese, nor well acquainted with their deeper feelings. The clothing of the Japanese figures is strikingly natural, and this together with the men dressed in *bombacha*, the missionaries in long cassocks, and the presence of missionary assistants wearing foreign headgear, are points worthy of special note.

The screens seem to date from about the first decade of the seventeenth century.

FIGURES 1, 95, 113. Although this is a single, unpaired screen, we find all the elements necessary to a typical *namban* screen: the foreign ship; the landing of the captain-major and his officers in full

regalia, accompanied by non-Caucasian ordinary sailors; the *bombacha*-clad Japanese and Jesuit missionaries who have come to greet them, and the residence and chapel (here again separated by stylized clouds). An exquisitely composed pine tree forms the background of the area in which the welcoming party meets the new arrivals. All these elements are arranged with the greatest skill, precision, and attention to color. The painting is, so to speak, an orthodox *namban* screen, and in no way incongruous is the presence of two horses, two dogs, and a deer. The map of the world that is inset at the top of the third panel from the left (Fig. 113) does, however, bring in a suggestion of the intentionally exotic, whether it was added at the whim of the artist or at the request of his patron.

The screen dates from the first decade of the seventeenth century. In the lower right-hand corner it bears an inscription to the effect that it was presented to Toshodai-ji around the Keicho era

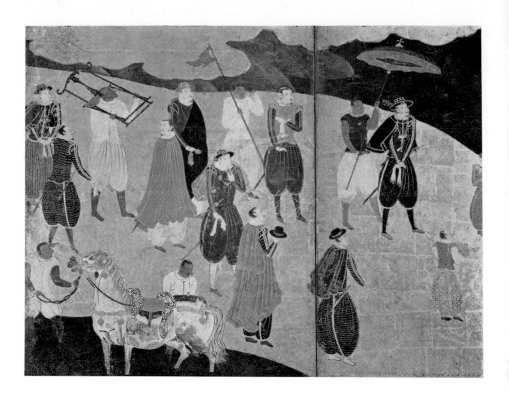

(1596–1615), but this is obviously a later addition.

FIGURES 13, 96, 100, and FIGURES 10, 118. Two pairs of *namban* screens. The screen shown in Figure 100 bears the signature of Kano Naizen in the lower left-hand corner. Together with the screen shown in Figure 23, these two pairs of screen paintings are basically alike in painterly construction: the left-hand screen of each pair shows a port scene in a foreign land and each shows the ship under full sail. The land on which the dock stands is separated from the church and rectory by the cloud device, and some parts of these are obscured while others vary slightly from screen to screen. The figures of the foreigners who are landing are also substantially the same in all three, but the position of the elephant and the way it faces differs in each pair. It is not hard to see that on the left-hand screen the artist has given free rein to his imagination, based on descriptions of Goa obtained from foreigners, with the result that the number of figures varies and

the addition and deletion of buildings of various styles has left us with a scene that resembles nothing so much as a Chinese port.

The Japanese port shown on the right-hand screen shows a virtually common arrangement in all three works, the single minor difference being the degree of minuteness of treatment given the ship. Also virtually identical in all three is the depiction of the church with pines to its left, and the appearance of the clouds is markedly similar.

While we may doubt that these screen paintings were the work of separate artists, there is no doubt at all that they are based on a single composition. And they probably date no earlier than the first decade of the seventeenth century. Other notable features are that mingled with the welcoming party of Jesuits are a few Franciscans in hooded habits, and the Japanese who follow them wear *bombacha*.

Finally, I should like to point out that the unity of composition that seems to bind the left- and

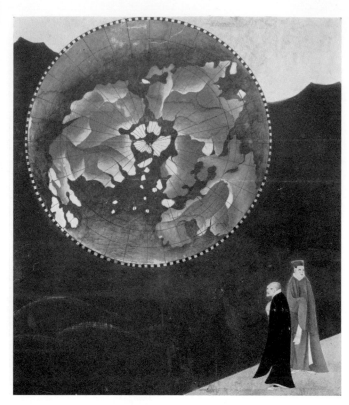

113. Detail of a sixfold namban *screen showing an inset map of the world and two missionaries by a follower of Kano Naizen. Colors on paper; 156 × 330 cm. Toshodai-ji, Nara. (See also Figs. 1, 95.)*

right-hand screens of these three pairs is such that the scene of the ship setting sail from the foreign port has been misconstrued by some viewers as an extension of the Japanese port scene. By thus emphasizing the depiction of two Portuguese *nao* in the same Japanese port at the same time, those who maintain this theory have popularized the impression that the painters were not entirely faithful to accuracy in their treatment of the subject matter since, as we have seen, these ships only called in Japanese ports singly.

But this misconception aside, we cannot go so far as to say that works showing two foreign ships on a single scene are entirely nonexistent. The first group of illustrations in the magazine *Yamato-e Kenkyu* (vol. 1, no. 2, 1942) contains a photograph of one screen of a pair from the Fuse Collection in Kobe that shows two *nao* in port together. Since

I have not had the opportunity to see the Fuse screens with my own eyes, I cannot presume to pass upon their authenticity. If they are spurious, it means that they must have been done around 1650 or later by an artist unfamiliar with Nagasaki who was attempting decorative embellishment. Alternatively, from the fact that the foreign ships and human figures seem to be copied from earlier screens, and the ships seem to be of smaller burthen, it is possible to conclude that they represent the smaller galliots, several of which visited Nagasaki together in the years after 1617.

FIGURES 17, 59, 62, 107. We do not find in this pair the vigorous style of the earlier screens but there is a broad conceptualization, appropriately realized in a minutely detailed composition. The work probably dates from around 1610.

On the six panels of the left-hand screen (Figs.

115. Folding chair of the type used by the namban *captains-major. Gold and black lacquer on wood; height, 104 cm. Tanko-ji, Kyoto. (See Fig. 8 for detail of backrest design.)*

17, 62), the ship is disproportionately large, and a single sturdy pine, after the style of Kano Eitoku, is depicted to the right. On the right-hand screen, minute attention is given to portions of the oft-recurring theme of the Jesuit residence and chapel, connected by a covered passage, which appear in the upper right, and to the dock and street scene shown at the bottom left separated by clouds. The establishments lining both sides of the street are not the rude stalls that figure in the earlier screens. The missionary group welcoming the arriving foreigners is limited to three Franciscans, and the two camels—easily mistaken for horses—that bring up the rear of the arriving party in all likelihood were not set down from actual observation, being more probably copied from foreign descriptions and pictures.

In addition, such features as the Jesuit missionar-ies in their rectory and the arriving foreigners seem to be inferior to those in other contemporary screens, no doubt because the artist, separated by time and distance from his original observations, mixed with his memory of what he saw, imaginings of things he could not possibly have seen. One such impossibility is that the welcoming party here consists of Franciscan missionaries to the exclusion of the Jesuits, and from this it is well to consider the possiblity that from around 1610 onward there were among the painters of the Kano school, ardently partisan converts of the Franciscans.

Even if the representations of foreign ships are based on recollections of actual observation, some reference was probably made to other previously completed screens, and indeed their influence may well have been preponderant. Be that as it may, this screen may at least be considered accurate to

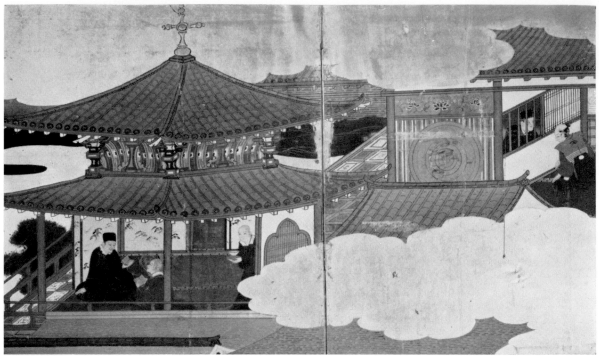

116. *Missionary and his Japanese lay assistant reading from parallel catechisms in Latin and Japanese script: detail from a pair of sixfold* namban *screens by a follower of Kano Mitsunobu. Colors on paper; each screen, 164 × 362 cm. Namban Bunka-kan, Osaka. (See also Fig. 125.)*

the extent to which it indicates that in Nagasaki during this time foreigners in long capes and distinctive headgear were much in evidence.

FIGURES 22, 99, 117. This pair of screens possesses a large number of characteristics that are not seen elsewhere. The first of these is that in the representation of the Japanese port on the right-hand screen (Fig. 22), the entire surface is filled with a rich variety of people and objects, arranged with the precision of players on a stage. The three panels on the left of this same screen portray the expected foreign ship, while the Jesuits who have come to greet the captain-major, the rows of exceptionally fine shops with Japanese men and women inside, and the residence compound (at top separated by the cloud device)—indeed virtually all the elements essential to the standard *namban* screen—are gathered in the three right-hand panels of the right-hand

screen. The inclusion of embellishments of the fore- and background in the form of clouds and various-sized pines, and even palm trees and rocky outcroppings, all combine to make this a highly variegated work.

Yet despite the unnatural crowding, the individual elements—ships, persons, buildings, and even the decorative pieces—are all arranged with a distinct flair, and though the style does lack animation, the overall effect is of great refinement. This work would seem to be the result of an attempt—now that the elements expected in a *namban* screen had been established through precedents formalized from about 1595—to include everything, without exception, in a single screen. For we may be reasonably sure that this work dates from shortly before 1614, when the new Tokugawa shogunate's persecution of Christianity began.

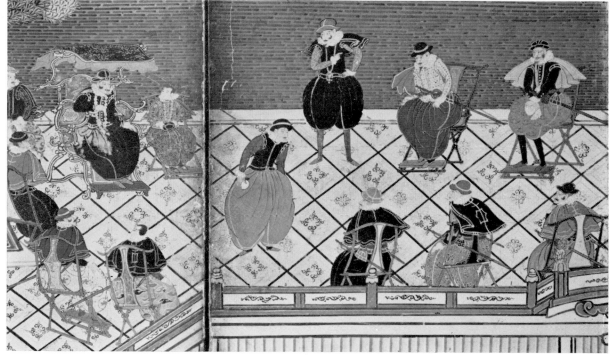

117. *Imaginary scene of Portuguese traders by a follower of Kano Sanraku: detail from a pair of sixfold* namban *screens. Colors on paper; each screen, 156 × 358 cm. Suntory Art Museum, Tokyo. (See also Figs. 22, 99.)*

The scene on the left-hand screen (Figs. 99, 117) is laid not in Japan but in some foreign country. Probably an artist who was friendly with the Jesuits and Portuguese had heard tell of their homeland, or some Asian city like Goa that was under their rule, and painted this work, adding details to this vignette of city life from his imagination. The artist could have no knowledge of the streets, squares, or buildings of Portugal much less its current fashions, because the books he would have needed for reference had not yet been brought into Japan. No doubt this is why he has conjured up a view of China, the only foreign land he could bring clearly to mind. And when we consider that he must have portrayed the attire of the Portuguese as he had seen it in Japan, the picture, even with all its peculiarities, becomes acceptable. The activity that appears to be horse racing is no doubt an attempt to

portray *canas*, a mounted game played on a circular playing field, which was popular with the Portuguese of this time. However, the baggy *bombacha* pants shown here were a feature of Portuguese colonial styles and were not seen in the mother country, while the game of *canas* bears little relation to what is shown here. No circle has been formed, and only the pavement where the many Portuguese are seated on folding chairs could in any way be judged European. Even the figures of the women at the far left are dressed after the Chinese style.

One other pair of screens that is similar in composition to this one is housed in the Tokyo National Museum (Fig. 109), and it is probably by the same artist. But the imaginary scene showing the *canas* game in Portugal shows a number of variations between the two works in the position of the human figures, the configuration of the buildings, and the

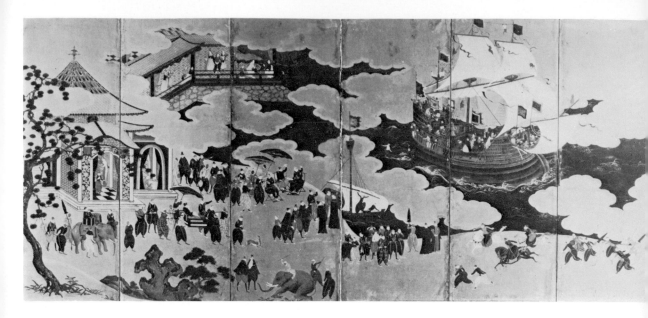

decorative foliage, presenting us with undeniable differences in composition.

To the extent that the right-hand screen of a pair formerly belonging to Rokuzaburo Kasahara is similarly an imaginary portrayal of the same kind of scene, reference to it may also be helpful, but the left-hand screen, though it shows a ship, a street lined with shops leading to a dock, and church buildings, has a different composition from its Suntory and National museum counterparts, leading to the conclusion that it is of later date.

FIGURES 116, 125. This pair of screens has positioned within its limited confines all the expected types of buildings, complete with the liberal use of decorative clouds. The way in which, with consummate craftsmanship, these are made to now hide and now reveal the scene greatly enhances the artistic merit of this work. The pair probably dates from around 1610.

One point on which this screen is strongly realistic is the scene of the Jesuit missionary and his lay assistant reading together from parallel catechisms in Latin and Japanese (Fig. 116). The transporting

ashore of the arriving ship's cargo is another realistic element that can, it is true, be seen in a number of other screens, but a clear representation of the landing of silk bales, like that on the left-hand screen of this pair, is rare indeed, and gives us an excellent idea of how things were done at this time.

The gate of the residence compound, as shown on the far right panel of the right-hand screen, is somewhat similar to the gate shown in Figure 94, and from this we may conclude that both representations resemble the actual gate.

FIGURE 64. Only the right-hand screen of the pair discussed is shown here. The dock, street, and shops in this painting have all undergone transformation, and the atmosphere of the earlier screens (from 1603–15) has entirely disappeared. There are Portuguese in the street, but no sign of Jesuit missionaries or their residence. There is no doubt that this elimination of all Christian connotations was in deference to the shogunate's severe policy of proscription.

It is likely that the artist worked from observations he made in Nagasaki before the construction

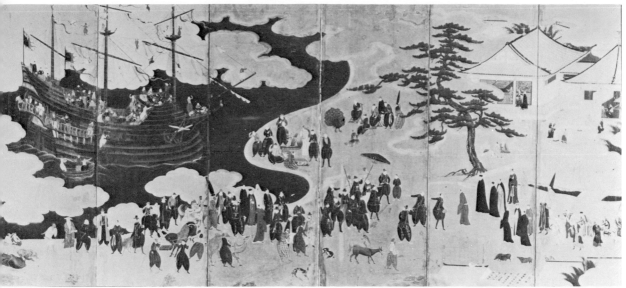

118. *Pair of sixfold* namban *screens showing two port scenes. Colors on paper; each screen, 156 × 365 cm. National Museum of Antique Art, Lisbon. (See Fig. 10 for detail.)*

of Deshima, the artificial island that was to serve as the Dutch factory during Japan's long isolation (1639–1854). Yet at the time of the painting, there should have been no sign in Nagasaki of the kind of large vessel shown. How then shall we explain the anachronistic treatment of the ship and the town? Could it be because the patron of the painter, still enamored of the *namban* taste despite the shogunate's proscription of Christianity, specifically requested that the ship, at least, be represented as in earlier times? Certainly the ship we see here is a faithful and finely wrought representation of the *nao* of earlier years and by no means inferior to treatment of *nao* on many other screens. Or could it be that a remembrance of earlier observation of Nagasaki allowed the artist to recreate this fine old *nao*?

The fact that the appearance of the Portuguese is less imposing than in earlier screens may well reflect the realities of the declining years of their trade. The distinctive headgear and capes too were probably widely worn even at this time, according to the season.

MAP SCREENS FIGURES 65, 66, 75. World-map and Japan-map screens. This pair of map screens, painted in the deep colors of the *kompeki* style, shows excellent examples of the gorgeous Momoyama-period screens. The pair constitutes an important cultural property.

Virtually all existing Japan-map screens (with the exception of those like the one in Figure 20 which employ a traditional style originated by the eighth-century Buddhist monk Gyoki) are composed on similar principles, and the Japan map in this pair is one of the earliest of these exemplary works. In the case of the *namban* screens, the repetition of such structural elements as the ship, dock, procession of foreigners, street lined with shops, and Jesuit residence located at top and separated by a bank of clouds is mainly due to conscious copying by *namban* artists of earlier works. The map screens, on the contrary, were each composed from European originals. The explanation of this distinction tends to become rather technical, but I would like to give at least an outline here.

When Valignano visited Hideyoshi at Kyoto in

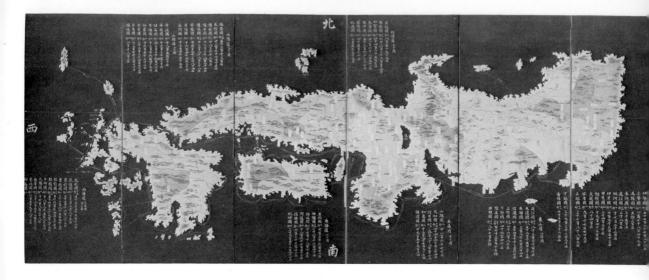

1591, among the twelve Portuguese who accompanied him was Ignacio Moreira, a man of some sophistication in geography and land surveying. During the more than two years he was in Japan, from July 1590 to October 1592, and particularly in the first year, during his journey to and from Kyoto, Moreira surveyed the coastal regions in the western half of Japan and collected materials and information from Japanese sources in connection with the eastern half. On the basis of these he drew a map of Japan.

During the month or more in early 1592 that Valignano and his party were in Kyoto, Moreira made the acquaintance of retainers in the house of Yoshihiro, daimyo of Matsumae in Hokkaido, who was visiting the capital. A monograph entitled *Ezo no Shima* (The Island of Ezo), which is thought to have been written some time after this meeting by Moreira himself as an appendix to his map, also mentions an occasion after the arrival of the embassy in Kyoto on which he received information about the island from some of its "natives" who were in the service of Hideyoshi. These "natives,"

however, seem to have been not Ainu but the retainers of the Matsumae daimyo.

Since Moreira's map of Japan has unfortunately been lost to us, it has been the subject in recent years of considerable controversy among Western scholars. Although the map is lost, a copy of his Latin monograph, *The Island of Ezo,* long lay in the archives of the Jesuit Curia in Rome, where it was brought to public view in 1909. It contains many helpful pointers to understanding the cartographic history of Hokkaido, which was entering the consciousness of map makers for the first time; but this is not the place to go into that subject.

Another Latin monograph by Moreira, *Record of Japanese Maps,* was appended to *Studies of Moreira's Map of Japan,* a document that also lay in the same Jesuit archives until unearthed by Josef Franz Schütte, a Jesuit expert on Japan. This study was written by Duarte de Sande, who was in Macao at that time. On many points it does not differ from Valignano's reports, although it is more detailed. In his work on this subject, Schütte measures the latitude of the islands and the distances between

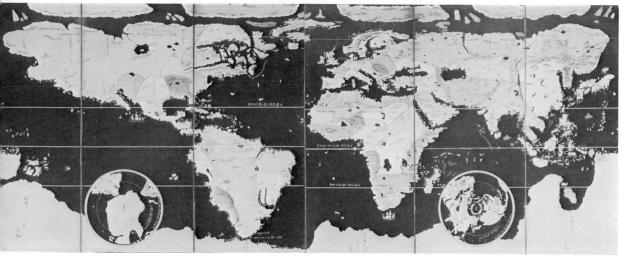

119. *Pair of sixfold map screens showing Japan (left) and world (right). Colors on paper; each screen, 104 × 264 cm. Shimosato Bunko, Shiga Prefecture.*

them according to Moreira, and discusses the problem of which of the surviving European-made maps of Japan it most closely resembles, but he draws no conclusions. It may also help to note that another Japan scholar of the Society, Georg Schurhammer, in 1943, held that the maps contained in a 1641 book edited by Bernardo Ginnaro and another of 1646 edited by Antonio Francisco Cardim, were revisions of the Moreira map. Two last points to be noted are, first, that since Moreira sailed away from Japan with Valignano in October 1592, he could not have had information obtained from the Japanese army of invasion in Korea, and second, as a result, he can have had no connection with the revision of the contours of the Asian coast to the north and east of the Korean peninsula that were based on tales about Orankai. A good guess would be that once the Society came into possession of detailed information from the Korean campaign, they determined new contours for northeast Asia, took the opportunity to make alterations to the map of Japan Moreira had left, and developed a new proposition concerning the position and configura-

tion of the seas separating northern Honshu from the Asian mainland, and of the island of Hokkaido, this process eventually culminating in the production of revised maps of both Japan and the world. Later into the seventeenth century, when the Society had accumulated even more information, they most likely made further revisions of their maps of Japan, eventually producing one of the type that was included in the 1646 work compiled by Cardim.

The new maps of Japan and the world conceived and produced during the Korean campaign at the Jesuit establishment not only exerted a powerful influence on maps made subsequently throughout Europe and Asia but were soon used to update Japanese maps as well. The 1596 copy of the chart of the *San Felipe* (Fig. 76) and maps shown on the *namban* screens of the early artists of the Kano school are conspicuous examples of this reaction.

The majority of the Kano school's world-map screens that have survived are paired with maps of Japan. By contrast, of the two world maps in Western style that still exist, one is paired with *Four Great Cities of the West* and one with *The Battle of*

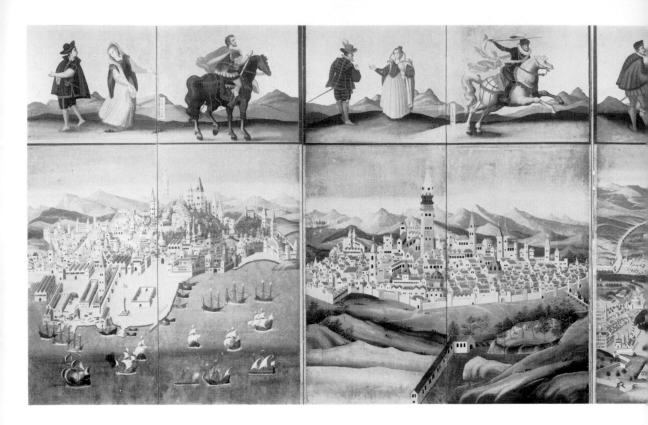

Lepanto, not with maps of Japan. Not only that, but among the works of art made by the Jesuits, there are few maps of Japan. This should suggest a difference in the objectives for which maps were made by the Jesuits and by Japanese artists—namely, that the Jesuits wished to bring home to the Japanese a picture of Western Europe and the larger world in which Europeans were active, as well as Japan's position in it, while the Japanese painters and the patrons who commissioned the screens were of course curious about the foreigners and their world, but as they went on to develop an interest in understanding Japan's place in it, a powerful desire grew in them to learn the latest and most accurate information concerning its geography.

FIGURES 67, 81, 114, 120. A world map and the *Four Great Cities of the West* screens. The bird's-eye views of *Four Great Cities* are painted in dazzlingly gorgeous colors, with such effective use of light and shade that they almost seem three-dimensional. The four cities represented are, from left to right, Lisbon, Madrid, Rome, and Constantinople. Two panels of this eightfold work are devoted to each of the cities, and at the top of each city are two scenes depicting the fashions current in each. The screen that is paired with it shows a world map, also in the brightest and most glorious color.

In 1585, the youthful ambassadors of the Kyushu daimyos took their leave of Venice and proceeded westward across the plains of Lombardy, and in the five or so days that they were in Mantua were made welcome by the duke and all the citizenry high and low. On the occasion of their visit to the botanical gardens, Melchior Guilandinus, the director, presented them with four rare books, among which was included a volume printed from

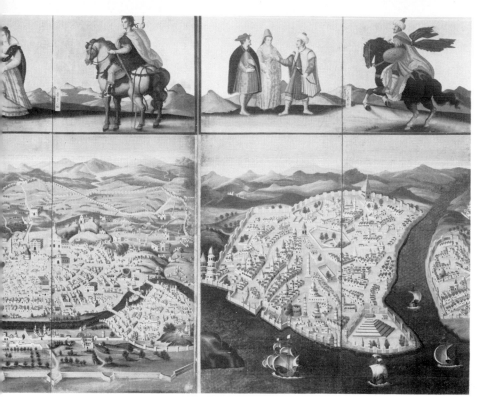

120. Four Great Cities of the West *(Lisbon, Madrid, Rome, and Constantinople). Colors on paper; eightfold screen; full size, 158.7 × 466.8 cm. Paired with world map in Figure 114. Kobe Municipal Museum of Namban Art. (See Figs. 67 and 81 for details.)*

copperplates and showing the noted cities of western Europe, and a copy of an atlas by Abraham Ortelius (Fig. 104). It was from these that, on the envoys' return, the pair of screens showing the four cities as well as the world map were made in the Jesuit art classes. The work is no mere copy, however. Even the most superficial glance shows that the original copperplate prints were of most restrained coloring. And, due to the emphasis provided in the screens by the use of stronger color in an effort to achieve a freshness of impression, each of the cities must have struck viewers of the painting as representing the very quintessence of permanence.

Doubt was expressed earlier that the city plans shown to various daimyos by the young Christian envoys when they accompanied Valignano to Kyoto were the same work that is now in the Kobe

Municipal Museum of Namban Art. This is because, given that the envoys' plan was painted in 1590, we would be asked to believe that it was paired with a world map that our earlier analysis tells us was completed three or four years later— that is, at or after the end of 1593. And while this is not impossible, it is surely more reasonable to take the view that, since the pictures of the four cities were probably copied a number of times, a new work was made for the purpose of pairing with the world map. At any rate, the study of Western painting at the Jesuit seminary had begun in the fall of 1590 and since it had long been the Jesuits' desire to show the Japanese pictures of the Eternal City, this was no doubt the very first work they set themselves to copy. It is certain, moreover, that when Valignano and his party left Nagasaki for Kyoto at the beginning of December, it was ready.

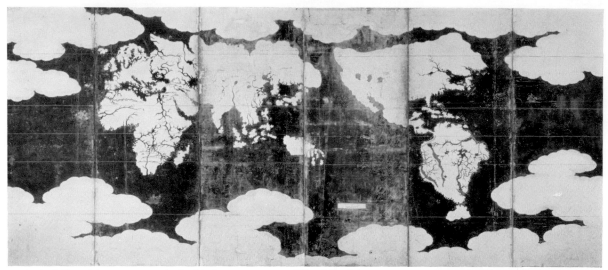

121. *Sixfold world-map screen, paired with Japan-map screen (Fig. 20). Colors on paper; each screen, 154 × 352 cm. Hosshin-ji, Fukui Prefecture.*

For each of the cities, there appears at the top of the painting two scenes, done in brilliant color on a gold ground, depicting the fashions current among the inhabitants of the four countries. Each left-hand scene shows mixed groups of two or three people (such as are to be seen in the Western genre screens we shall discuss later) while the scenes on the right-hand side show a single mounted knight. Specifically, one of the figures above Lisbon corresponds closely to a knight shown static on the two panels on the right of an eightfold screen in the Fujii Collection, the figures above Madrid are very similar to those in a framed picture in the Fukushima Collection, and the mounted figure above Constantinople is similar to the figure of a Moslem warrior that appears on the two panels on the right of the right-hand screen of a pair depicting mounted knights, now the property of the Kobe Municipal Museum of Namban Art. The mounted figure above Rome is that of a woman who is not to be found on any other surviving screen.

Other pictures of this type, illustrative of men's and women's fashions, and of the same period, are a series of people of sixteen countries and the five continents of the world that are ranged on either side at the bottom of a world-map screen in Western style (Fig. 77) that is paired with the *Battle of Lepanto* screen made by the Jesuits and belonging to the Murayama Collection. This work introduced the styles of all the peoples with whom the Portuguese came into contact during the sixteenth century, with the exception of the Romans (who were the same as in the *Four Great Cities of the West*), the Spaniards (who resemble those in the left-hand scene of *Four Great Cities*), and the Turks (who are the two figures farthest right in the group appearing in *Four Great Cities*). It would seem that the only ones drawn purely from imagination were the natives of Tartary and of "Macaranica" (tentatively identified as near the south pole), and there is little doubt that there was some copying from earlier sources. These depictions of the people of the sixteen countries were also made with the intention of acquainting the Japanese with the existence of the races inhabiting the wider world. And these figures were the forerunners of people in two similar works, *People*

Around the World and *Peoples of Forty-two Countries*.

The world map (Fig. 114) paired with the *Four Great Cities of the West* was made, as indicated earlier, in the Jesuit art classes in 1593, and on the basis of Korean maps of a generation earlier, such as the Hon Il Kang Ri Yokdae Kuk Kun maps showed the peninsula of Korea, an extended coastline to the northeast, and a revised representation of the islands of Japan.

This map screen, with its oval map in rich and attractive color is profusely decorated with a multitude of ships on the Indian, Pacific, and Atlantic oceans, compass cards in the Indian and Pacific, and the four hemispheres and two representations of the Ptolemaic universe at the upper corners of the screen. The fact that the screens made by the Jesuits, both this one and that in the Murayama Collection, are paired not with maps of Japan but with the *Four Great Cities of the West* in the one case and *The Battle of Lepanto* in the other, indicates that their objective was the communication of European knowledge to the Japanese.

FIGURE 76. Copy of a *San Felipe* navigation chart. This chart bears at lower left an inscription to the effect that when the *San Felipe* foundered at Urato, in October 1596, Hideyoshi sent to it a man named Nagamori Masuda. This man had a copy made of a chart belonging to the ship and this he brought back to Kyoto. The copy, however, is not a faithful reproduction of the original, and there are three points of evidence for asserting this. First, north and south on the copy are reversed, something never found on European maps and charts of this time, although in Japan, where latitude was unknown, traditional maps commonly and contemporary maps occasionally showed this feature. Japanese failure to understand latitude is evident in the map of Japan owned by Hosshin-ji temple (Fig. 20), another in the National Library in Florence that is copied from a map taken to Europe by the Kyushu daimyos' envoys in 1585, and a map that appears in the *Shukaisho* (Compendium of Trivia), published near the start of the seventeenth century, as well as several other maps dating up to the early eighteenth century. Second, the copy is centered on Japan, and was therefore obviously made there. Third, while

122. *Toyotomi Hideyoshi's fan-shaped map of a portion of northeast Asia with only Japan, Korea, and China identified by name—the areas that were of chief interest to the military ruler.*

the map does show sea routes running from Manila to Kyushu, Macao, and Mexico, from Mexico to Spain, and from Spain to the North Atlantic, these were probably added by the copier on the basis of information from the Spanish pilot, whereas the copier, on his own initiative, has inscribed Japan's main coastwise trade routes from Osaka through the Inland Sea to Shikoku and Kyushu.

Further characteristics that reflect Japanese revision are "Fuzankai," the Japanese name for Pusan, the contours of the Asian continent to the east and the name "Orankai" inscribed thereon, and the depiction of a peninsula at its eastern extremity, separated from the northern tip of Japan's main island of Honshu by a narrow strait, and labeled "Eso" (Ezo). This surely reflects the advanced geographical knowledge of Hokkaido, Korea, and regions further north that existed in Japan at that time.

It is most likely that the map shown here was copied with great care at Kyoto from the copy made of the *San Felipe's* chart in Urato, and that at this time the major revisions referred to above were made.

FIGURE 122. Hideyoshi's fan map. This fan, which used to repose at Hideyoshi's right hand, shows on

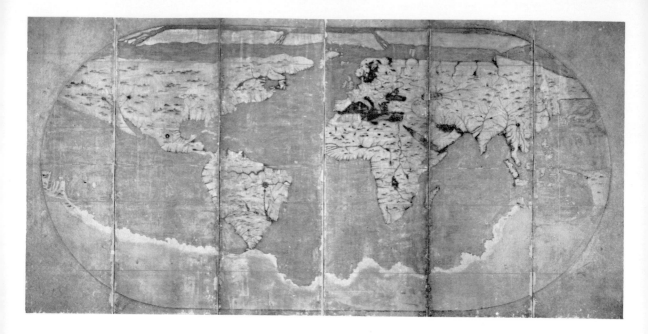

one side an abbreviated map of Japan, Korea, and China, and is reputed to have been made during the Korean campaign. Although it cannot properly be included in the corpus of *namban* art, it is of some interest in the sense that it shows the influence of foreign knowledge of geography.

The Japanese islands, China, and Korea—the countries that at this time attracted Hideyoshi's interest—are shown on this map in ocher, while other areas are in yellow and are entirely without identification. It is probable that the area to the top and right of Japan, separated by a narrow strait, is an imaginative representation of the coastline northeast of Korea, already known to be a peninsula, and owing something to the sixteenth-century Korean Hon Il Kang Ri Yokdae Kuk Kun maps. Some of the areas jutting into the sea at the right, below this, would be the unknown portions of New Spain, as the New World was then called, while the areas south of Shikoku and Kyushu, of which only the fringe appears, probably represent the countries of Southeast Asia.

What holds interest for us here is the coastline northeast of Korea. I have already noted (on page 118) that in the Europe of 1590 there was no knowledge whatsoever of Asia to the north of China, and that we must conclude that an idea of the contours of this coast can only have been originated by the Jesuits in Japan on the basis of information about Orankai supplied by Kato Kiyomasa's forces during Japan's invasion of Korea. Just as the copy of the *San Felipe's* chart showed revisions only of this coast and of Japan itself, this fan map too can safely be concluded to incorporate information coming indirectly from the Jesuits. It may at first be thought strange that it lacks the name "Orankai" and that "Eso" is inscribed in northeastern Korea, but there were many contemporary Japanese scholars who confused Ezo and Orankai and thought they were both very near northern Honshu, so that the same thinking may well have been current among the Jesuits. The mistake of showing Hokkaido as contiguous to the Korean mainland by no means allows us to brand the originators of this work as ignoramuses. This fan cannot, of course, tell us whether Hideyoshi himself was of this opin-

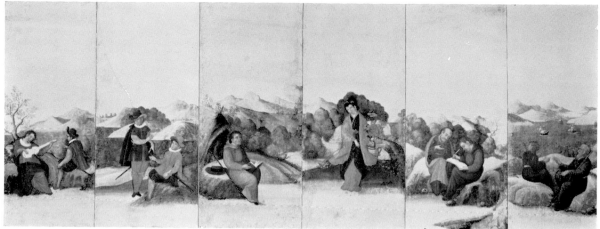

124. *Screen painting showing Western customs. Colors on paper; pair of sixfold screens; each screen, 117 × 303 cm. Kobe Municipal Museum of Namban Art.*

◁ 123. *Sixfold world-map screen. Colors on paper, 135.5 × 266.2 cm. Collection of Kichiemon Yamamoto, Osaka.*

ion, but this vew can hardly have been unique to the fan painter.

It was in the early 1590s that the areas north of Japan first came to be drawn with great clarity and accuracy, but space does not permit us to trace this process.

WESTERN-STYLE PAINTINGS FIGURES 11, 102. Mounted princes. While the years that spanned the end of the sixteenth century and the beginning of the seventeenth saw a steady resolution of the civil strife that beset Japan, warriors of all ranks remained filled with martial spirit. It was only natural then that when they came into contact with the Christian missionaries they should express an interest in European men-at-arms and their exploits. The Church too considered that if the Japanese could be shown the majesty of the Christian princes as they battled the infidel, evangelization would be greatly facilitated. The depiction of mounted princes shown here is one of a type of Western-style works executed for this purpose in the Jesuit art classes after the return of the Kyushu daimyos' envoys. There is also a pair of fourfold screens on the same subject (Fig. 82) that was handed down from Gamo Ujisato, daimyo of Aizu Wakamatsu in the late sixteenth century, and is now in the Fujii Collection.

The Kobe screen (Figs. 11, 102) shows two pairs of knights, Christian and Moslem, fighting on prancing horses, each occupying a single panel. The Fujii screen also shows four warriors, Christian and Moslem, but these men are seated quietly on their mounts. There are also two pictures of fighting warriors, similar to those on the Kobe screen, in the Fukushima Collection, each picture showing a pair of combatants; these are probably the remains of a larger set. And if we reexamine the figures at the top of Figure 120, we see that those above Madrid and Constantinople appear in two of the Kobe Museum mounted-prince portrayals, while the warrior above Lisbon appears in the Fujii screen. This, again, is no doubt the result of the Jesuits' characteristic policy of borrowing elements from one work for inclusion in another.

Another work which must be considered in rela-

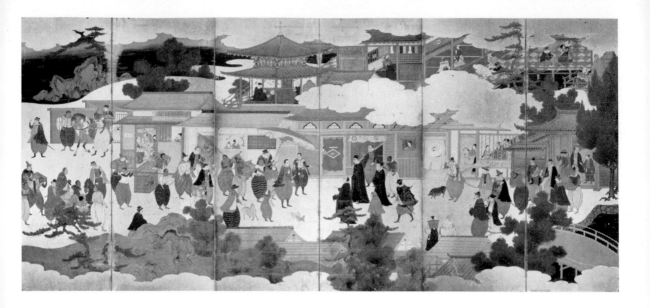

tion to these depictions of knights is *The Battle of Lepanto* screen in the Murayama Collection. Research has shown that there was borrowing of figures between this work and the mounted knights, but it is impossible to tell which is the original and which the copy. Nevertheless, it would seem that *The Battle of Lepanto* work and the one discussed here were both copied from different paintings of battles, with several figures added in common. The calmly seated cavaliers of the Fujii screen do not appear in the *Lepanto* work, and it would not have been feasible to try to build up the battle scene in the *Lepanto* work by combining many separate mounted-warrior figures.

For this reason we must conclude that the Kyushu daimyos' mission brought back several such representations of battles against the Moslems; indeed that they carried with them an album of pictures on war, probably very finely done copperplate prints, and that the martial scenes we have discussed were composed from a selection of the pictures in it. This copying was certainly carried out between the autumn of 1590 and 1593, and despite the fact that not all the early attempts of the fledgling Jesuit-trained artists to reproduce the

human form can be accounted successes, these works at least must be acclaimed as astoundingly fine. The training of these young artists had no doubt stressed the copying of human figures, both religious and secular, but the making of enlarged colored works from these war prints was by no means an easy task, and the way each individual figure is enlarged, fleshed out, and given a sense of animation indicates an artist of no mean talent. We can only think that there was a talented teacher to instruct his pupils in their collective efforts.

WESTERN-STYLE
GENRE SCREENS

There are a number of this type of genre screen still in existence, including *European Social Customs* (Figs. 42, 86–87, 103) as well as works in the Ohara Collection, the Kobe Municipal Museum of Namban Art (Fig. 124), and the Atami Museum of Art. All seem to have come from the Jesuit art classes of the early 1590s, and show townsmen and country people at their leisure in outdoor settings. Characteristic of these works are the persons playing instruments of the period such as the harp and a viol-like instrument, and the fact that the background is an open countryside or the

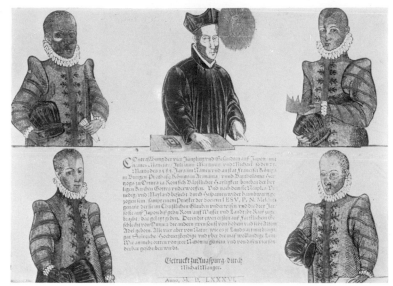

125. Namban *screen showing missionaries greeting the newly arrived captain-major. Kano Mitsunobu school. Colors on paper; each screen,* 164 × 362 *cm. Namban Bunkakan, Osaka. (See also Fig. 116.)*

126. *Members of the Christian daimyos' embassy to Europe of 1582–90. Printed in Augsburg, Germany, 1586.*

outskirts of a town. Most show great similarity in regard to the style of clothing and the attitude of the figures and there are relatively few features that are the special characteristic of any single work.

When the figures here are compared with those on the left side of each panel above the four great cities in Figure 120, common elements of composition and style can be discerned. In other words, these genre screens were in the main composed of male and female figures in various postures and styles of attire, skillfully arranged together with animals and buildings. Screens composed in this way are found with great frequency among the *namban* artworks of this period.

These genre screens differ from the *namban* screens in that the former are done in tempera in Western style and show figures in Western clothes, with Western-style buildings against the background of European pastoral scenes, while the latter are in the India-ink-lined *kompeki* style, and show foreign and Japanese figures, and Japanese-style church buildings against the background of Nagasaki harbor.

Both styles were done in the richest and most gorgeous of color schemes, in order at every turn to gratify the contemporary infatuation with extravagant and gaudy treatment, but the result has been, on the contrary, to heighten their artificiality.

Even a glance is enough to point up the contrast between the *namban* screens, with their liveliness born of the fact that the human figures, ships, and buildings were recorded from direct observation, and the genre works, in which the copying of each figure or building from European originals has resulted in a lifeless sterility. This was the most egregious fault of the Western-style works produced by the collective efforts of the painters in the Jesuit schools, and it becomes particularly striking in the large surfaces of the genre works where the organic and natural interdependence among the many figures, and between the figures and the background, has been handled with such casual indifference. The Japanese of that time, unversed in the appreciation of Western styles of art, must have derived their satisfaction solely from the pretty and colorful representations of exotic scenes that these screens provided.

We should also note that, because this type of genre work was at the same time a kind of landscape painting, it seems to have an admixture of the tech-

127. *Detail of* Cleric and Two Children *(Fig. 37), from a painting attributed to Nobukata. Colors on paper; full size, 115 × 54 cm. Kobe Municipal Museum of Namban Art.*

niques of Japanese painting. The mountains, fields, streams, and skies of the deep backgrounds are treated with simple contrasts of light and shade in a wholly European mode, while the hills, valleys, rivers, and trees of the middle distance exhibit Japanese landscape-painting techniques. And indeed, much of this is forced, and by no means entirely successful, leading many to conclude that some painters were first trained in the Kano school and then turned their talents to Western-style painting. The Japanese techniques can mainly be perceived in the use of color, but also occasionally in the use of India-ink outlining.

It may be that these peculiarities grew out of an effort on the part of the artists to cling to at least some part of their Japanese traditions, but it may just as easily be that, forced to use traditional mineral pigments along with carmine and other imported materials, the Japanese style naturally became imprinted on their work. Granting this, there

can be no denying that the characteristics of the Momoyama period, in which the Kano school played a central role, had a degree of influence, whether for good or ill, on these works in Western style.

FIGURE 36. *Maiden Playing the Lute.* Among the many depictions of women playing instruments that are found in genre screen painting, each shows small individual variations, and the kind of instrument differs, but, devolving as they do from a common original, the main points of face and figure are similar. And the fact that this work is nearly identical to one owned by the Hakone Museum of Art confirms the contention that both are the work of the same artist.

One tends to feel that the majority of the screens painted at the Jesuit schools were the result of collective efforts by the student artists, but it is likely that the student who was responsible for a given figure in one screen took charge of its representation in others, and equally, that he worked in some degree of variation of the position and clothing of his subject. The theory holding this work to have originally been one panel of another type of genre painting is at least reasonable.

This *Maiden Playing the Lute* bears a seal which has long been considered that of an artist called Nobukata, and while there is doubt that this reading of his name is the correct one, we shall continue to go along with convention and accept it. There are a number of paintings extant that bear the Nobukata seal, and though differing in size, all are single works, or screens having complete pictures on each panel. Nobukata's seal does not appear on any of the works—like the large genre paintings—that are done collectively with other artists, leaving us free to speculate that this work also was not one panel of a larger screen painting, but rather a separate work that he painted alone.

If we take it that this Nobukata was one of those

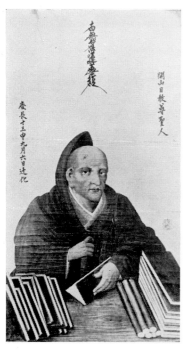

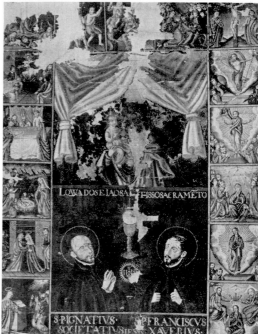

128. *Portrait of the Buddhist monk Nikkyo (1552–1608), by the Jesuit-trained artist Nobukata. Colors on paper, 112 × 60 cm. Seiren-ji, Hyogo Prefecture.*

129. The Fifteen Mysteries of the Rosary. *Colors on paper, 81.6 × 64.8 cm. Collection of Fujitsugu Azuma, Osaka. (See also Fig. 3.)*

who worked collectively on the making of genre screens for the Jesuits, we may be sure that he was the first of their art students, and that as a result of his technical superiority over his fellows received frequent commissions both from within and outside the Society, to which works he affixed his seal. For surely the pictures which survive bearing his seal can only be a fraction of the many works he must have completed.

Among the painters of the Jesuit art classes there were many who, like Brother Jacobo Niwa, fled to Macao upon the shogunate's proscription of Christianity, thereafter becoming famous for the work they did in China, but it seems that Nobukata remained despite the proscription and continued his craft for some time.

FIGURES 37, 127. *Cleric and Two Children.* This painting is now framed, but was probably joined originally to a number of similar works, now lost, perhaps forming a screen. It is known as one of the finer examples of Nobukata's work, but for all that, it is certainly a copy. Figures similar in looks, posture, and clothing to the one here referred to as "cleric," and which, one feels, were copied from a common original, may be seen in other genre screens, but there are no other figures extant that correspond to the two children, and we are unable to make any fuller investigation since not one of the originals brought back by the Kyushu daimyos' mission still survives. This work can certainly be dated no later than the closing years of the sixteenth century.

FIGURE 35. Portrait of St. Peter. This work, I feel, can safely be placed among those that have come down to us from the group of artists that belonged to the Society of Jesus. A true oil painting, its state of preservation is also comparatively good. How it came to be presented to Kakuo-ji temple is unknown, but it is said that the present mounting was done around the last decade of the seventeenth

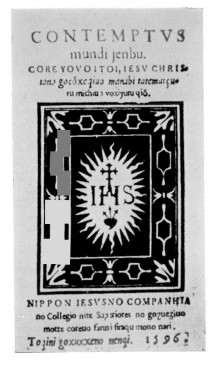

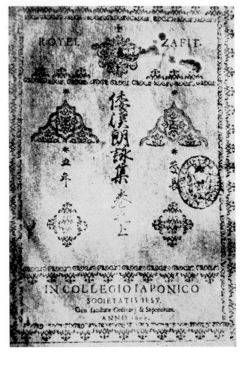

130. (left). Title page of Contemptus Mundi, *a Japanese translation in roman script of four books from* De Imitatione Christi *by Thomas à Kempis. Published in 1596 at Amakusa, Kyushu. Copperplate print. Bodleian Library, Oxford.*

131 (right). *Copperplate-engraved title page of* Wakan Roei Shu *(Anthology of Japanese and Chinese Poetry). Library of the Escorial Palace, Nueva Castilla Province, Spain.*

century. When we compare this St. Peter with the earlier copperplate prints of the apostle that were done in the Jesuit art classes (Figs. 84, 92), we find considerable difference in detail, but a preponderance of similar features. All would seem to have been copied from a common original. We cannot be sure whether to attribute the work to the students or to their instructor, but we can say that it was the work of a skillful craftsman who worked very freely from his original, and completed the work somewhat later than the copperplate prints, probably around 1593–95.

FIGURE 38. European Prince. FIGURE 39. European Warrior. When we compare these works with the two knights in Figure 80 and two paintings of European knights in the Tokyo National Museum, we are forced to conclude that all three are copies made from works depicting European royalty, nobility, and men-at-arms brought back by the Kyushu daimyos' mission. However, since none of

these originals has survived, we do not know what they looked like.

The three surviving works, done in tempera, date from around 1595, and while it is unlikely that they are exactly contemporaneous, neither can they have been separated by any great interval. It may be that each was connected with other works to form twofold or fourfold screens, but if so the other parts have disappeared. The complete works were thus wider, and the background more fully developed, although it is doubtful whether the background was actually copied from an original.

It is unlikely that all three are the work of the same person. The theory has been advanced that the works at the Tokyo National Museum are by Nobukata, but this would seem to be a spurious attribution.

FIGURE 33. *The Fifteen Mysteries of the Rosary.* FIGURE 34. St. Francis Xavier. These two works should be considered together with a third, also

132–33. Two pages of the text and title page of Spiritual Xuguio *(Spiritual Shugyo, or Spiritual Discipline). Printed at the Jesuits' Nagasaki academy from copperplate engravings in 1607. Oura Cathedral, Nagasaki.*

titled *The Fifteen Mysteries of the Rosary* (Figs. 3, 129) owned by Fujitsugu Azuma. This is because not only have all come to light in this century in the same part of Osaka Prefecture, near Ibaraki, but also because in them the figures of the Jesuit founder Ignatius Loyola, and the first missionary to Japan, Francis Xavier, both bear the title "S·P·" (Sanctus Pater) thus clearly indicating that this work postdates 1623, the year of their canonization by the Roman Catholic church. It is also suggested that all are the work of a single artist, although where in Japan (or perhaps even in Macao, for that matter) they were painted remains a mystery. At any rate, it seems safe to suggest that they were done in the same period, at the same place, and by the same artist.

When we consider that the main objective of the Jesuits in establishing art classes was the production of paintings and copperplate-engraved books and pictures showing portraits of Christ, the Virgin Mary, and the early saints, and that even secular works tended to feature the painting or engraving of European personages, it is by no means strange that the talents of the Japanese students showed their greatest development in treatment of the human form. Indeed, it might well be more correct to say that their paucity of experience with such nonhuman subjects as landscapes, buildings, and animals left their talent in these areas scarcely worthy of remark. If we confine ourselves to the Western-style works, done in oils and tempera, exact-scale copies of the originals were the exception since teaching tended to emphasize the technique of taking a single figure from the imported original and enlarging it to make a well-crafted portrait: that of Xavier is sixty-one centimeters high and forty-nine centimeters wide. The examples that survive indicate that technique in the early period was immature, but with the passage of years of practice these artists established for them-

134. *Title page of* Fides no Quio *(Scriptures of the Faith)*, *published in 1611 at Nagasaki, the last publication of the Christian press in Japan.*

135 *(opposite page, left)*. *Title page of* Fides no Doxi *(Companions of the Faith)*, *published in Amakusa, Kyushu in 1592. Leyden University, Leyden, The Netherlands.*

136 *(opposite page, right)*. *Title page of* Breve Ragvaglio *(Record of the Christian Daimyos' Mission)*, *published in Bologna, 1585. The young envoy is wearing clothes presented by Pope Gregory XIII.*

selves a mastery that no others could approach.

In that the purpose of the portrait of Loyola and Xavier (Fig. 3) was to present the faithful with imposing figures worthy of their reverence, we should not perhaps be overly concerned with its merits as a work of art. But not only is this objective most admirably attained; even a narrowly critical appraisal as portraiture shows it to be in no way inferior to any European representation of these two saints. There are those who hold that the figure of St. Xavier was copied from the title page of an edition of Horatio Tursellini's *Life of Xavier*, first published in 1594, but even if this were so, the painting of this work in color from an original that can hardly be considered a masterpiece forces us to recognize a truly outstanding talent, and the same verdict is surely due the figure of Loyola. At the time this portrait was painted, it was nearly thirty years since the artist began his studies in the Society. Surrounded by savage repression of his faith by the

Tokugawa shogunate, and experiencing brutal hostility, yet he attained to this exalted level of achievement! He was indeed a rare jewel among the Jesuit-trained artists.

On reflection, it seems sure that the achievement in this work, through adroit use of lucid color, of the very essence of Western religious art, came not only from the technical skill of the painter, but also from his ardor to express the beauty of his faith. No less does the inscription (in the archaic *man'yo-gana* style of the eighth century) below the figure of Xavier, as well as the artist's signature, indicate his remarkable classical erudition.

COPPERPLATE PRINTS FIGURE 32. Illustrated Western-style calendar. This work consists of four pieces depicting the origins of the major feast days of the Roman Catholic church for the twelve months of the year, of which one is a copperplate print, and on the basis of the

style of the plate we may suppose that it was made in Holland toward the end of the sixteenth or at the very beginning of the seventeenth century. Although it was not brought back by the Kyushu daimyos' envoys, and there is little evidence that it was copied by the Jesuits' students, it is a typical example of the prints made from original copperplates brought into Japan in the early seventeenth century.

FIGURE 30. Madonna and Child. The Latin inscription in the lower margin of this work ends by stating that it was made in 1597, in the Japanese college. At the time in question, this college was located at Arie, on the Shimabara peninsula. It should be borne in mind that this is one of two prints that Father Bernard Petitjean obtained at Manila in 1869 and later brought back to Japan, and is the only example extant of the pictures printed from a single plate by the Jesuits in Japan.

The marginal Latin inscription referred to above

gives the following story of the origin of this picture. In the first half of the thirteenth century, Fernando III, king of Leon and Castile, attacked the Moorish kingdom in southern Spain, conquered Cordova, Seville, Murcia, and Jaen, and subjugated the king of Granada. On entering Seville in November of 1248, he founded a community of Christians which soon grew to great size, and the king himself died there in 1252. Later a cathedral was built on the spot, and this depiction of the Madonna and Child was copied from a mural in a chapel dedicated to the Virgin that had stood there since the eighth century.

The copperplate engraving was done by the sixteenth-century Hollander Hieronymous Willex. In support of this, when the American scholar Berthold Laufer brought to light in 1910 a woodblock print copied in the second decade of the seventeenth century in Cheng Ta-yueh's *Annals of Cheng* by the Chinese painter Ting Yun-p'eng from

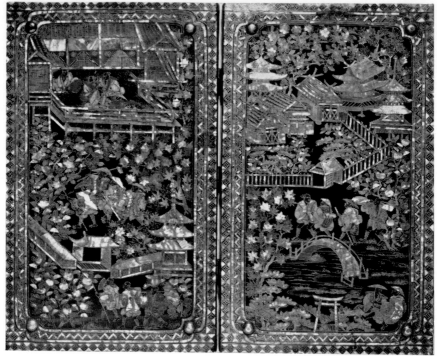

137. Outer surface of backgammon board shown in Fig. 46. Gold, black, and red lacquer on wood inlayed with mother-of-pearl. Length, 53 cm. Collection of Katsumi Yamagata, Tokyo.

an original by this same Willex, he also referred to the plate made at Arie, and established its authenticity. Later studies by the French orientalist Paul Pelliot that appeared in 1921 and writings by Tadashige Ono in 1944 and Sadamu Nishimura in 1944 and 1958 that compared the Japanese and Chinese plates have made these works extremely well known.

FIGURES 88–92. *Cruz no Monogatari* (The Story of the Cross). Among copperplate prints still in existence, many are thought to have been done in 1590. They form a book of prints belonging to the Vatican Library, inscribed in romanized Japanese, and provisionally entitled *The Story of the Cross.* The book was compiled by Manuel Baretto, a missionary who came to Japan with the Christian daimyos' envoys, and bears the date 1591. The illustrations to

which I would like to call attention are the Passion of Christ, the Savior, the Holy Mother, St. Jacob, and St. Peter. In the illustration of St. Peter, of particular importance is the inscription "1590" on the stone on which the saint's right foot rests.

This raises the suspicion that although the book may have been compiled in 1591, the five copperplates—or at least the one of St. Peter—were made in the previous year. Certainly the pictures of the apostles Peter and Jacob, which seem to be somewhat inferior technically, and are printed on paper brought from the West, seem to predate the other three, which are more skillfully done and are printed on Japanese paper. If these later three plates were indeed printed in 1591, such other surviving works as the Peter Surrounded by Other Saints (Fig. 84), which is the title page of *Acts of*

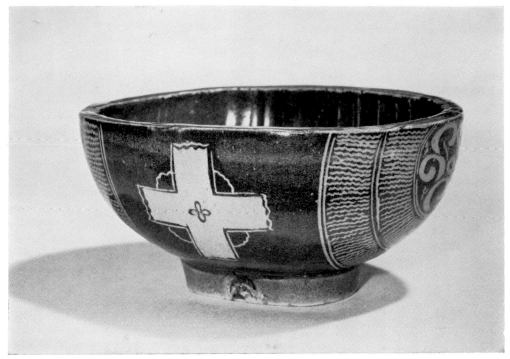

138. *Water bowl with flower and cross designs. Height, 9 cm. Collection of Yoshiro Kitamura, Osaka.*

the Saints (Sanctos no Go Saguio) printed at the school in Katsusa in the same year, must also be newly viewed as dating from 1591. This possible difference of a year or so, however, need not concern us unduly.

The primary difference we observe in any comparison of the two representations of St. Peter—that is from *The Story of the Cross* (Fig. 92) and from *Acts of the Saints* (Fig. 84)—is that in the former he is alone, while in the latter he is accompanied by a multitude of other saints. Yet the figure of St. Peter is almost identical, although there are minor differences: in the head covering, in the bending of the left arm, and in the manner he holds the Bible with the right, and one or two other points, such as the arrangement of the clothing.

There is a school of speculation that holds that

these St. Peters are not mere copies of an imported original. The theory is based on the fact that both *Education of Children* and *Record of the Christian Daimyos' Mission*, published in Macao in 1588 and 1590 respectively, before Valignano and the envoys returned to Nagasaki, had an identical print on their title page indicating that the embassy brought back no sacred pictures of this sort, or only very few. But since Valignano reported that the engraving of copperplates was impossible in the Macao of that time, it is likely that the publishers of the Macao books, unable to make a suitable original for their title pages had to make do with prints they had on hand.

The St. Peter in *The Story of the Cross* print and the one of the *Sanctos no Go Saguio* title page can only be viewed as copies, each altered in its own way

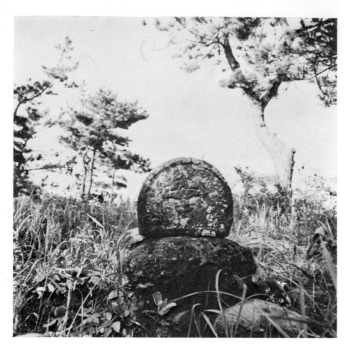

139. *Christian grave on the coast near Kuchinotsu, Nagasaki Prefecture. Height of stone, 27 cm.*

from an original print imported from Europe. Scholars who say these are not copies point to the unskillful engraving techniques to support their theory, but this very lack of craftsmanship in young students just learning their craft would equally lead to just such an inferior print as this one.

Similarly, the Savior from *The Story of the Cross* (Fig. 89) and on the title page of *Doctrina Christan* (Fig. 29) printed at Amakusa in 1592 can be seen to constitute a similar case, since the only differences are in half-length versus full-length treatment, and a few other minor points.

This copying technique, in which minor alterations were made to a single original to produce a number of "different" works, was in general use in the art classes of the Jesuits in Japan both in painting and copperplate printing. It was by no means confined to the two series of plates printed in 1590 and 1591. This technique was, of course, unavoidable, given the paucity of original paintings and plates.

COPPERPLATE TITLE PAGES We have shown several title pages of books published by the Jesuits that contain examples of the copperplate prints produced by their art classes, but since these books also serve to illustrate the craftsmen's high level of technique in engraving and in the casting of Japanese type fonts, I should like to mention some other examples that still survive:

Title page of *Doctrina Christan*. Published in 1600 at Nagasaki. Tokugawa Collection, Mito, Ibaraki Prefecture.

FIGURE 131. Title page of *Wakan Roei Shu* (Anthology of Japanese and Chinese Poetry). Library of the Escorial Palace, Nueva Castilla Province, Spain.

Title page of a Japanese-language edition of *Doctrina Christan*. Published in 1600 at Nagasaki by Goto Thomas Soin. Casanatense Library, Rome.

FIGURE 28. Title page of *Arte da Lingoa de*

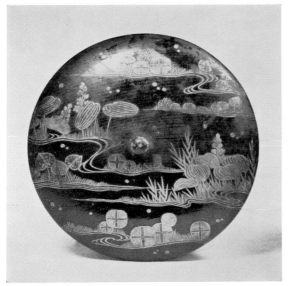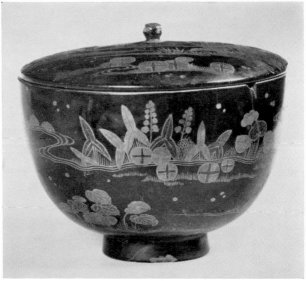

140. Cover (left) and chalice with flower and cross designs. Gold lacquer on wood: height, 7 cm. Collection of Fujitsugu Azuma, Osaka.

Iapam, Compiled by João Rodrigues. Published in 1604 at Nagasaki. Bodleian Library, Oxford University.

FIGURE 134. Title page of *Fides no Quio* (Scriptures of the Faith). Published in 1611 at Nagasaki by Goto Thomas Soin. With this book publication by the Christian press in Japan ended.

FIGURE 29. Title page from *Doctrina Christan* (in romanized Japanese). Printed in the same year and at the same place as *Fides no Doxi* (Companions of the Faith), this title page shows a full-length depiction of the Savior holding an orb in his left hand. A copy in Japanese script of *Doctrina Christan* in the Barberini Library in Rome (which is without its title page, making determination of its date and place of publication impossible) bears on the reverse of its first page a small print showing the upper body of this same figure of the Savior. The Latin inscription that appears below the plate in the romanized version is printed in all four margins of the page in the Barberini work.

FIGURES 132–33. Title page of *Spiritual Xuguio* (Spiritual Discipline). Printed in 1607 at Nagasaki. Oura Cathedral, Nagasaki. This is a Japanese translation of *The Fifteen Mysteries of the Rosary* and *The Passion of Christ Meditations,* along with other works. It was originally illustrated with more than thirty copperplate prints, but all that remain are six from *Mysteries.* The example shown here belongs to the later works of the Jesuits' production. At this point, work on copperplates had been in progress for some fifteen years or so, but there seems to have been considerable turnover among the students so that this title page, showing the Virgin Mary, typically shows no evidence of progress.

FIGURE 135. *Fides no Doxi* (Companions of the Faith). This is the second work printed in Japan. The copperplate print that is the title page shows the scene where Thomas, one of the twelve apostles, having shown himself doubtful of Christ's resurrection, is placing his hand on the wound in His side. It is known as having been copied from an

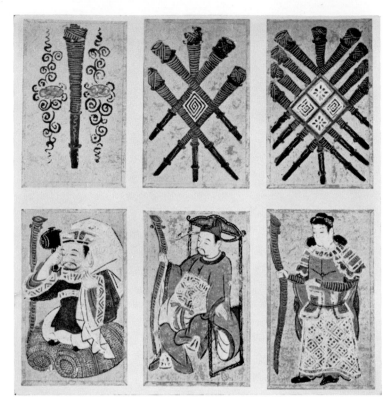

141. *Momoyama-period playing cards (*unsun karuta*) based on Portuguese models. Yamaguchi Bunka Kaikan, Hyogo Prefecture.*

original copperplate that was seized by the Mito branch of the Tokugawa family and passed down in their line. Comparison with the original shows it to have been adapted for use as a title page by a slight reduction in its width, telescoping of the background, and a bringing closer together of the figures. The Latin inscription below has also been changed, and the execution itself is decadent.

FIGURE 136. Title page of *Breve Ragvaglio* (Record of the Christian Daimyos' Mission). Published in 1585. Leaving Rome on June 2, 1585, the young envoys arrived in Bologna on June 19, where they stayed until June 22, warmly received by the authorities spiritual and temporal. This work is an abbreviated record of the mission published in commemoration of it at Bologna within the same year.

The title page shows one of the envoys wearing clothes of black velvet and colored damask decorated in gold that were presented by the pope.

FIGURE 4. Street scene in Goa showing Portuguese styles. Jan Huygen van Linschoten, a Hollander, collected logs kept by the pilots of the Portuguese ships that plied the world seas during the sixteenth century, translated them into Dutch, and published the collection in 1595. This street scene is from his work.

We can see the *bombacha*-clad Portuguese figures under enormous parasols carried by slaves, a scene typical of the Portuguese colonies. Linschoten was himself in Goa from 1583 to 1591.

NAMBAN THEMES IN DESIGN There are a large number of objets d'art in the *namban* mode that have come down to us, including works in lacquerware, porcelain,

and metal, but unfortunately there is only space to deal with lacquerware here. In this art, unlike painting, foreign influence did not affect the materials and media in which the artists worked, rather it manifested itself mainly in design. The raised designs in gold dust, or *maki-e*, that were popularized so rapidly in the late sixteenth and early seventeenth centuries, were used with great freedom and a spirit of creativity to give expression to motifs suggested by the *namban* experience.

Just as in painting there can be discerned two clearly defined streams—the Japanese-style *namban* screens reflecting the popularity of the new vogue and the Western-style works demanded for the propagation of the Christian faith—so too the lacquerware must be analyzed in terms of pieces made for popular consumption in the newly popular *namban* style, and pieces made for foreigners and the Church authorities.

Articles for popular consumption came onto the market in the 1590s, about the same time as the *namban* screens. But unlike the *namban* screens, with their large elaborate pictures, these designs were on small, conveniently portable lacquer vessels, so that motifs were simpler and less time consuming in the execution. Being thus relatively plentiful and widespread, the number still extant is by no means small.

Among the lacquerware articles so decorated were saddles, stirrups, folding chairs, small portable medicine, seal, and incense cases, inkstone cases, picnic boxes for prepared foods, tobacco trays, and drums (Figs. 7, 8, 9, 40, 41, 43–47, 71, 72, 115). The most popular designs were the *namban* visitors themselves, followed by their playing cards, smoking pipes, firearms, and other utensils. Naturally the designs were appropriate to popular preference and skillfully matched to the object being decorated. There is no doubt that the artistic treatment of the *namban* figures and clothing is highly realistic. Equally certain is that the figures on the *namban* lacquerware articles are the very images of the individual figures on *namban* screens, and are in no way inferior in terms of realism.

It seems logical to conclude that at least in the earlier period, the lacquerware artists were the same men who produced the *namban* screens, but that later they were joined by painters of other styles, and that still later there appeared a number of lacquer artisans who simply copied existing designs. Some of the designs featuring *namban* figures, and a majority of those depicting *namban* utensils can be attributed to artists unconnected with screen painting. For the *namban* figures could readily be copied from the not inconsiderable number of screens that were in the hands of the public, while *namban* utensils were everywhere to be seen and copied.

One striking riddle in connection with the selection of *namban* figures for subject matter is that despite the virtual obligatory appearance of Jesuit missionaries on the *namban* screens, they do not appear even once in lacquerware designs. It could be that lacquerware designers and artisans were not that interested in them, or again, that in the 250 years of strictly enforced proscription during the Edo period, all those articles that depicted missionaries were confiscated. Yet lacquerware articles decorated with a cross design in raised gold lacquer have survived, thanks to having been secreted among the heirlooms of private families.

Just as *namban* screens continued to be produced during the first fifty years of the Edo period, though in an increasingly stereotyped and decadent form, so the manufacture of objets d'art in lacquer continued, but with an ever-accelerating loss in artistic merit.

Typical of the second group of laquerware vessels were those for the communion host and for relics of saints that were made at the instigation of the Church and bore the IHS emblem of the Society of Jesus (Figs. 41, 70, 140).

Backgammon boards, decorative stands, and letter cases (Figs. 46, 137) were made by lacquer artisans, chiefly on orders from the Portuguese transmitted via Nagasaki merchants. These works were decorated, sometimes with Western lettering, but there is no way of knowing when their production was begun. The articles designed to the order of the Portuguese also came into use among the Japanese with the spread of *namban* taste, and some were also exported. With the proscription of Christianity in the early years of the Edo period, first the produc-

tion of Church utensils came to an end, and after the enforcement of the edict of isolation, other articles of foreign inspiration also went gradually into eclipse. The present scarcity of lacquerware made for the Church or inspired by foreign influence reflects the difficulties encountered in secreting them from the severe surveillance of government authorities during the Edo period.

TITLES IN THE SERIES

Although the individual books in the series are designed as self-contained units, so that readers may choose subjects according to their personal interests, the series itself constitutes a full survey of Japanese art and will be of increasing reference value as it progresses. The following titles are listed in the same order, roughly chronological, as those of the original Japanese editions. Those marked with an asterisk (*) have already been published or will appear shortly. It is planned to publish the remaining titles at about the rate of eight a year, so that the English-language series will be complete in 1974.

The "weathermark" identifies this book as having been planned, designed, and produced at the Tokyo offices of John Weatherhill, Inc., 7-6-13 Roppongi, Minato-ku, Tokyo 106. Book design and typography by Meredith Weatherby and Ronald V. Bell. Layout of photographs by Rebecca Davis and Ronald V. Bell. Composition by General Printing Co., Yokohama. Color plates engraved and printed by Mitsumura Printing Co., Tokyo, and Benrido Printing Co., Kyoto. Gravure plates engraved and printed by Inshokan Printing Co., Tokyo. Monochrome letterpress plate-making and printing and text printing by Toyo Printing Co., Tokyo. Bound at the Makoto Binderies, Tokyo. Text is set in 10-pt. Monotype Baskerville with hand-set Optima for display.